CW00347163

CHÂTEAU
CANTEMERLE

VALÉRIE LABADIE
Texts and photographs

ABRAMS | NEW YORK

FOREWORD

The story of Château Cantemerle, an Haut-Médoc Grand Cru Classé, is first and foremost a story about France. Indeed, the domain of Château Cantemerle is a land of History with a capital "H," embodying the elegance, subtlety, intensity, ambition and style, but also the pride, conviction, daring, tenacity and strength of the country itself. Both were born of the commitment of generations of men and women whose efforts have preserved the unique traditions and precious equilibrium of the French *terroirs*, where outstanding qualities and talents come together to offer unsurpassed excellence.

This book explores the mysterious chemistry between Man and Nature. At Cantemerle, the noblest aspects of humanity are at the heart of all we hope to achieve: to embrace, accompany and serve the slow progress of Nature, without ever coercing it or, worse, attempting to supplant it.

In return for this deep-rooted respect, the *terroir* of Château Cantemerle gives back a hundredfold what it receives from those stewards of Nature dedicated to work well done, men and women who might merit the title of "the gardener" as defined by Antoine de Saint Exupéry.

It is certainly no coincidence that Château Cantemerle and Groupe SMA have linked their histories for so many years. Shared values and common goals lie behind their respective identities. Groupe SMA is a mutual insurance group founded 160 years ago by public building and works experts. It is committed by vocation to its customers and teams, to the people who breathe life into the company and who make it so unique. Like Château Cantemerle, Groupe SMA owes its success to solid core values built on a profound sense of humanity: a desire to achieve excellence; a long-term strategic and financial vision; and most importantly a profound respect for the past – on which to build a better Future.

Bernard MILLÉQUANT
Chief Executive Officer

SMA

Ensemble, allons plus loin !

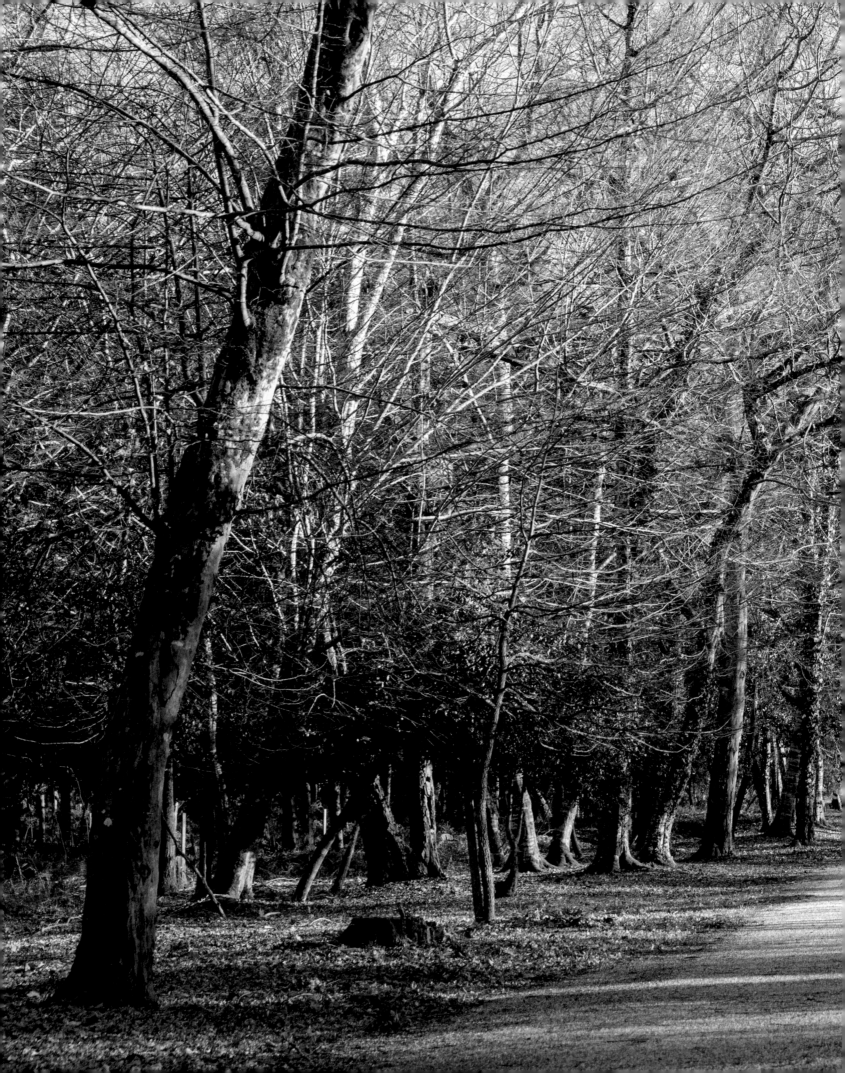

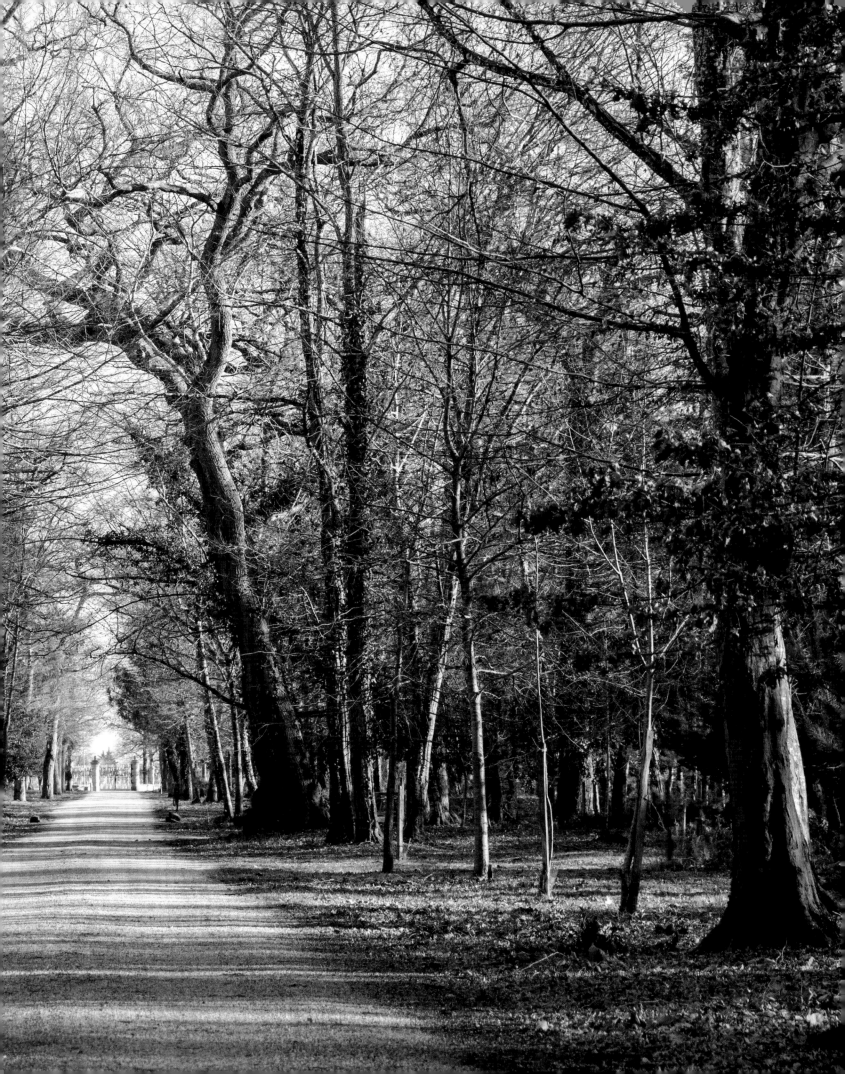

CON-
TENTS

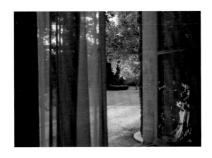

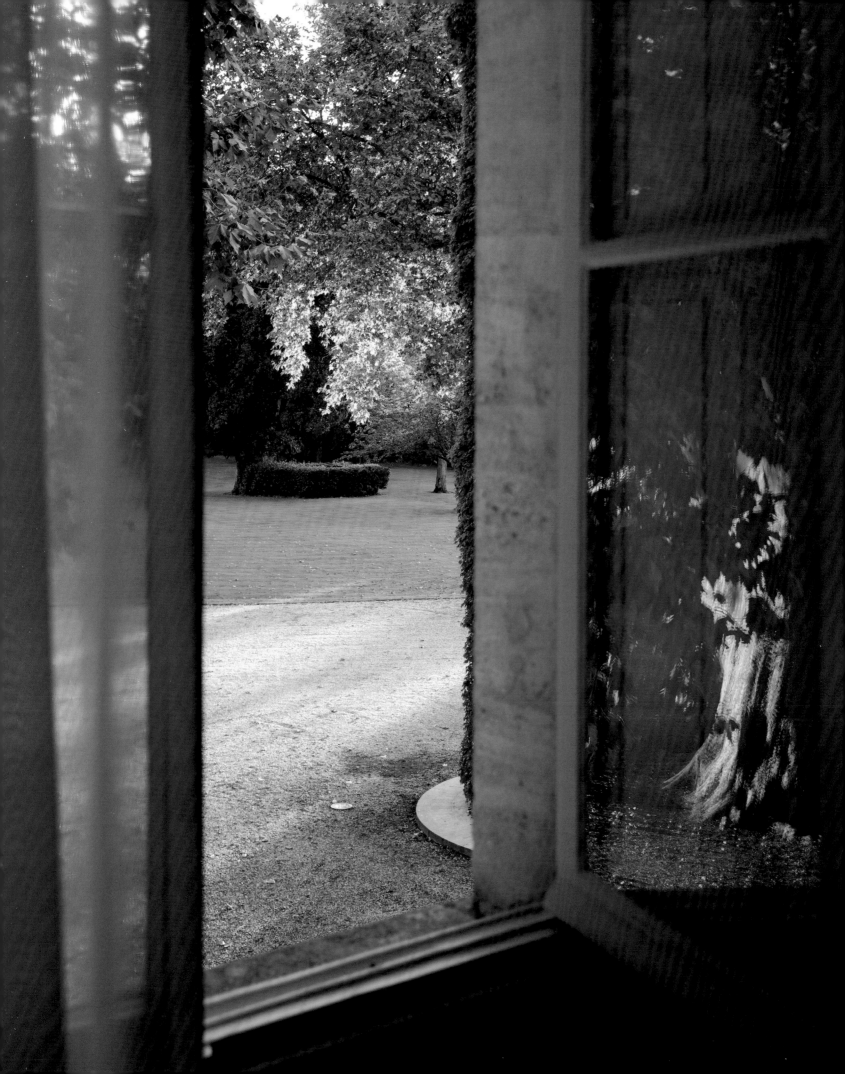

A HEIRESS
OF THE REVOLUTION

"I had lands in Aquitaine, a white château standing on the edge of woodlands and vines. A domain as rugged as the gravely soil whose warmth my fingertips have never forgotten, as delicate as the purple grapes that flourish in the winds off the Atlantic, as majestic as the great plane trees surrounding my estate."

Today I can still see it. I can picture Cantemerle and share it with you even now. Like a peaceful spirit among the living, I make regular visits and I've forgotten nothing: the majestic gardens with their winding paths where I would lose myself in thought, the rustle of the ferns turning brown in the autumn, the dazzle of the light on the château walls. And the vines of course, where I would contemplate the antics of ... elves and sprites! You smile perhaps? Take a closer look at the vineyards, the parkland and the château. You will find hidden treasures revealed only to those happy souls inspired by the splendor and the magic. You feel it, don't you, that certain stillness, the enchantment of the grounds, and the long centuries of effort, struggle and joy. They say it's still there.

My name is Caroline Joséphine Françoise Josèphe de Raymond de Lalande. I was born in Bordeaux on 8 February 1783, and if I am not yet completely forgotten (we all die twice, don't we, first our bodies and then all memory of us) then that is no doubt thanks to the Grand Cru classification that I won for my wine in 1855. What a year! I was aged seventy-two, the sole owner of Cantemerle, and it was no small matter to earn this prestigious ranking, which undeniably secured my vineyard's lasting fame. Legal proceedings against Chadeuil in 1845 for the illegal use of the Cantemerle name may have played a part too. The trial was famous in the Gironde at the time. I can't help but smile even now. I won! Two women, mother and daughter, won against a man! It would seem I was one of those women with the temperament to fight when I had to.

I would live for eighty-three years and have two children from my marriage to Jean de Villeneuve Durfort. I would then lose my son in August 1844, ten years after the death of my husband. These early deaths propelled me to the head of an estate that I had never imagined under my control. Family inheritance decided my destiny.

Opposite: Throughout the house, the tall windows of Château Cantemerle open onto one of the biggest estates in the Médoc.

Like all women of my position at that time, I occupied myself with domestic life, supervising the servants' work and the religious and moral education of my children, receiving guests and visiting charities. I was happy in that role, and well loved too. A year before he died, my husband mentioned me in his will in terms that clearly attest to his affection. *"I, Jean Baron de Villeneuve, hereby declare this to be my Last Will and Testament made with the intent to dispose of all of my property as follows: I am married to Lady Caroline Joséphine Françoise Josèphe de Lalande, my dearly beloved spouse; two children were born of our union, my son Pierre-Jules, and my daughter Jeanne-Armande. In token of my dear love and affection, I give and bequeath unto my well-beloved wife Lady Caroline a life interest in all personal properties, moveable and immoveable that I shall own at the time of my death, without exception or reserve. I make this bequest independent of the advantages that were made in her favor in our marriage contract, the full extent of which I hereby validate. I exempt my beloved spouse of the obligations imposed by the law of usufruct."* Bordeaux, 30 March 1833, Baron de Villeneuve.

He indicated in his will his desire to bequeath the domains of Cantemerle and Sauves to our son Pierre-Jules. But Pierre-Jules being still young – only nineteen at the time of my husband's death in 1834 – he never had a chance to oversee the property. At the age of fifty-one I found myself at the head of an enormous estate with only a limited grasp of the work entailed. But being born a Lalande and married to a Villeneuve, I was familiar with the world of wine and the great noble families who owned estates in the Médoc. My sister was married to Baron Pichon de Longueville. Like all women propelled by circumstances into the "affairs of men," I found I had unexpected talents, and I was ambitious to see the name of my domain held high and to protect it. Six days after the death of my husband, I planned my succession: should I die before Pierre-Jules reached adulthood, my sister would be legally entrusted with the administration of Cantemerle. I also wanted to preserve my independence, aware of the newfound freedom that I could now enjoy despite being a woman. Others before me had done just that. As early as the 12th Century, female monastic orders like the Cistercian Tart Abbey had single-handedly managed a small vineyard in Burgundy; in the 14th Century, Jeanne de Bourgogne would defy custom and the Jura climate to supervise the Château de Bracon, near Arbois. Françoise Josephine de Sauvage d'Yquem would face the hazards of the Revolution – she was repeatedly imprisoned – to keep her estates from being sold off as national property. Then there was Nicole-Barbe, the "Veuve Cliquot," a widow like me who at the age of twenty-seven defied convention and refused to give up her husband's wine house. She would face disastrous harvests, general disapproval and even bankruptcy, but her intelligence and courage would see her through.

All of these women had fought to make their way in a world that was closed to them, in all likelihood giving up something that was a part of their nature. I was one of them. In spite of the hopes of the Revolution and the likes of Olympe de Gouge and Condorcet, despite the Clubs and the early feminist movements (which were rapidly banned) most women of my era were considered to be of inferior station…

Opposite: Renovated throughout by the Groupe SMA in the Nineties, the château today boasts a sober and refined elegance.

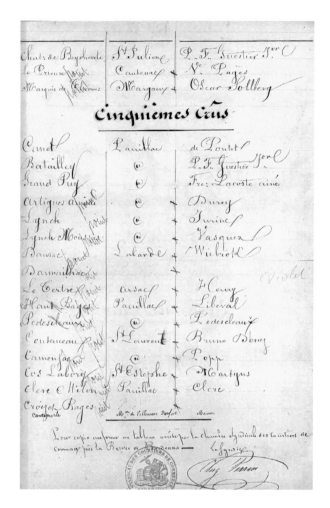

The social elite to which I belonged did nonetheless provide me with an education. Yes, it was my good fortune to have been well born, to have learned enough to think for myself, and to have been born after the Revolution. The 1789 Declaration had sown the seeds of women's emancipation, at once freeing us from paternal tutelage and granting us freedom of opinion and choice; the Constituent Assembly had given us equal succession rights, marriage contracts and the right to divorce – the basis of a civil status. I was from a century in which emancipation was at least conceivable, though actually gaining it meant turning one's back on the customs of the day, exposing

oneself to criticism and even insults. This is what I had to face when I took on the running of Cantemerle. What other choice did I have? Having my son Pierre-Jules made things easier for me, because he would have become legal owner when he came of age. He had settled in Macau to oversee operations on the estate, while I managed the business from Bordeaux. But nine years after I had taken possession of the domain, he died unexpectedly and intestate. So the property reverted to me and my daughter Jeanne-Armande. She was the wife of Charles Baptiste Oswald d'Abbadie, living on her husband's lands in the Pyrenees. So I would have to manage the estate virtually unaided, helped only by a few exceptionally broad-minded men, including Count de La Vergne, the mayor of Macau, an eminent agronomist and a great landowner in his own right. He was an important man in the Médoc region of whom I will say more later…

But let us return to that remarkable year of 1855 and the French World Fair. The country was preparing to shine on the international stage. The Republic had been abolished, the Second Empire proclaimed, and Napoléon III was eager to sing the praises of "modern" France. So he planned a vast universal exhibition showcasing the jewels of French industry and business, and appointed committees to select the best of France's regional achievements. In the first instance, the vineyards of the Gironde were not even considered. Were the traditions of wine-making regarded as old hat? Eventually however a list was drawn up, and the wines of Bordeaux would go to Paris. Château Cantemerle should have been included on that initial list, but it wasn't. At this juncture, I should like to explain why, since it might seem that our wine did not deserve its ranking…

Above: Thanks to the persistence of Baroness Caroline, Château Cantemerle was recognized as a Grand Cru Classé in 1855.

Given the difficult task of identifying the best vintages, the Bordeaux Chamber of Commerce eventually deferred to the *negociants*. These wine traders immediately ruled out ranking on the basis of tasting – an assessment they considered prone to favoritism and therefore much too uncertain. They chose instead what they thought would be a more easily regulated classification based on price. But the price lists, those infamous slips of paper that they used to prepare the classification, barely mentioned Château Cantemerle. The only information in the archives was the number of Bordeaux barrels produced by the estate, and fewer than a dozen prices. Why? Because unlike most other estates, we did in fact export our wines directly. For decades almost all of our wines had been sold to Holland, bypassing the Bordeaux market altogether. The wine brokers knew almost no details of our transactions with the Dutch, in particular our selling prices. As the wine broker Guillaume Lawton would point out in 1815: *"The wines of Macau do well in the north & even two or three of the owners, Messrs de Villeneuve, La Lande & Dufour, situated in the area around Ludon, dispatch [their wines] to Holland where they are well received. Especially the first."* In 1816, he remarked that Villeneuve was of *"the first order in the region. His wines do very well in Holland & he sends them there."* Up to this point, I had merely followed in the footsteps of my husband, Baron de Villeneuve Durfort, who had fled to the Netherlands during the French Revolution at the age of thirty-four. There, the energy, experience and demands of supervising a lucrative estate had helped him to develop close commercial ties with the Dutch that would be maintained upon his return, particularly since wine exports from Cantemerle to Holland were nothing new.

In 1854, based on good advice and encouraged by the Bordeaux brokers who were courting my wine, I decided it was time to change. I would begin selling my wine on the Bordeaux market through traditional brokers and *negociants*. This was a genuine revolution for the estate, though one short year was little compared to our one hundred years of sales outside the Bordeaux market. Was my wine too obscure to be a success here? Very unlikely, given my estate's reputation. Everyone had heard of the Dames Villeneuve Durfort, confronting the immensity of our estate all alone. We were descended from a long and noble lineage, and we represented one of the main wine-growing families of the Macau region. Was our wine deliberately excluded by a handful of traders who didn't want to see my name on the list, as some have claimed? Was the available information on my selling prices thought inadequate, despite the Fifth Growth prices recorded in Tastet and Lawton guides (300 francs a Bordeaux barrel in 1775, 950 francs in 1815, and 1500 francs in 1825)? The truth of the matter was, the Brokers' Union, pressed by the Chamber of Commerce, had two only weeks to prepare and deliver the classification document…"

A FATEFUL MENTION/THE 1855
CLASSIFICATION

Was the Baroness Caroline aware of the importance of receiving such a ranking? Did she sense the great mark it would leave on the history of Bordeaux wines? Being represented at the World Fair opened an enormous potential for increased trade, and she had begun selling her wine on the Bordeaux market the year before. These factors surely strengthened her resolve to be included on the list of Fifth Growths, which was plainly justified by the historical records of Cantemerle's selling price.

A number of protests were addressed to the Chamber of Commerce, causing quite a stir in the world of wine, but to no avail. It is not known whether the estate's manager Count de La Vergne, her daughter Jeanne-Armande or other influential people worked on her behalf, but the commotion and the impact of such an appeal must have been known to Cantemerle's owner, domiciled in Bordeaux. She wrote directly to the Brokers' Union to plead her case, and a letter from Auguste Perrin in September that same year reads as follows: *"The Brokers' Union writes on this 16th of September to announce that the wine of Cantemerle (in the commune of Macau) belonging to Madame de Villeneuve Durfort be added to the list of Fifth Growths."*

Thus, at the very bottom of the last of the three pages of the Bordeaux wine brokers' listing of red wine classifications, distinguishing Grands Crus from ordinary Crus Bourgeois, an extra line was added: *"Cantemerle, Madame de Villeneuve Durfort, Macau."* The cramped and almost illegible line of writing stands in sharp contrast to the rest of the document. Clearly it was added later than 18 April 1855 when it was dispatched to the Chamber of Commerce, but before the official document would have reached the imperial services. By receiving its rightful Grand Cru ranking among sixty-seven other classified red wines, Baroness Caroline had upheld her property's reputation and presumably – though she would hardly have dared imagine such a thing – perpetuated the Cantemerle name for years to come.

Château Cantemerle, situated at the mouth of the Garonne in the communes of Macau and Ludon in Haut Médoc, is the sum of extraordinary stories of struggle and resilience, of passionate adventure and day-to-day effort. It abounds with echoes of a vibrant past, of the memories of the men and women who helped to shape it over the centuries. The countryside too has its own rich and unique history. Long before these lands became a vast viticultural domain, they were home to early Bronze Age populations, feudal lords, and a succession of great families…

Above: Baroness Caroline was one of the few women to head up a wine estate in the 19th Century.

**FROM
BRONZE
AGE TO
THE AGE
OF VINES**

"The Médoc, from time immemorial, has never been an empty land." Charles Daney

" In the tasting room, I come across relics of a past even older than mine, simple display cases enclosing a wealth of memories: thimbles, old coins, shoe buckles, musket balls, pistols… fragments of life. Valuable traces, like those that I too left behind. **"**

These relics culled from the grounds of the vineyard testify to bygone eras and the men who inhabited the lands of Cantemerle. The earliest artifacts date from the Neolithic Era, the age of polished stone, in the days of early settlements and the beginnings of agriculture and livestock farming. Ancient Médoc, with its lakes and marshes abounding in waterfowl and fish, its wealth of arable land and natural resources, was propitious for the settlement of nomadic tribes. "Most migratory species passed through the region: cranes, ducks and woodpigeons. Sharpened flint was used to hunt deer, aurochs and waterfowl…" *(A Short History of the Médoc, by Charles Daney).*

Though the Médoc of these early days is no more, the aquatic nature of the region has always played a part in the evolution of the landscape. More here than elsewhere, climatic changes have had a direct impact on geography. Surrounded by water, the territory has been fundamentally modified by periods of glaciation and thaw. A thin slice of land between river and sea, the Médoc Peninsula has seen incessant change, with portions new and old in turn emerging and disappearing, swallowed up by river and sea… Take the Cordouan Lighthouse, built on an island in days gone by, and now standing on a sandbank… These chosen lands of the Neolithic peoples were the product of spectacular erosions. The banks of the Garonne would spread to form gulfs, then change once more when the water levels dropped, forming shorelines and vital marshes favorable to early human settlements…

Opposite: The Cordouan lighthouse: originally built on an island, now standing on a sandbank.

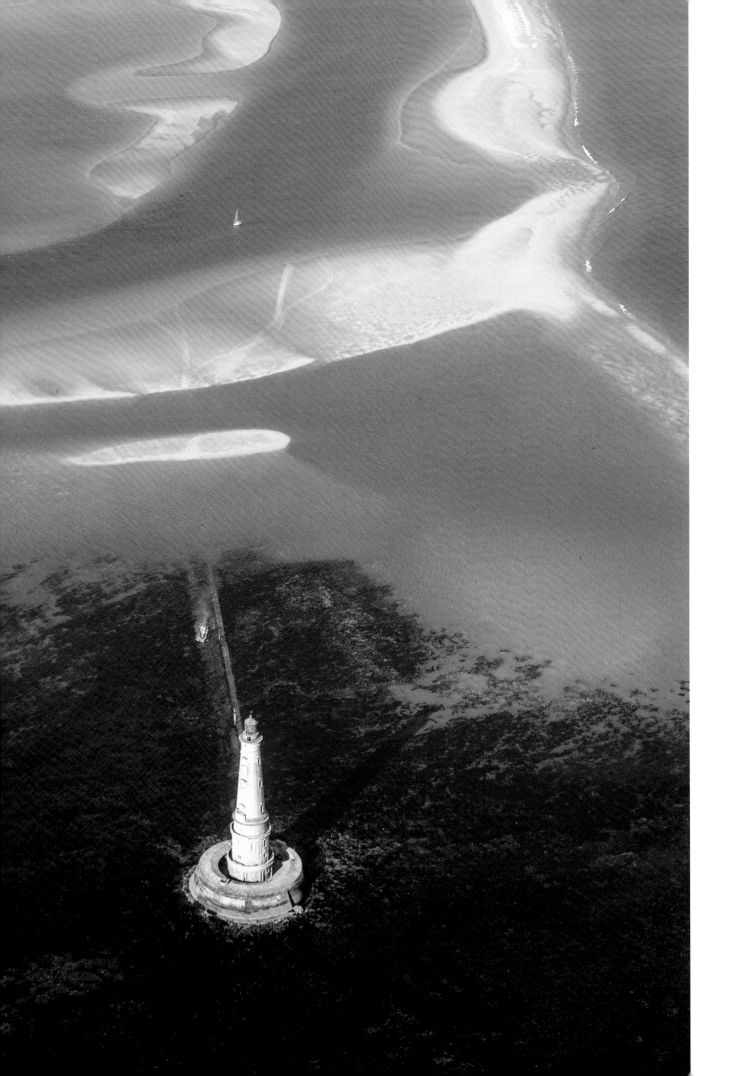

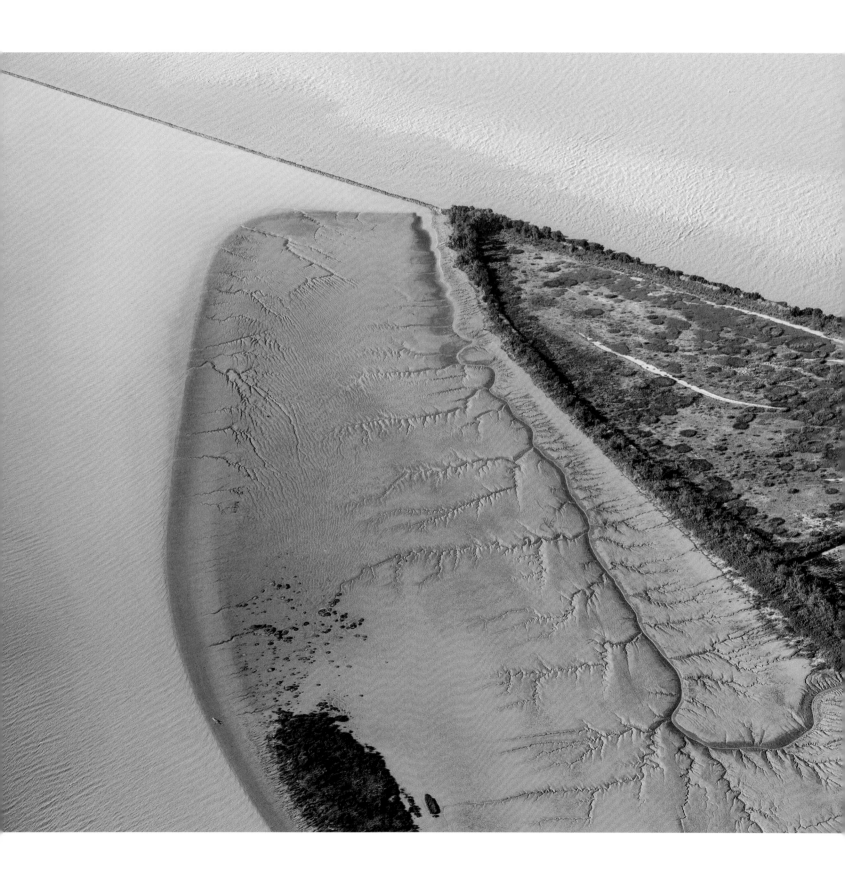

TIN, COPPER...

Though the traces of hunter-gatherer communities are few and far between, man's Bronze Age presence in the region is clearly demonstrated. Even then, the lands of Cantemerle were open to commerce, especially since ore for smelting was lacking in the Médoc: tin was imported from the islands of Cornwall, copper from the Limousin, Brittany and Spain. The Médoc would become known for making perfectly-balanced edged axes, which were used locally by the agrarian community and also exported. What we picture in this remote era is a seafaring people who made the most of the region's natural environment and geography, a people also familiar with technical innovation and trade. The Médoc Peninsula at that time would have been covered with a vast oak forest, on account of the Atlantic climate that followed the last Ice Age. It would also have had a wealth of natural harbors, inlets and channels, openings to territories both interior and exterior. Export would merely have been a matter of organization and resolve. From these early days of flourishing trade, we can already make out the great viticultural *terroir* of the future. Skill and knowledge are essential to wine growing, but opportunities to promote know-how and export goods are equally important.

... AND SALT

As copper became scarce, the Bronze Age was succeeded by the Age of Iron, a raw material abundant in the region, though not much of a boon – it was much more difficult to work! Meanwhile the inhabitants of the Médoc would once again demonstrate great ingenuity and an innate flair for business with a new industry, the harvesting of salt. *"(...) the extraction of sea salt makes it possible to conserve meats. Pebbles by the seaside are washed to produce a salt brine that is reduced in clay buckets over a wood fire."* (Fascinant Médoc by Marie-José Thiney). Though the lands in the immediate vicinity of Cantemerle did not produce salt, the entire region would prosper from its trade and thus gain access to the principal products that were exported during Antiquity – starting with wine!

Opposite: Nowhere is the geographic impact of climate change more apparent than in the submerged landscapes of the Gironde Estuary – where the rivers Garonne and Dordogne meet the sea, still dotted with islands today.

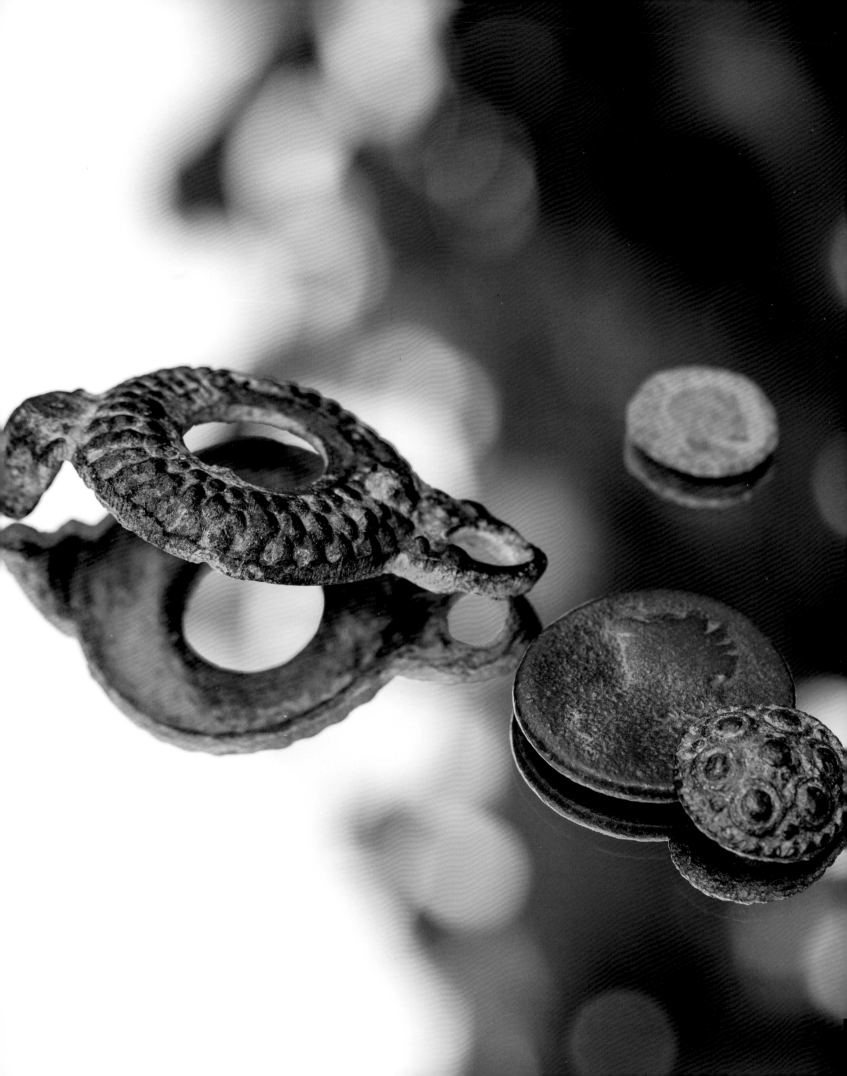

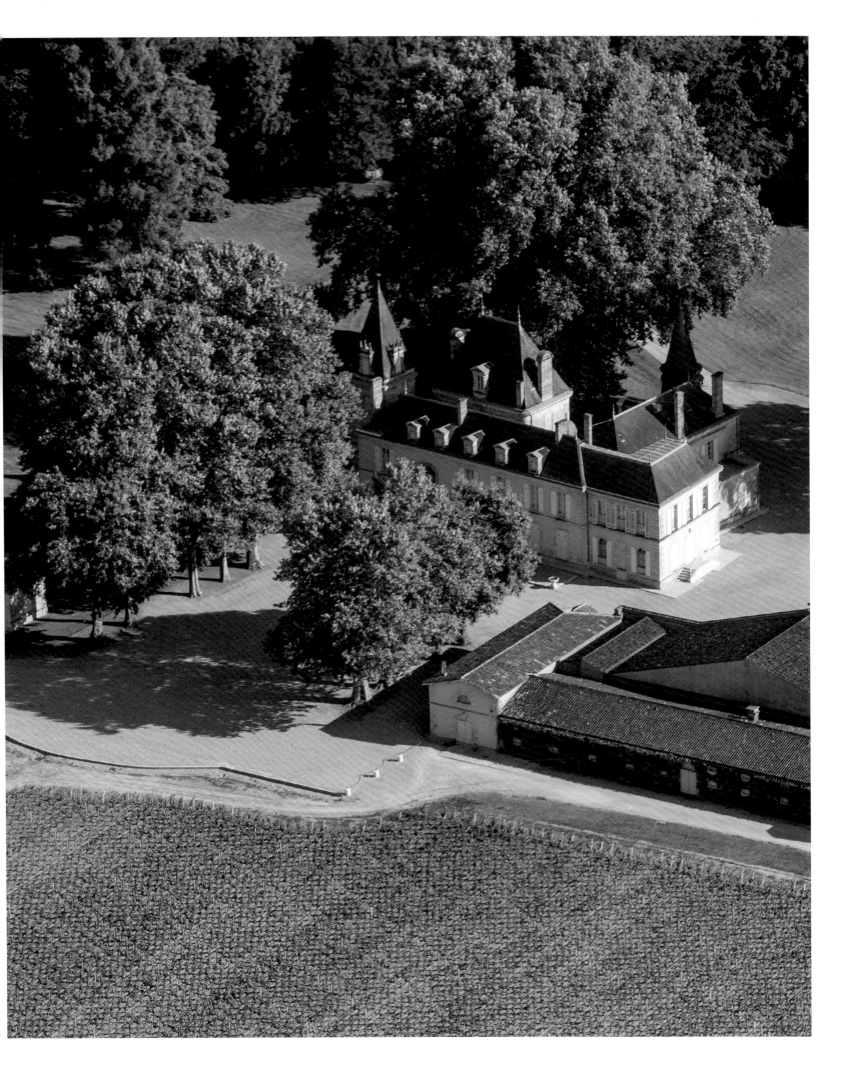

THE TASTE FOR WINE

In the first hundred years AD, repeated invasions would change the face of the Médoc region. In 56 BC, Publius Crassus, a young lieutenant under Julius Caesar, set off from Gallia Narbonensis, already under Roman rule, to conquer Aquitania. Local populations put up little resistance to the foreign invaders, who would modernize buildings, building in stone rather than wattle and daub, and improve and expand road networks. Mention has been made of an ancient Gallo-Roman villa and a Roman road on the lands of Cantemerle, and two major thoroughfares were said to have crossed the Médoc at the time: the Via Medullica, connecting Brion to Bayonne along the Atlantic coast; and the Via Lebade, between Noviomagus and antique Burdigala, now Bordeaux, which passed through communes in the vicinity of Macau.

Signs of the Volcae Tectosages, one of the earliest Gallic tribes to trade with the Romans at the end the La Tène period, have also been found on the estate. Though not yet produced locally, wine would enter the Médoc by way of the ancient Bronze Road, now the Salt Road, first from the Roman Campania and then from the province of Gallia Narbonensis. Though wine was still a luxury reserved for an elite – an amphora of wine was equal to the price of a slave – the taste for the divine beverage was born! Plato makes mention of the Gallic passion for wine. Though primarily a token of wealth and therefore status and power, wine would acquire a central function in the funeral and sacrificial rites of the privileged classes, well before it entered the Christian liturgy. Since time immemorial, it had been regarded as the drink of the Gods. The mysteries of fermentation were attributed by the Greeks to Dionysius, the god of resurrection, but it would be the 19th Century before the discoveries of Louis Pasteur would elucidate its laws. Its color, the symbol of blood, and its alleged medicinal virtues would earn wine a reputation for regenerative capacities and powers of immortality.

> Since time immemorial, wine has been regarded as the drink of the Gods.

Previous pages and opposite: From bronze casting to grapevine pruning, the objects found in these ancestral lands, site of the former fiefdom of Cantemerle, testify to a long tradition of human occupation.

VITUS BITURICA, THE BIRTH OF A GRAPE VARIETY RESISTANT TO WIND AND RAIN

Burdigala in the days of Pax Romana was a thriving capital open to trade. Over time, Gallic viticulture based on Roman know-how would develop as a vineyard of scattered plots. In Aquitaine, winemaking was dominated by the Biturica grape, ancestor of the present-day Cabernet and a name suggestive of the Bituriges Vivisques tribe, which had been present in the area for the past several centuries. Local production reached its apogee in the 2nd Century AD and would at last offer less affluent Gallo-Romans a chance to enjoy the pleasures of the divine brew. Still, we are a long way from the Médoc winegrowing *terroir* of today, and the gradual decline of the Roman Empire in the aftermath of the Barbarian invasions would lead to a notable decline in viticulture in the region. It wasn't until the advent of Christianity that the grapes of *Vitis Biturica* would flourish in the region again.

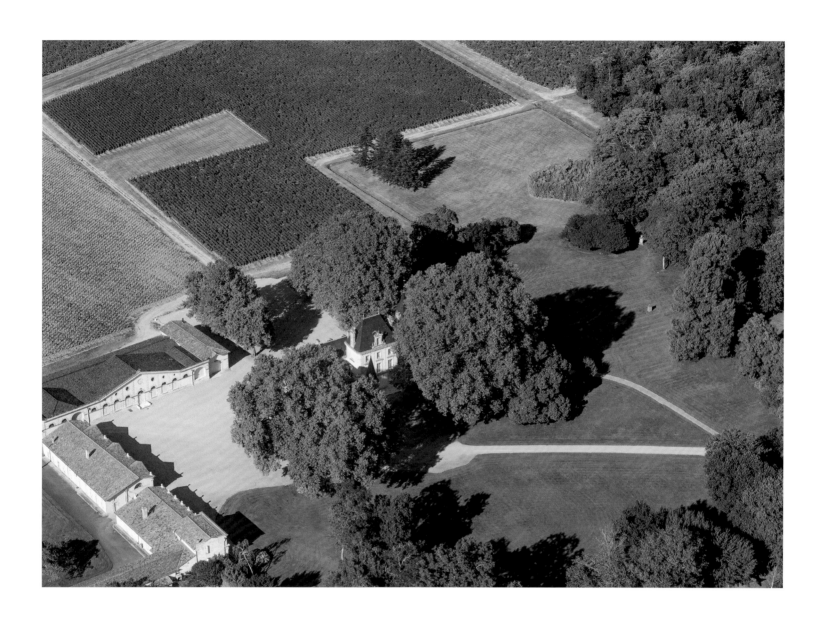

THE EARLY LORDS OF CANTEMERLE

The Seigneurie of Cantemerle was situated north of Ludon Médoc. There, a fortified castle rose up out of the salt marshes, on a mound of earth, bricks and weathered pebbles, part of a line of fortifications defending the banks of the Gironde. The settlement was home to a true village of farmers, domestics, craftsmen and winegrowers, with a watermill fed by the La Mouline spring, and a harbor where ships could wait for favorable winds. Cantemerle was then the county seat of the Macau-et-Ludon-Dehors barony, to whom manorial obligations and dues were owed. The jurisdiction extended over a great many noble houses, notably Gironville and Maucamp, as well as Sauves, today the present site of Cantemerle.

WARRIOR VASSALS TO THE KING OF ENGLAND

After the exceptional annulment of her marriage to the King of France, the Catholic Duchess of Aquitaine and Countess of Poitiers Eleanor married the future king of England Henry Plantagenet in 1152. The union would seal the fate of Aquitaine for centuries to come. The regions' lords pledged allegiance to the English sovereign, notably the Lords of Blanquefort and Lesparre who having made a pact with King Edward's emissaries were granted high jurisdiction over the entire region. The Lords of Cantemerle who fell under the jurisdiction of the Château of Blanquefort were no exception; they swore fealty to the English king.

It is not known whether Poncio da Canta Merla was the earliest lord of Cantemerle. However there is historical mention as early as 1147 of a certain Pons de Cantemerle. His name appears in the *Grand Cartulaire de la Sauve-Majeure*, an impressive document recording all transactions executed within the monastic community of Sauve-Majeure Abbey. His name appears twice, in 1147 and again in 1151. When the Lord of Blanquefort donated vast territories to Sauve-Majeure Abbey before setting out on the Second Crusade, Pons de Cantemerle was a witness to the gift.

Opposite: Tucked away between vines and trees at the end of long avenues, Château Cantemerle is a haven of greenery at the entrance to Bordeaux. The estate lies in the southern Médoc, in the communes of Macau and Ludon.

In 1242, a circular letter from Henry III summoned another Pons de Cantemerle, a knight by profession, to join him in Saintonge to fight in the Battle of Taillebourg.

Mention is made of yet another Lord of Cantemerle named Gaillard in 1274; twenty years later the name of a certain Raymond de Cantemerle appears in a letter written by Edward I, in which he requests fealty from the Lord of Cantemerle to help him recover provinces lost in his struggle with Philip IV of France, known as Philip the Fair. This marks the start of the Hundred Years' War, when the Lords of Cantemerle would cement their alliance against the king of France by siding with Henry IV of England.

In 1340, another Ponset de Cantemerle is mentioned and history repeats itself, as the Cantemerle dynasty continues with yet another Gaillard, then Raymond.

In 1366, Louis Chabot is made Lord of Cantemerle by Edward III. The feudal domain would soon after pass to the Caupène family, originally from the Landes region. A title deed of 1 February 1422 describes Jean de Caupène as Squire and Lord of Cantemerle. His son Médard was lord of the domain until the end of the 15th Century when a union was formed between the Caupène and La Rocque families. Through the marriage of Jeanne de Caupène and Henry de La Rocque, the noble house of Cantemerle in the jurisdiction of Blanquefort came into the possession of Charles de La Rocque, also a squire. A title deed of 1536 shows that his son Jehan was lord of both Cantemerle and Gua.

The fate of Château Cantemerle takes a decisive turn in 1579 with the arrival of the Villeneuve family, which will administer the domain for the next three centuries. Jean de Villeneuve, the second president of the Parliament of Bordeaux, bought the domains of Cantemerle, La Raze and Mestérieu plus 340 hectares of land for 12,500 pounds or "4,166 écus and two-thirds of an écu" from a certain Francois de Geoffre. Under the new owner, wine production for export became the principle activity of Cantemerle.

Opposite: The original residence of the Lords of Cantemerle was built as a fortified castle on the border of the villages of Ludon and Macau. It was demolished in 1789. The chateau we see today evolved over centuries out of the former noble house of Sauve.

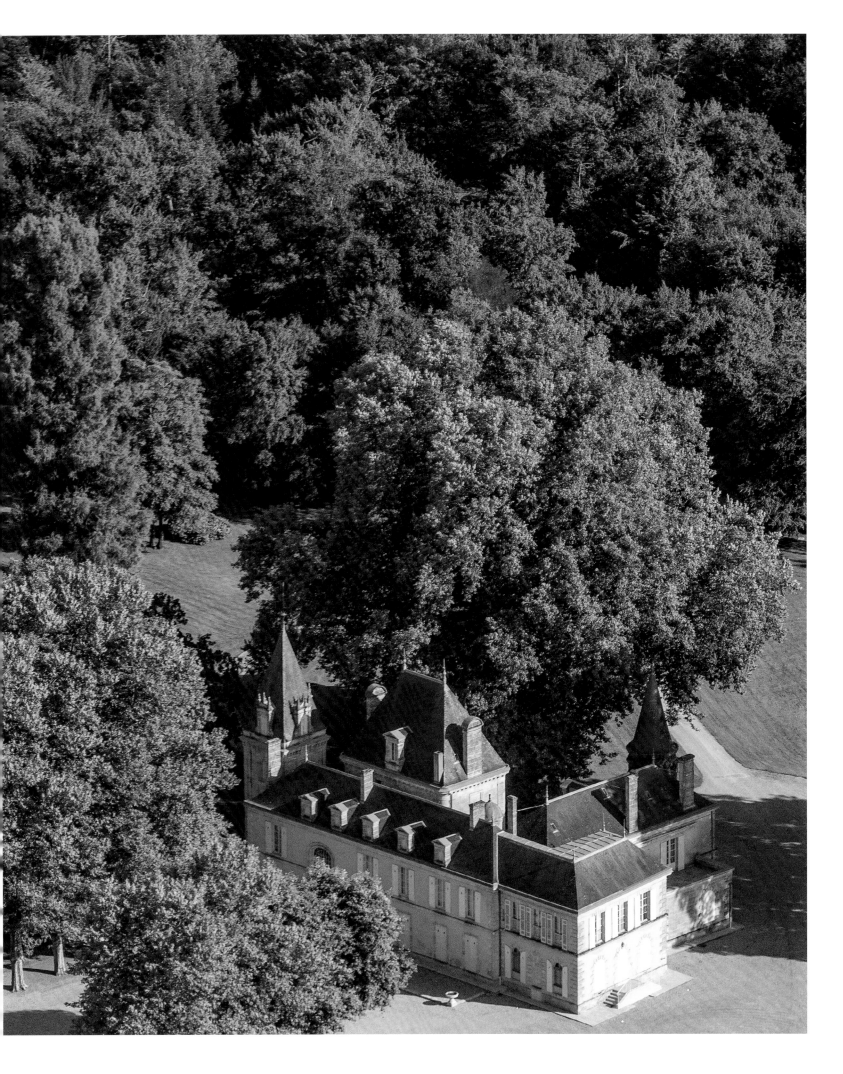

A
VITICULTURAL
TERROIR

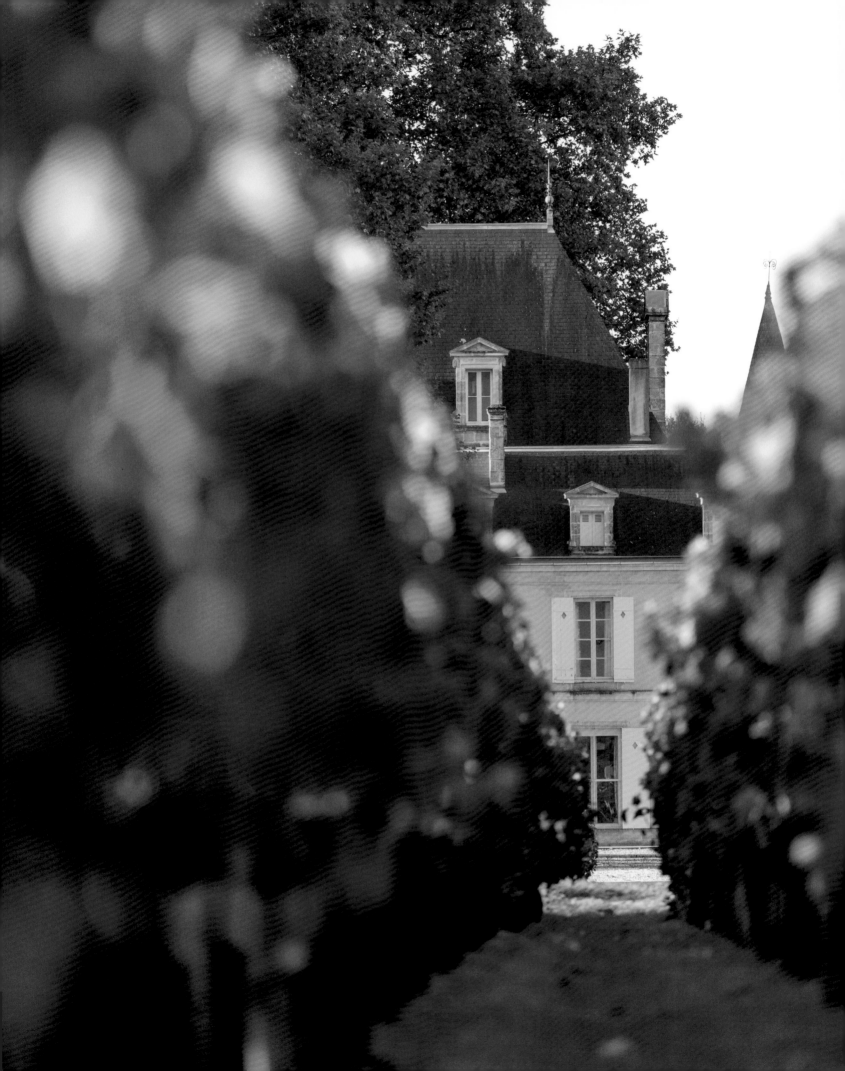

❝ It was the good fortune of my region to have been a unique geographic entity, a center of trade since the dawn of time… to which Cantemerle was the gateway. A natural haven just beyond Bordeaux, my domain was easily reached on horseback, introducing the Médoc region to the passerby and welcoming merchants, local traders and, in the days of the *sauveté*,* the less fortunate; foreign vessels would drop anchor here, either to load up with the region's riches or to unload their own. My Médoc, that incomparable aquarelle with its soft subtle contours, ever exposed to the winds from the ocean and the waters of river and sea, was fashioned by the countryside itself – a slip of land between ocean and estuary, at times inviting invasion, at others open to exchange with the world. **❞**

FROM THE FIRST TRACES OF VITICULTURE TO THE BIRTH OF A GREAT WINE-GROWING *TERROIR*

The Médoc was ideally situated for commerce and grape growing, but its fate was tied to the ups and downs of history, to the customs, religions and alliances of the region. It also depended on the men – heirs to the traditions of wine-growing and trade – who would gradually shape this great *terroir*, starting with the Christians who were custodians of the secrets of the vine.

THE HISTORY OF WINE AND CATHOLICISM

Though the earliest vineyards in Macau probably date from the Year 1000, the records start in 1354 when Ponset de Cantemerle, the Lord of Cantemerle, paid his tithes to the Church with a cask of claret. The lands of Macau were then mainly devoted to cereal growing and food crops. But Christian dwellings, and notably Sauves, which was most likely an abbey or *sauveté* at the time, were surrounded by vineyards. The centuries-old yew tree still standing near the château today suggests a church or graveyard in the vicinity – yew being a symbol of the link between Heaven and Earth.

Opposite: Château Cantemerle looks out today over a vast and thriving vineyard, surrounded by an estate where the earliest evidence of wine production dates back to 1354. The lands of Macau were traditionally planted with grain and staple crops before they eventually turned to vine growing.

*Translator's note: In southern France in the Middle Ages, a *sauveté* (in Occitan, *sauvetat* or *salvetat*) was a delimited area surrounding a church within which it was forbidden to prosecute fugitives.

As repeated Barbarian invasions lead to the destruction of entire villages and the depopulation of the Médoc starting with Macau, it was the monks who preserved the viticultural traditions of the past, and made it possible for winegrowing to take hold in the region. Monasteries in those days of chaos were havens of peace, especially since the hordes of Barbarians sweeping down from the north avoided the monks who they suspected of sorcery!

On the banks of the Garonne River and its estuary, monks cleared and cultivated the lands donated to the religious orders by lords eager to expiate their sins and save their souls. In the Roman era, each and every monastery and bishopric planted vines to meet their liturgical needs. Wine had entered into the celebration of the Eucharist – it was the blood of Christ – but great quantities were also consumed in everyday life. The alcohol in wine served to purify water, which was often contaminated in those days, and to disinfect wounds; wine was also more generally reputed to heal body and mind. The clarets of the day, similar to our rosés, were used in numerous medical preparations and considered a cure-all for numerous diseases. They were supposed to help digestion and were even credited with aphrodisiac qualities. As it was in the Gallo-Roman era, serving good wine was also a social obligation. Powerful guests at the tables of bishops and monks had to be generously entertained, so as to increase the prestige of the orders and encourage future endowments. So the men of the Church explored new winemaking methods, selecting grape varieties, studying soil quality and developing the concept and practices of what became known as the *terroir*.

The advent of Christianity and the popularity of pilgrimages served to accentuate the viticultural momentum. The English, Scottish, Irish and all of northern Europe flocked to the small harbors of the Gironde. The Médoc was the principal Christian region in the Bordeaux diocese, a place of transit and hospitality. Wine was accordingly produced there for reasons of faith.

Thus the Médoc combined all the ingredients for winegrowing to prosper, especially since the monks were not the sole producers of wine. Most of the winegrowing land around Bordeaux belonged to the region's great noble families. The lords in their turn had invested in vines, the fruit representing a symbol of wealth and power, and its cultivation producing an economic benefit. Contracts granted farmers half of the harvest, while the other half went to the lord. The 11th and 12th Centuries would see the first intensive development of the Macau vineyards, and the Seigneurie of Cantemerle would no doubt have had grapevines at the foot of its fortifications. Hadn't our Ponset de Cantemerle paid his tithes with a barrel of claret?

The Médoc
was ideally situated
for commerce
and grape growing.

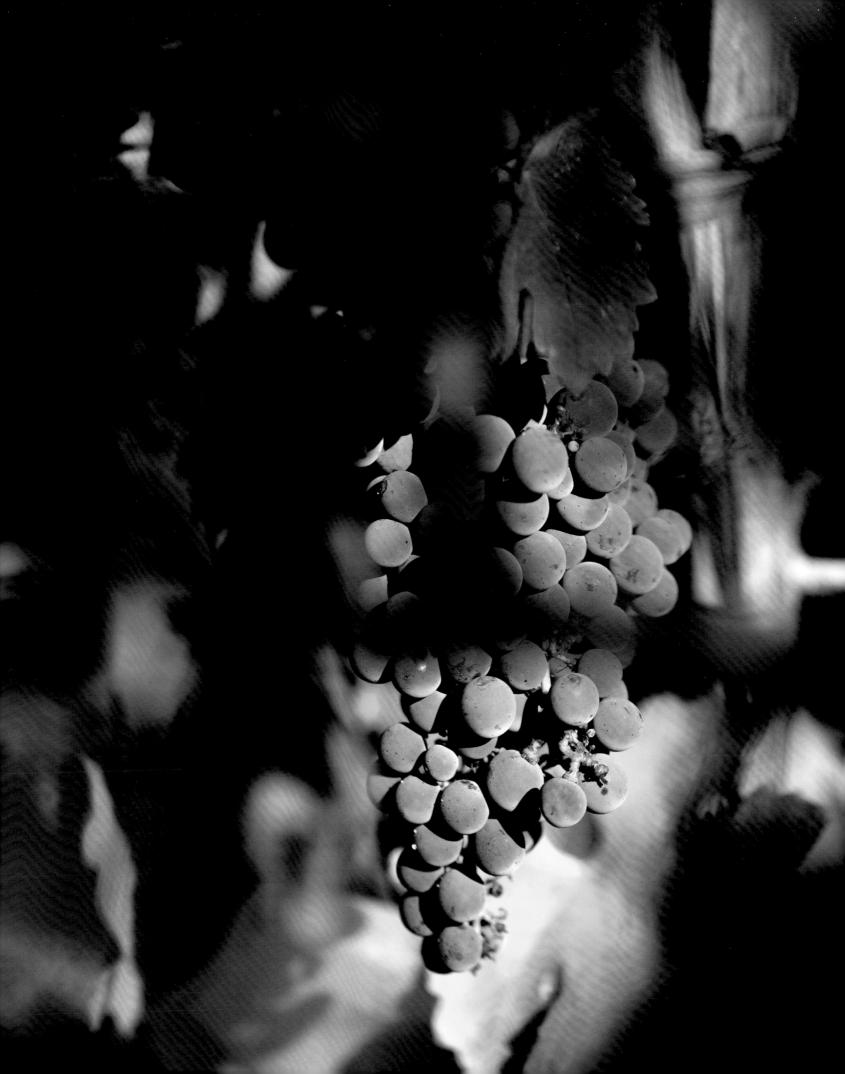

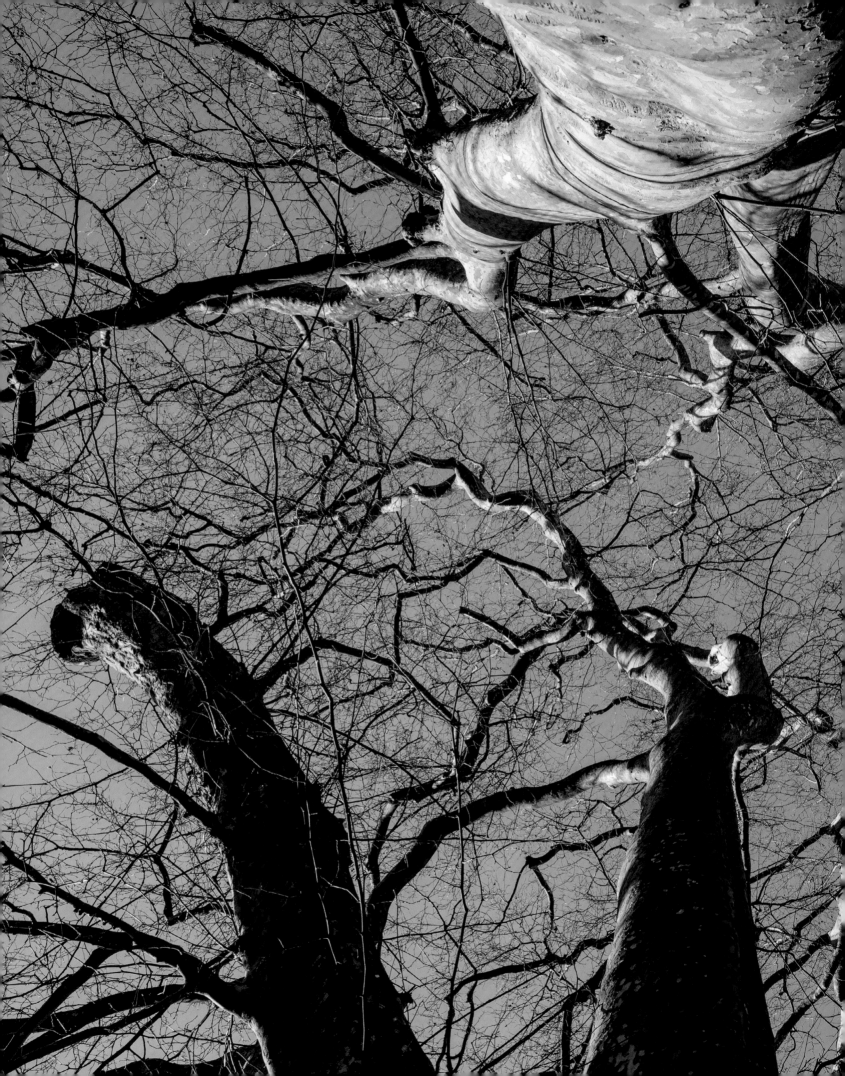

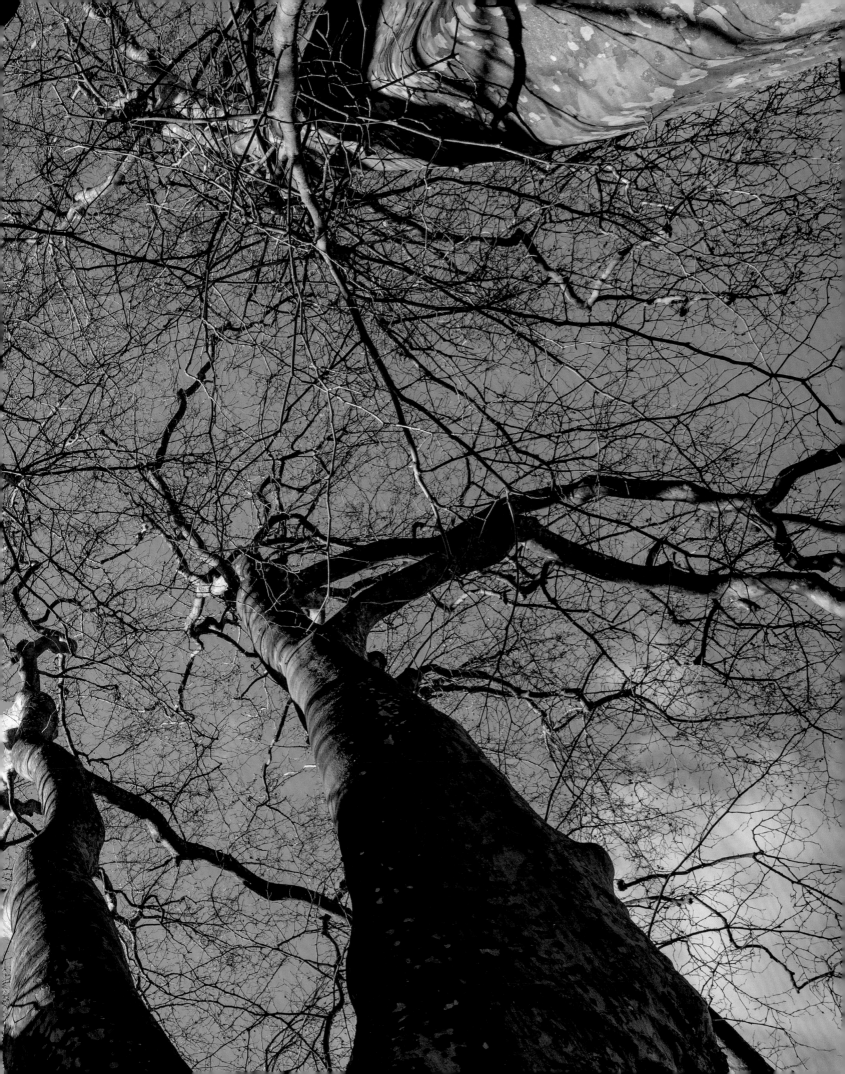

*"Vines had been cultivated on the lands of Médoc
from time immemorial and mainly during that time
when the English were masters of the Guyenne."*
Abbot Baurein 1784

The development of winegrowing *terroirs* was also owed to the emergence of a thriving trade with England and the countries of northern Europe. Eleanor of Aquitaine made a point of promoting her wine with the English aristocracy, whose taste for wines from the Bordeaux region would continue to grow, particularly on account of the numerous tax advantages accorded to the city's *negociants* in order to encourage export.

Bordeaux would see another economic boom in 1224 when England lost its main wine outlet, the port of La Rochelle, and began trading with the ancient port of Burdigala whose wine production would soon dominate the market. In 1241, Henry III granted them the "privilege of the wines of Bordeaux," a commercial priority over all other wines from Aquitaine. The writ was exceedingly favorable to the notables of the city who then began to take an interest in the lands on the banks of the Garonne where grapevines known as Graves and Médoc were cultivated. Their efforts were generously rewarded. London and all of the capitals of northern Europe were now drinking French clarets, those clear and slightly alcoholic wines of which millions of liters were shipped, immediately after fermentation. Encouraged by long-standing ties between the two countries – contact between the British isles and the Médoc dated back to the Bronze Age – these exchanges would prosper throughout the Hundred Years' War.

Yet during the Anglo-Gasconne period, the estates of the Médoc did not enjoy the same advantages as those of the Bordelais. Not by a long shot. They were required to pay special taxes and even had to request permission to enter Bordeaux. The wine produced in the Médoc was therefore shipped directly out of local ports without passing through the capital, and here Cantemerle enjoyed an important advantage: the domain possessed its own port. In the 14th and 15th Centuries, numerous land tenure leases were recorded on the lands of Cantemerle, perpetual leases granted by the lord. Tenants and their families cultivated small plots of land for the Seigneur, who received a fourth of the harvest. It was not yet conceivable that these scattered plots might be consolidated into large estates; and with the return of Aquitaine to France

Opposite: Medoc wines have always been popular, pleasing English and Dutch palates for centuries. The priceless bottles housed in the château cellars bear witness to former times and former owners, a testament to taste, climate and the labor of times past.

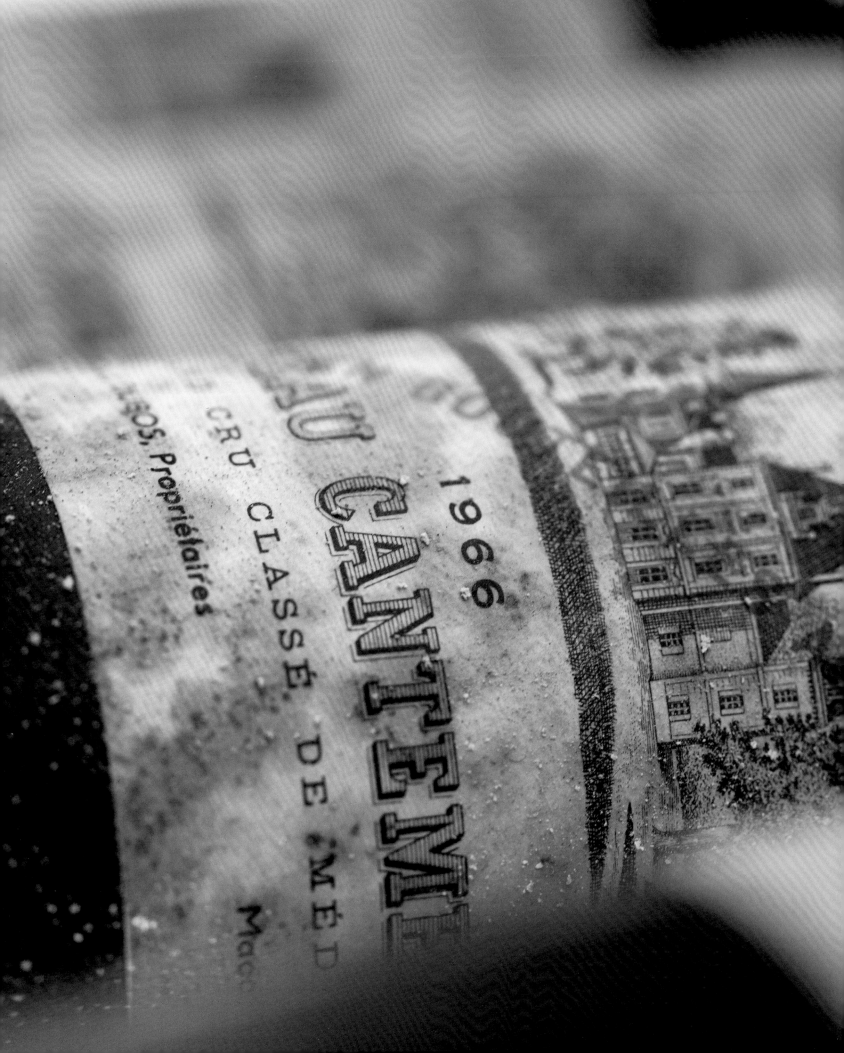

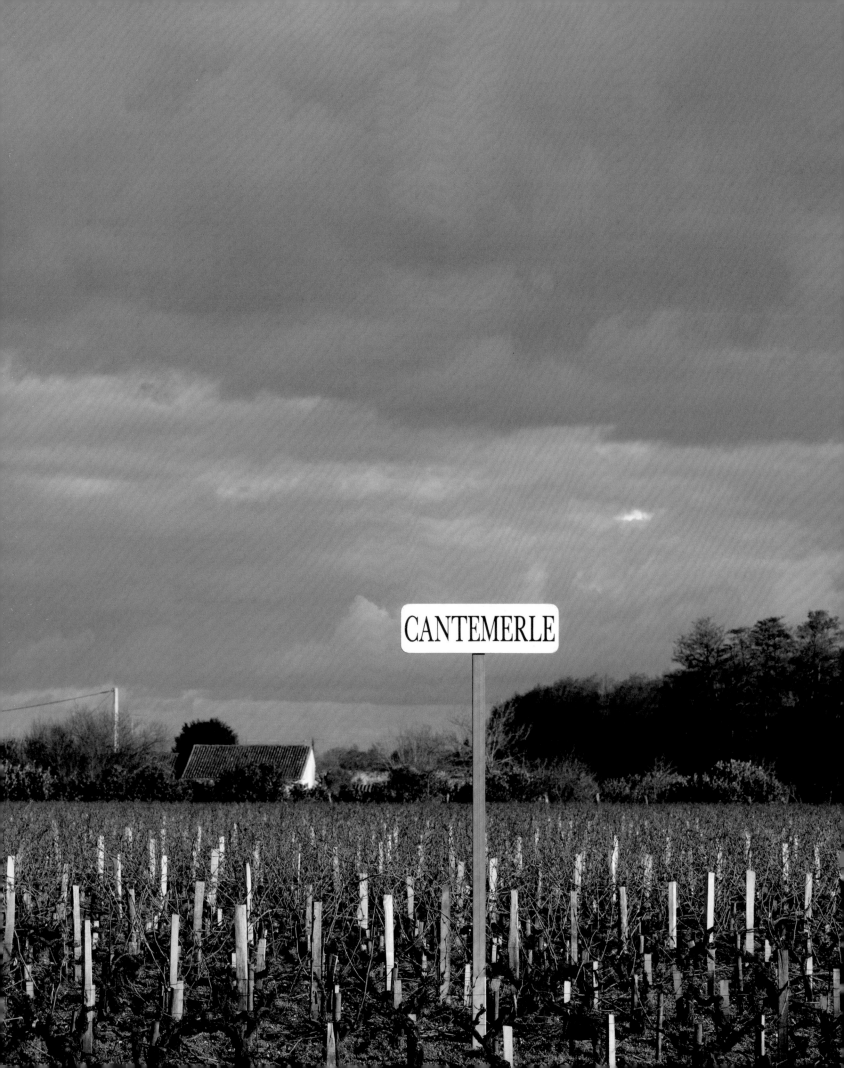

in 1453, it was an entire industry that fell apart. For a time, the French king abolished the privileges of Bordeaux only to reinstate them later. As for the Médoc, it wasn't until the great properties passed into the hands of the noble and bourgeois families of Bordeaux that they would enjoy those advantages from the English era. Jean de Villeneuve was one of those Bordeaux buyers . His purchase of the Cantemerle estate in 1579 was not a random choice. This second president of the Parliament of Bordeaux was exempt from paying *octroi* taxes on his wine, by virtue of *droit de bourgeoisie*, and he intended to make his estate a major exporting vineyard.

JEAN DE VILLENEUVE AND THE *BOURDIEU*

In 1575, only three "tonneaux" of wine – that is, twelve Bordeaux barrels – were produced by the Cantemerle estate. The Médoc was still primarily a cereal-growing region, although it would soon introduce a new cultivation practice known as le *bourdieu*. This innovative approach to land management would be a decisive step towards the greater commercialization of wine, especially since the medieval regime of tenure had given way to a new system of farming: the sharecrop lease. These leases, which were of shorter duration, would contribute to the development of larger, better-maintained vineyards. The Médoc enthusiastically joined in the "frenzy to plant," which continued to the end of the 18th Century. Under Jean de Villeneuve, the destiny of Cantemerle would take a new turn. And he had guessed correctly: his newly-purchased *terroir* was undeniably promising!

Opposite and following pages: In 1575, wine production was no more than three tuns per year. The great estate we see today extends over more than 90 hectares and grew out of the social upheavals and changes in viticulture wrought by the confiscation of the vineyards after the French Revolution.

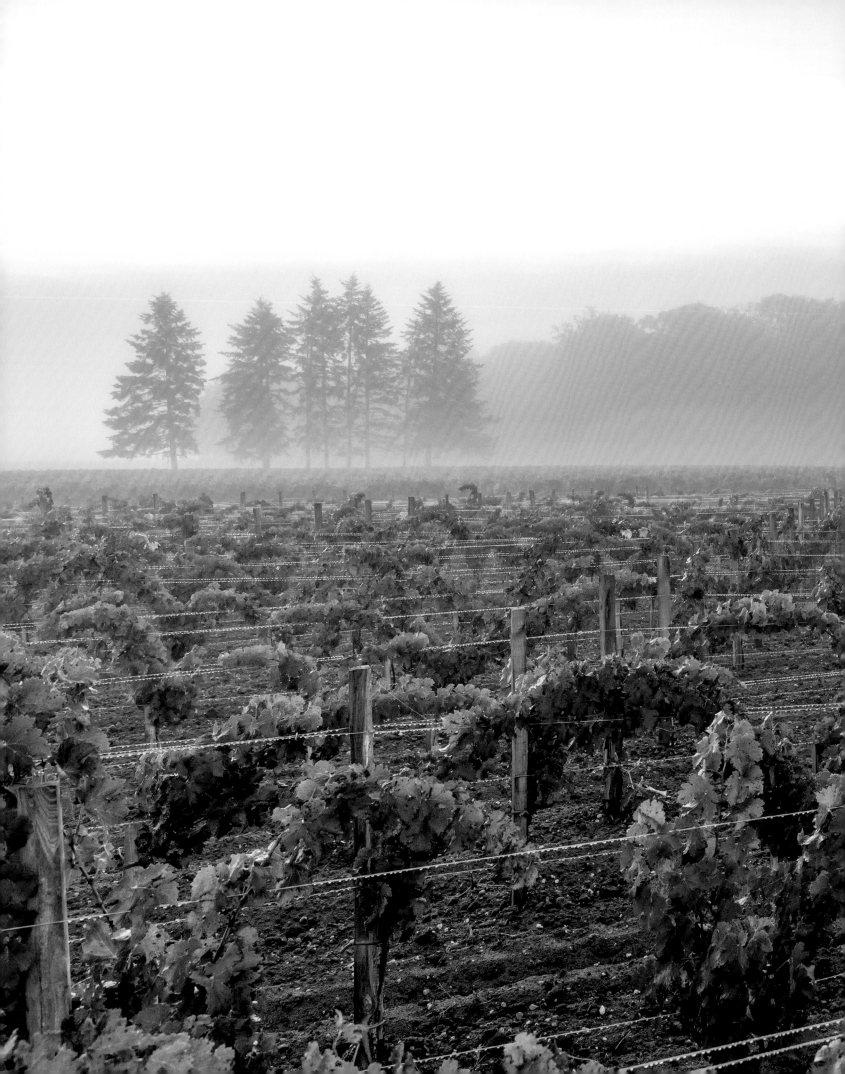

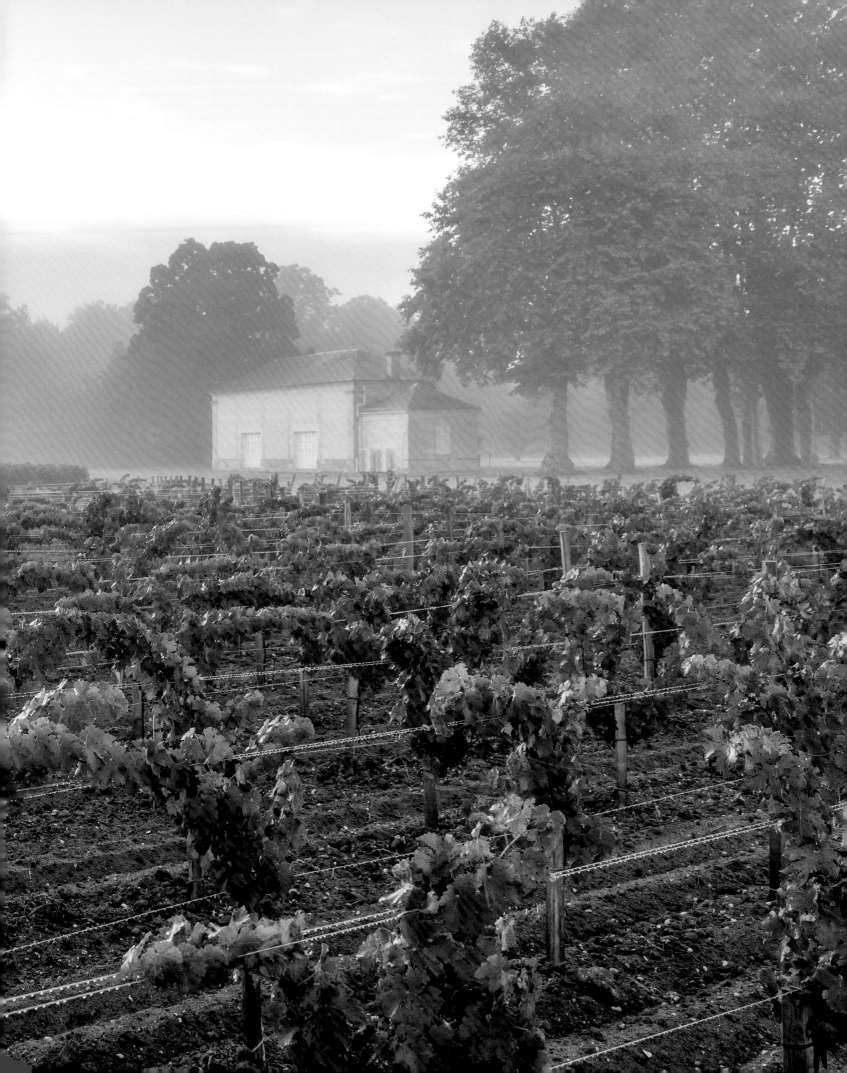

THE
CONSISTENT
ELEGANCE
OF WINE

"Our wines are born of the river."
M de Lur Saluces

The vineyard of Château Cantemerle spreads over 94 hectares in the southern part of the Haut Médoc appellation. The history and strategic position of the domain have no doubt carried the great Cru Classé to new heights. Despite the prestige and demand for this renowned vintage, it has never lost its characteristic elegance. From one vintage to the next, Cantemerle has remained faithful to its *terroir*, which is indeed the very essence of its nature.

While each parcel of land is a *terroir* in itself, the lands of Château Cantemerle are truly exceptional. So many factors must be taken into account for a superior vineyard to flourish… What one looks for is that perfect synergy of geographic location, microclimate and exposure, soil water supply, and soil composition…

THE SECRET OF GRAVEL

The face of the Médoc has been shaped by an ever-changing climate that has transformed the innermost composition of the land itself. Alluvium from the Pyrenees and Massif Central – pebbles, gravel, sand and clay deposited by glaciers from the Ice Age – form the basis of the typical viticultural *terroir* of the Médoc today. The renowned gravelly soil of the estates in the region is the legacy of past upheavals – a precious gift indeed!

Why are these ordinary white stones, those quartz and crystalline rocks that range from one to fifteen centimeters in diameter, so revered by winegrowers? Reach down and touch the ground at nightfall, when there's no light on the vine, and you will understand why: the sun's energy soaked up in the day is retained by the gravel, which then releases the stored heat at night. In other words, the vine has its own hot-water bottle to protect it from the hazards of the weather!

Opposite: The Château Cantemerle terroir owes much of its character to the famous gravel deposits distributed around the vineyard. These white stones absorb heat from the sun, then release the heat at night, reducing diurnal temperature variations and creating a favorable microclimate for the vines.

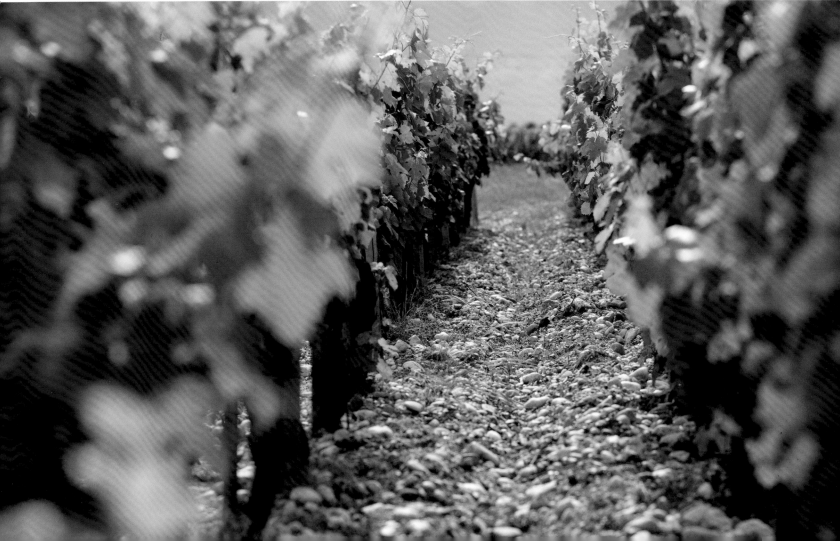

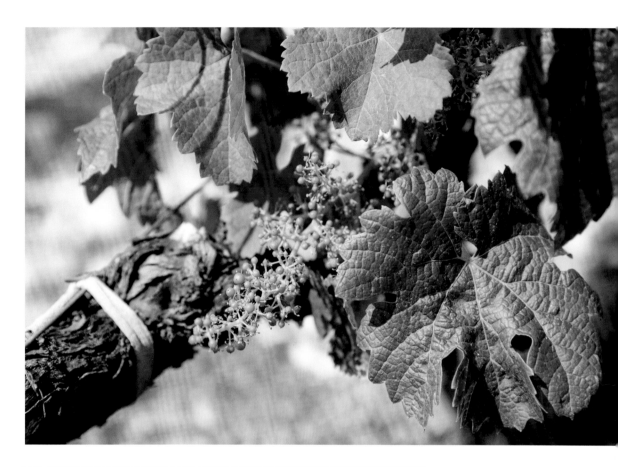

Opposite and below: Soil, geographic location and a favorable climate combine to make Cantemerle an exceptional *terroir*. The emergence of leaves and buds in spring is a delicate phase in the life of a vine.

Above, left and page 54: Vine antics. A dancer? A smiling leaf? Mother Nature puts on a dazzling show. Let your imagination run away with you! Opposite: Spring, summer, fall, winter... the vine enjoys a temperate oceanic climate in all seasons.

Opposite: As warm weather approaches, just after flowering, the berries finally emerge and start to color, varying in hue depending on the variety.

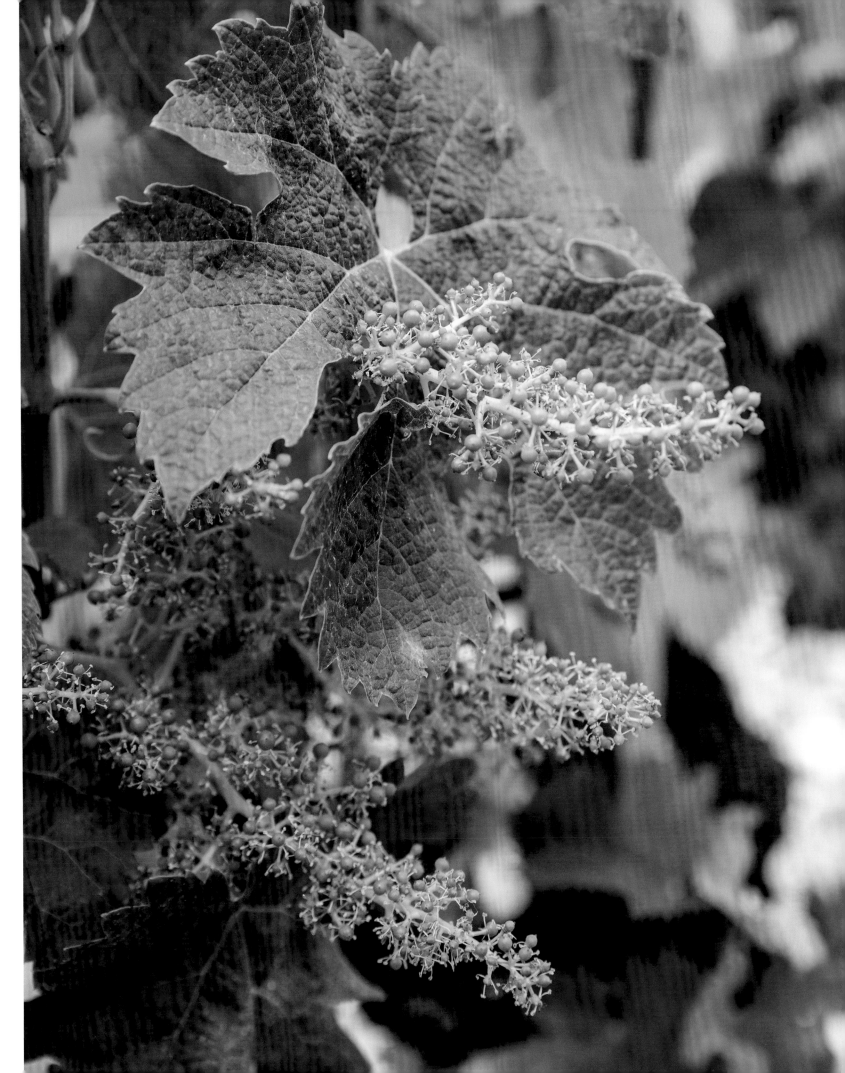

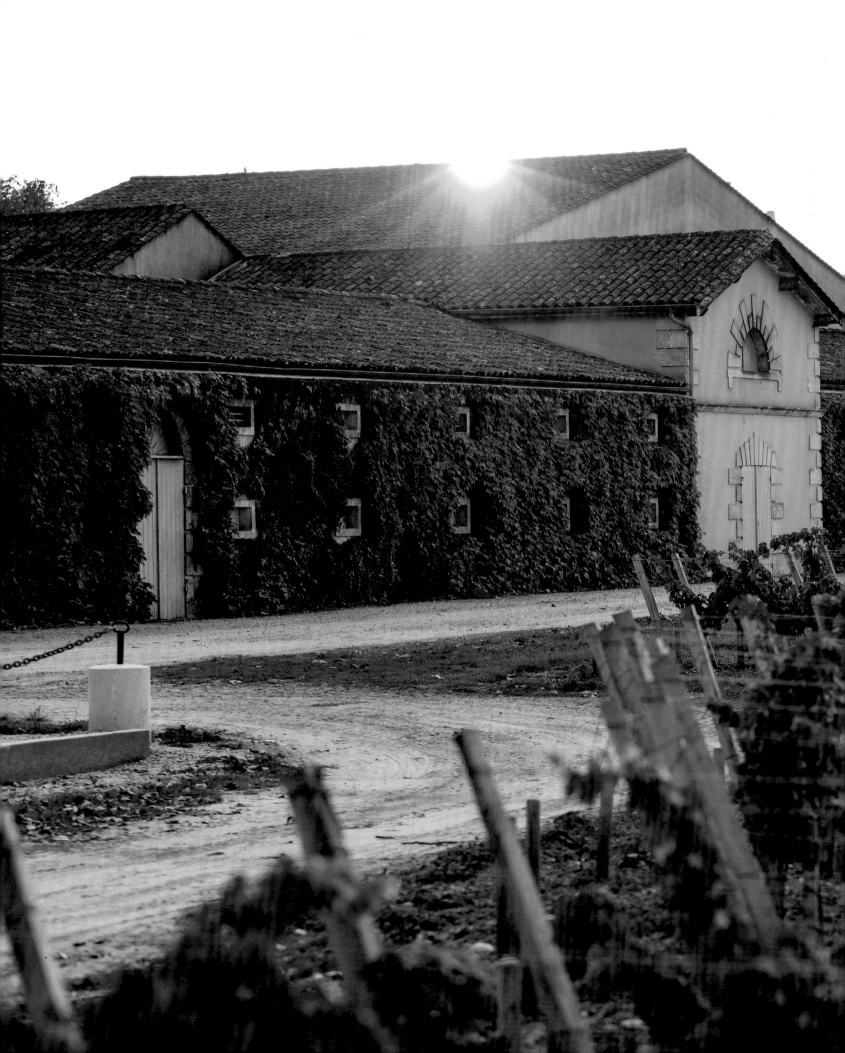

As the sun goes down behind the *chai*, the vineyard prepares for a long winter sleep. The annual growth cycle is unchanging but the vines improve as they age to render a more distinctive expression of *terroir*. The vines on the Cantemerle estate have an average age of 30, so fully mature.

Château Cantemerle's vineyard is located on deep gravel terraces with sediments of sand and vital organic matter – the product of thousand year old alluvial deposits and also the inheritance of the *terroir's* ancient viticultural past. Indeed, the history of the land is an important factor in the excellence and vitality of every great vineyard: soil analysis reveals fabulous chemical and agronomical properties derived from earlier eras of cultivation, and the vineyards of Château Cantemerle are no exception. Most of the parcels cultivated there today were already under production in the eighteenth century. They are at the very heart of today's Grand Cru.

THE 45TH PARALLEL

Winemaking in the Médoc is the result of a happy marriage of climate and soil, earth and sky – united for better, not for worse! The location *in medio aquae*, between river and sea, on the 45th Parallel midway between the North Pole and the Equator gives Château Cantemerle a mellowness that is reflected in the vines that grow there. The climate is lacking in neither sun nor rain, temperature swings are limited and frosts are few and far between – optimal conditions for the region's typical grape varieties. The vines at Cantemerle are Cabernet Sauvignon, Merlot, Cabernet Franc and Petit Verdot, planted in tight ranks. High-density planting and low grape clusters tend to produce vines that are "unstressed"; on the contrary, they seem to exult! With an absence of organic matter on the surface, a healthy competition is promoted among the vines. The roots that dig deepest will be rewarded with the necessary nutrients.

Opposite and following pages: The human factor plays an essential role in terroir. Protecting the vine for the sake of the future crop keeps winegrowers busy in winter.

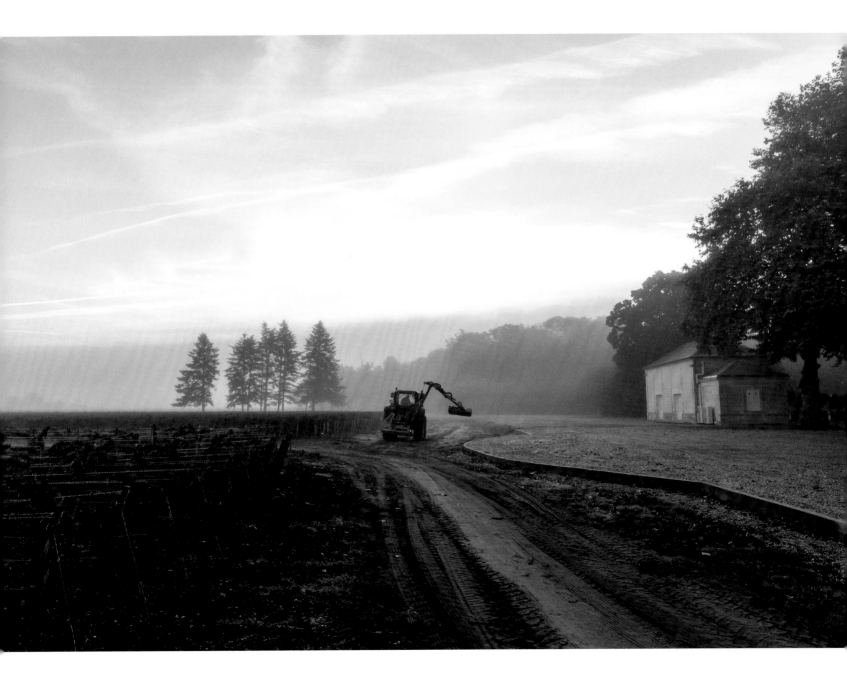

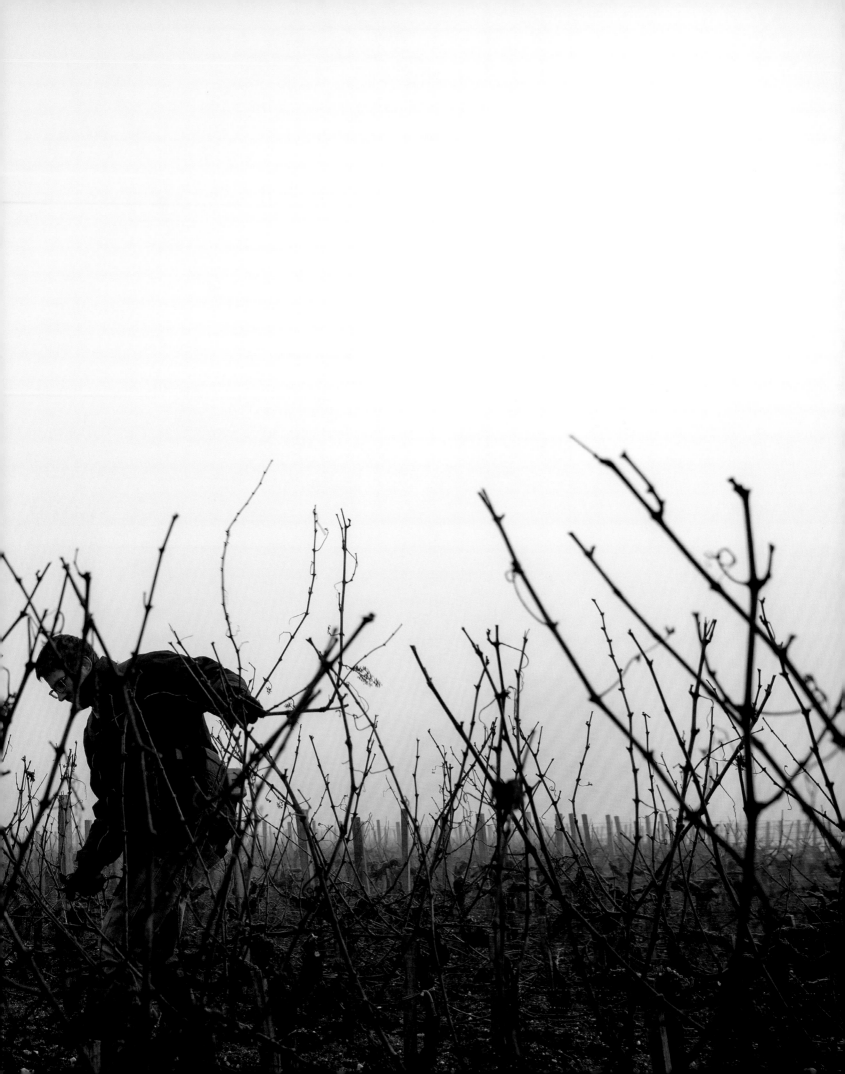

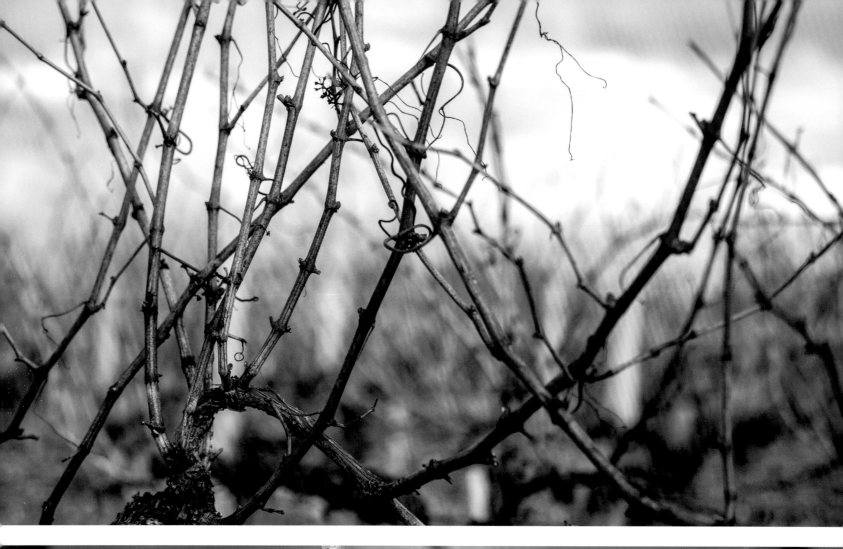
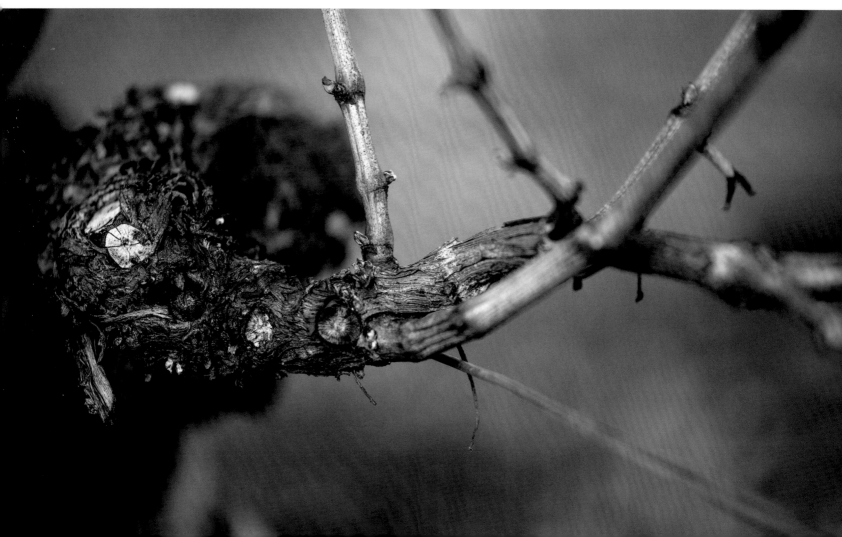

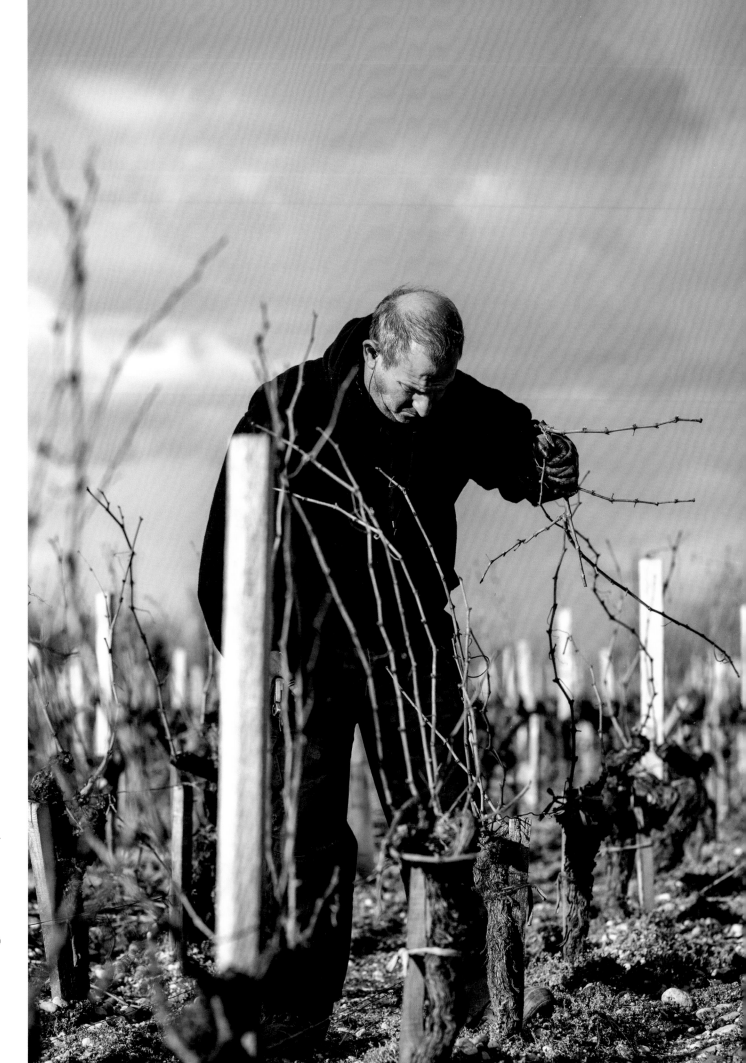

The traditional Médoc pruning system is "Double Guyot Poussard": manual pruning to keep the vines in balance while respecting sap flow. Wielding the secateurs is hard work for both sexes, laboring in winter mists or chilly sunshine for several weeks at a stretch.

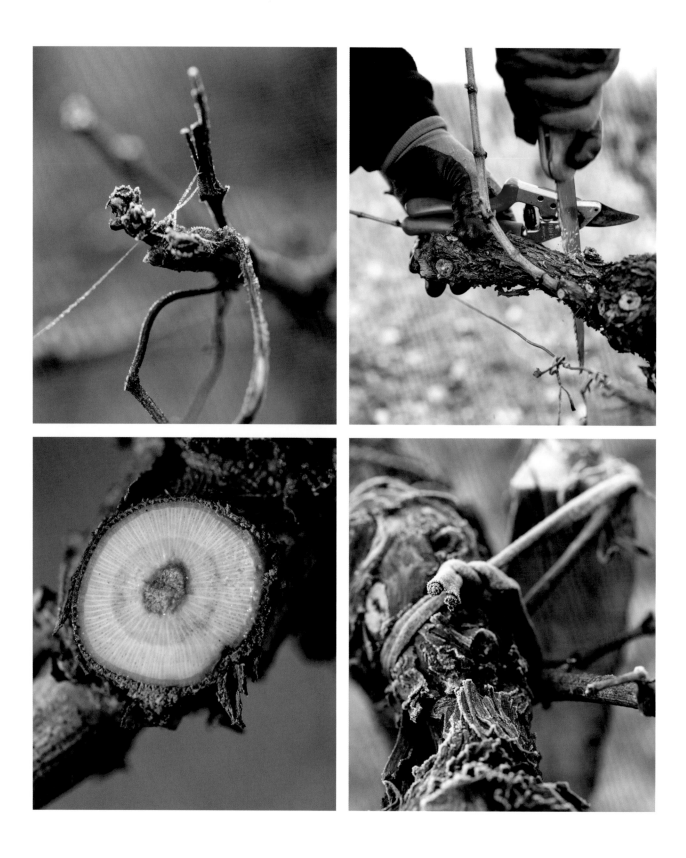

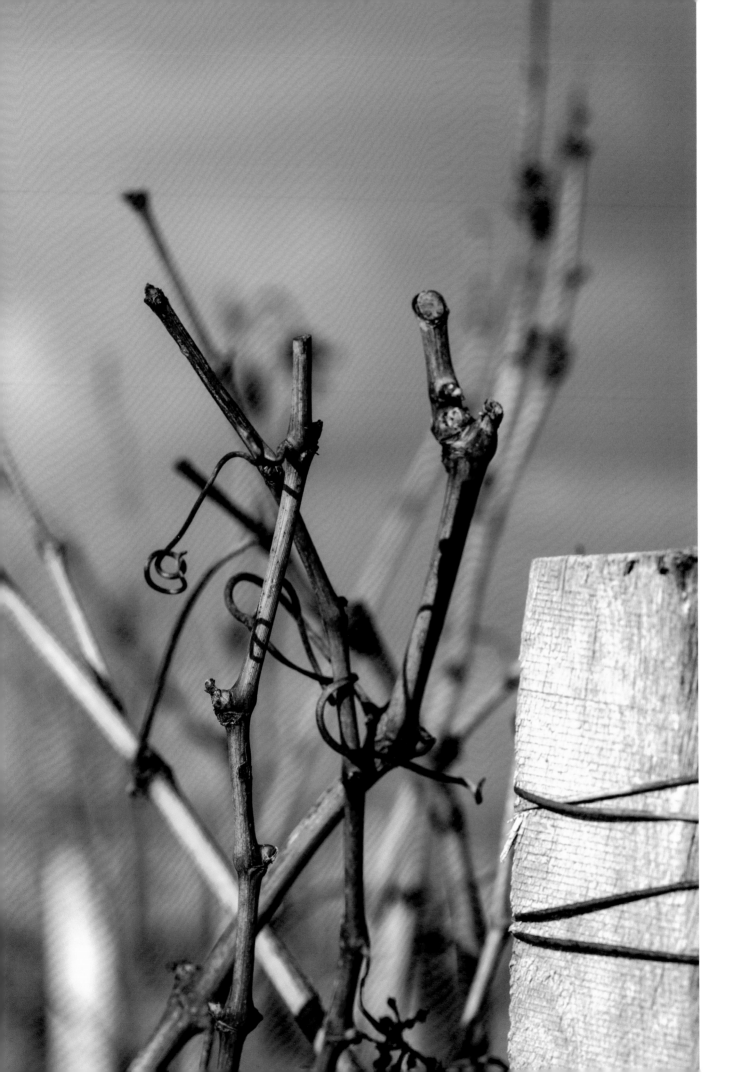

Early in the morning, armed with secateurs and saws, practiced hands sculpt the shape of the vine. The sap continues to flow no matter how hard or frosty the winter.

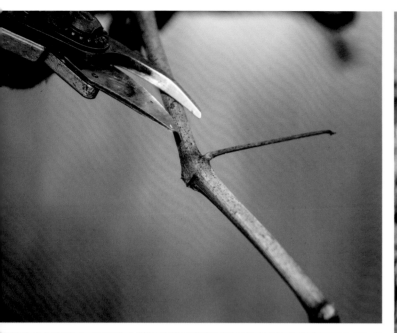

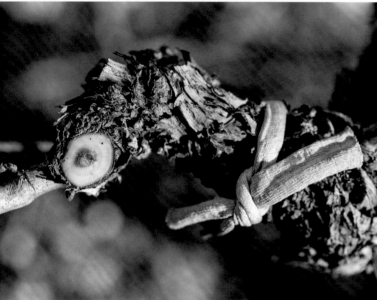

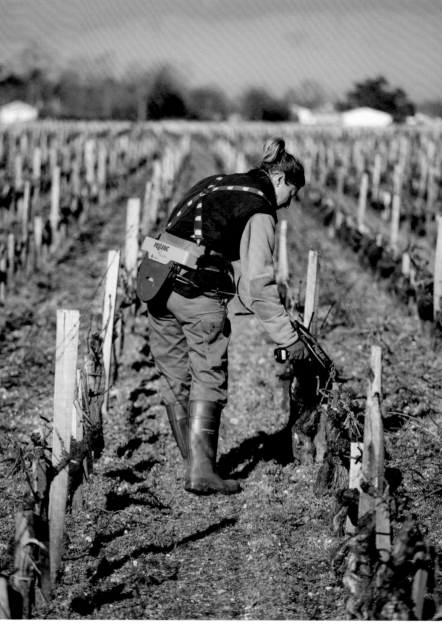

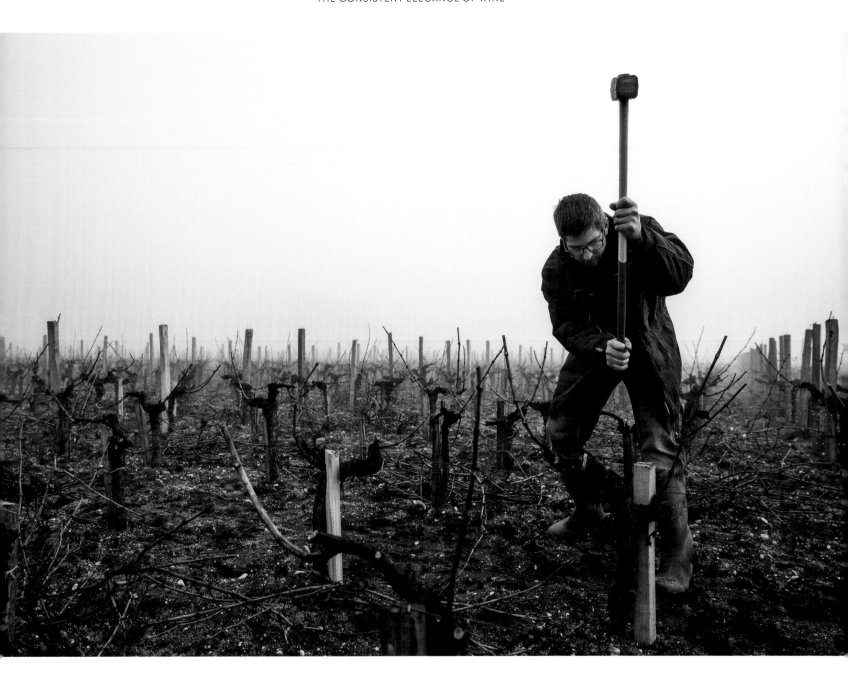

WINTER MEANS
LONG HOURS
OF WORK IN THE
VINEYARD – PRUNING,
DISBUDDING,
TYING-DOWN AND
TRAINING THE VINES.

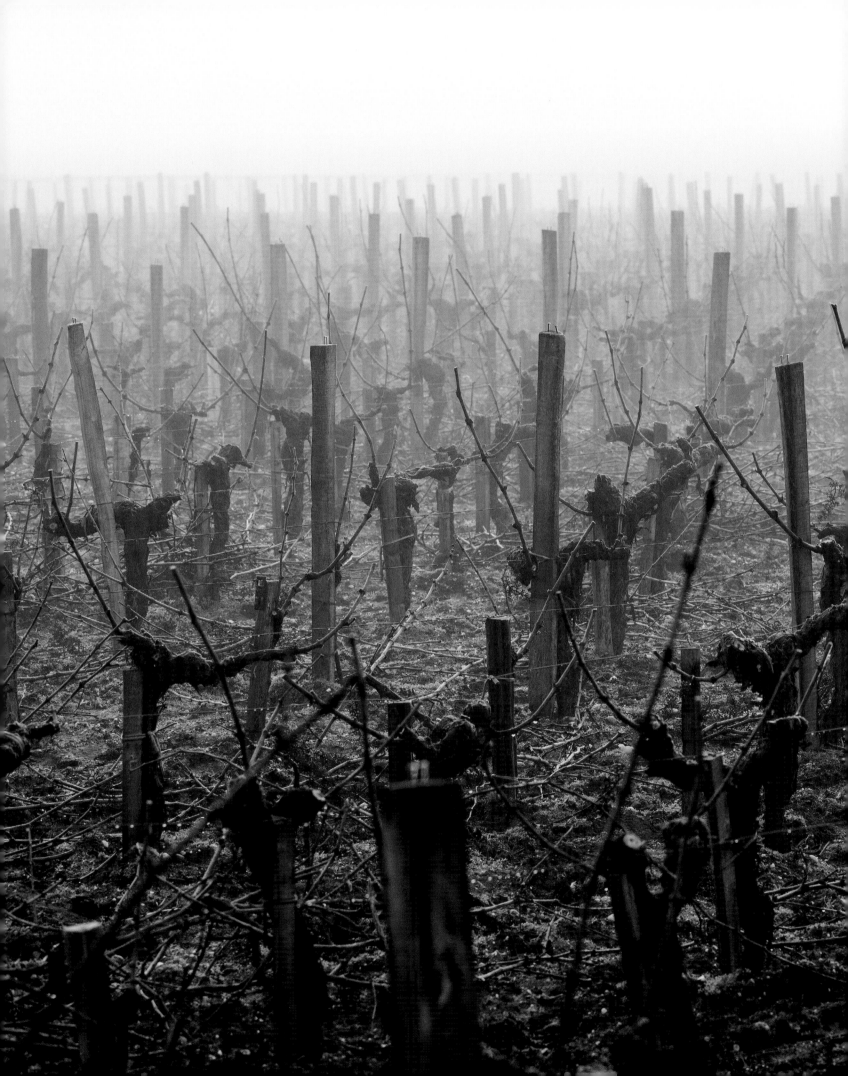

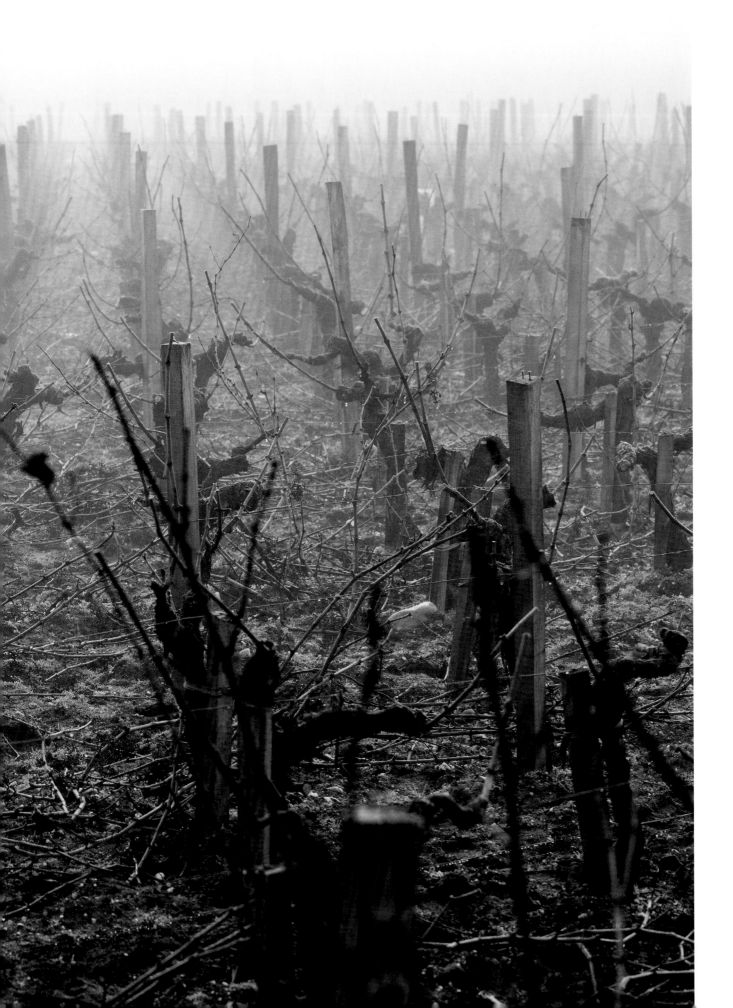

Branches rise naked from a sea of vines, ready to explode into greenery when the warm weather returns.

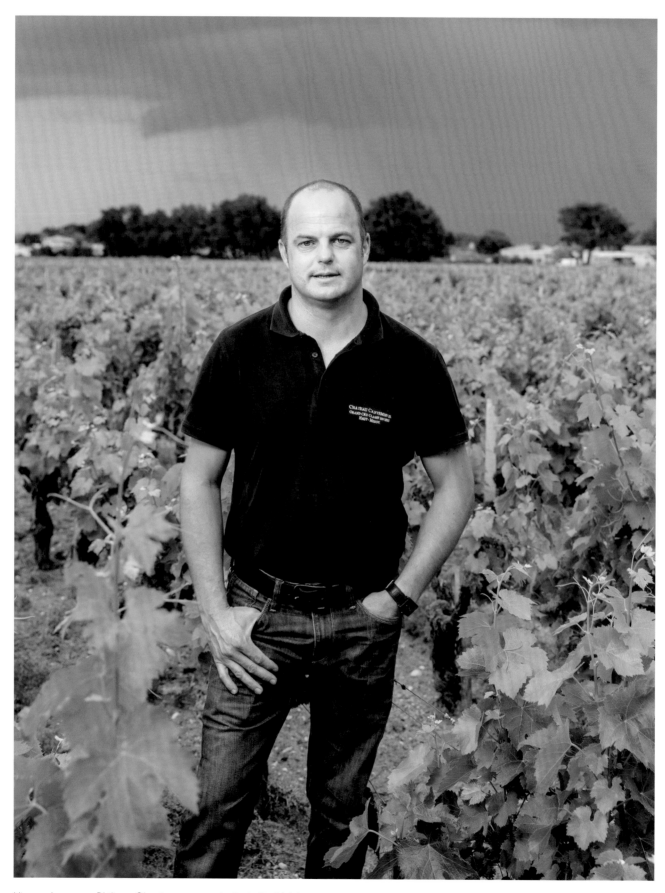

Vineyard manager Philippe Glumineau, a man dedicated to his job.

Selection and rejection then inevitably reduce the yield, but what remains will represent a greater concentration of the grape's noble compounds.

The older the vine the better. Age gives the vine a greater capacity to express the unique properties of the land, and with an average age of thirty years the vines of Cantemerle have maturity in abundance. No wine better reflects its *terroir*.

SPRING, SUMMER, FALL AND WINTER – THE RITUALS OF QUALITY CRAFTSMANSHIP

Land, soil, climate… What would they be without the men and women who work the land, without that extraordinary accumulation of knowledge and skill passed down through the centuries? It starts with the choice of grape varieties. Then the planting of the vine, the layout and the pruning… The *terroir* is also the work of the vine grower. With the experience and traditions of Médoc winemaking behind them, employees at Château Cantemerle pride themselves on excellent craftsmanship. With each changing season, the vine is protected, cosseted and prepared for the harvest to come. Encouraged, and even given a little push at times, but never without due appreciation and respect, the vine responds willingly to the touch of its caretakers.

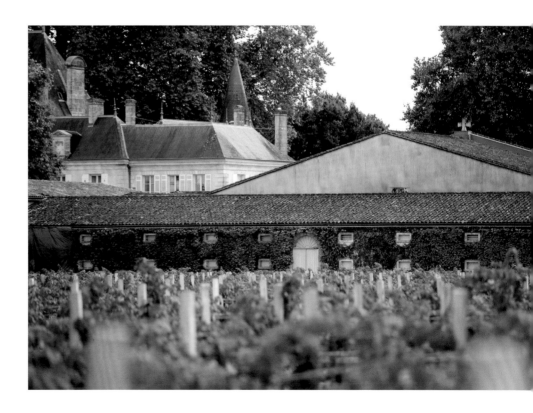

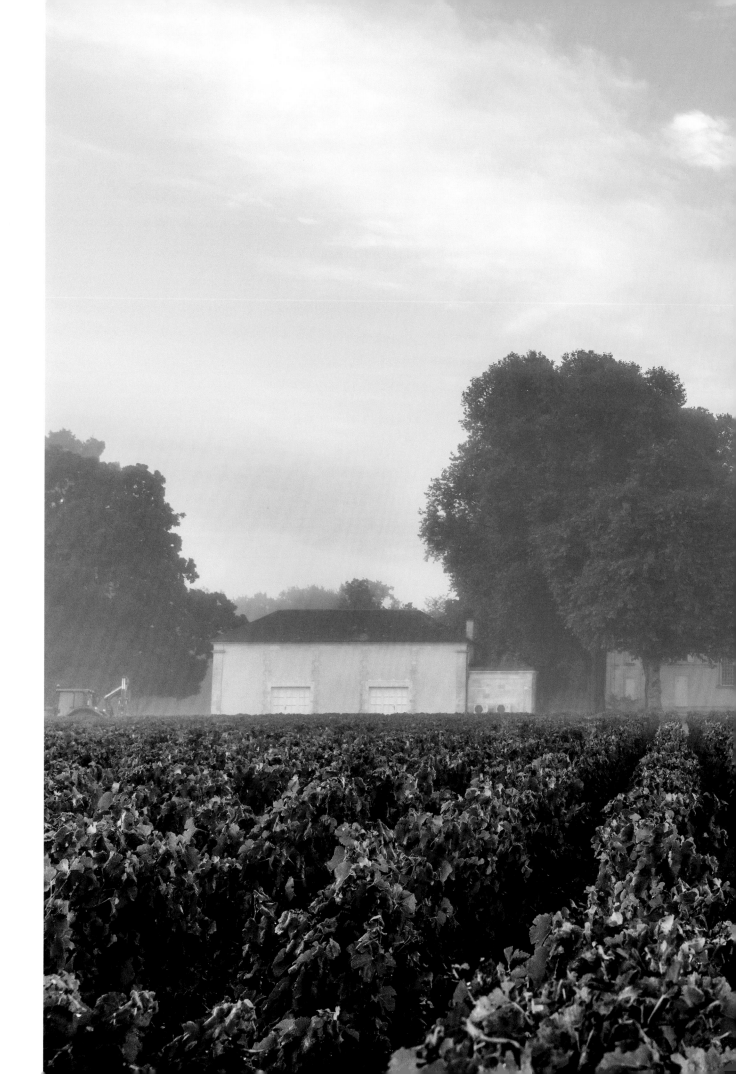

A sight to behold: Château Cantemerle swathed in winter mists. Elegant and charming, the estate combines the best of old and new, using only sustainable vineyard practices that respect the environment.

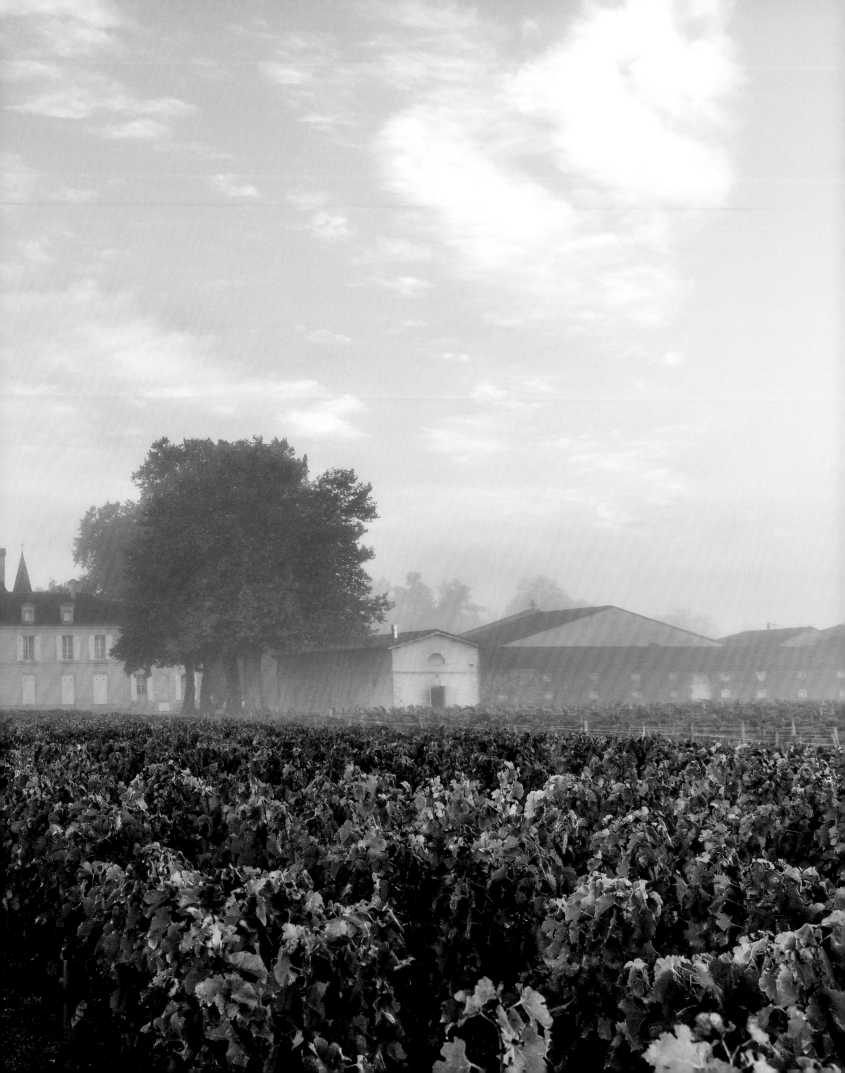

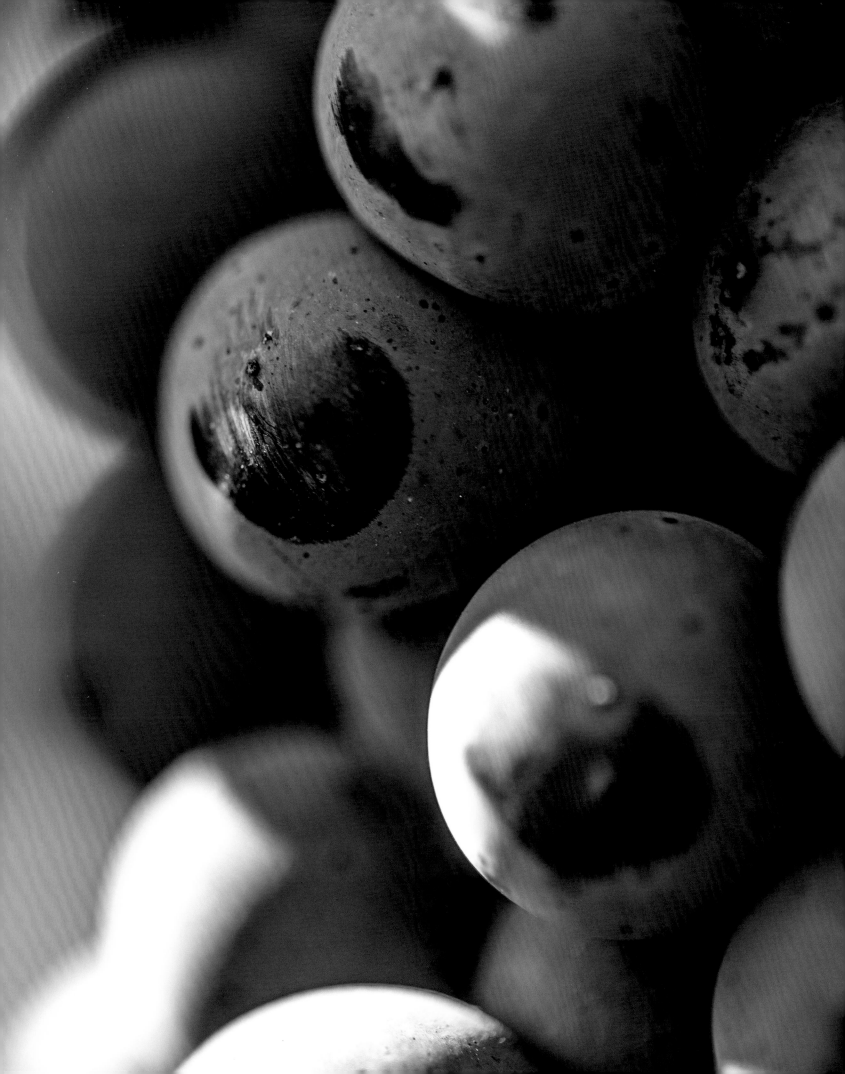

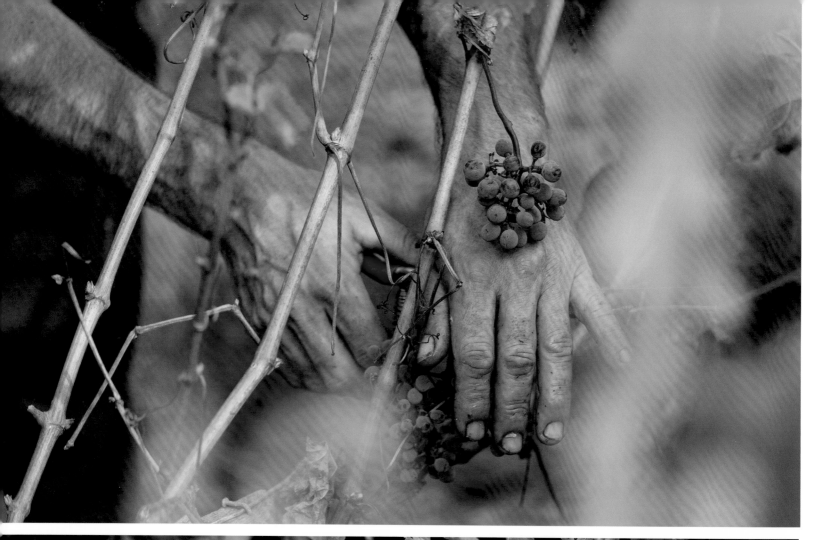
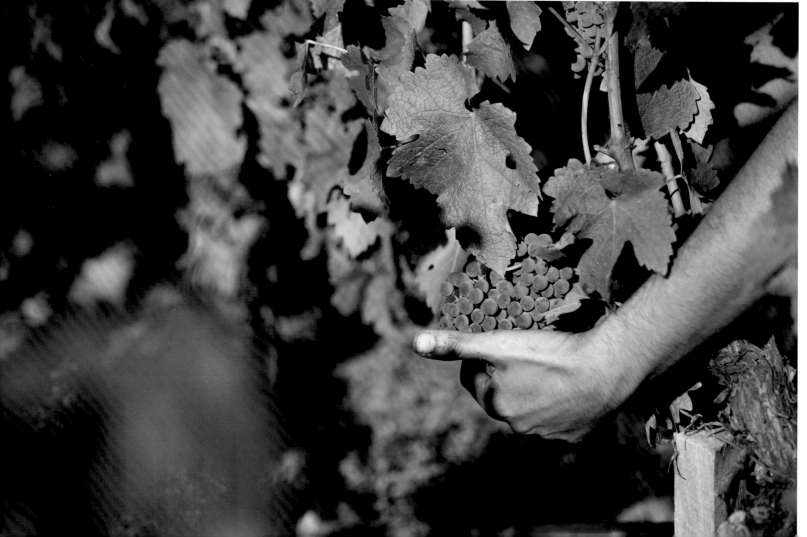

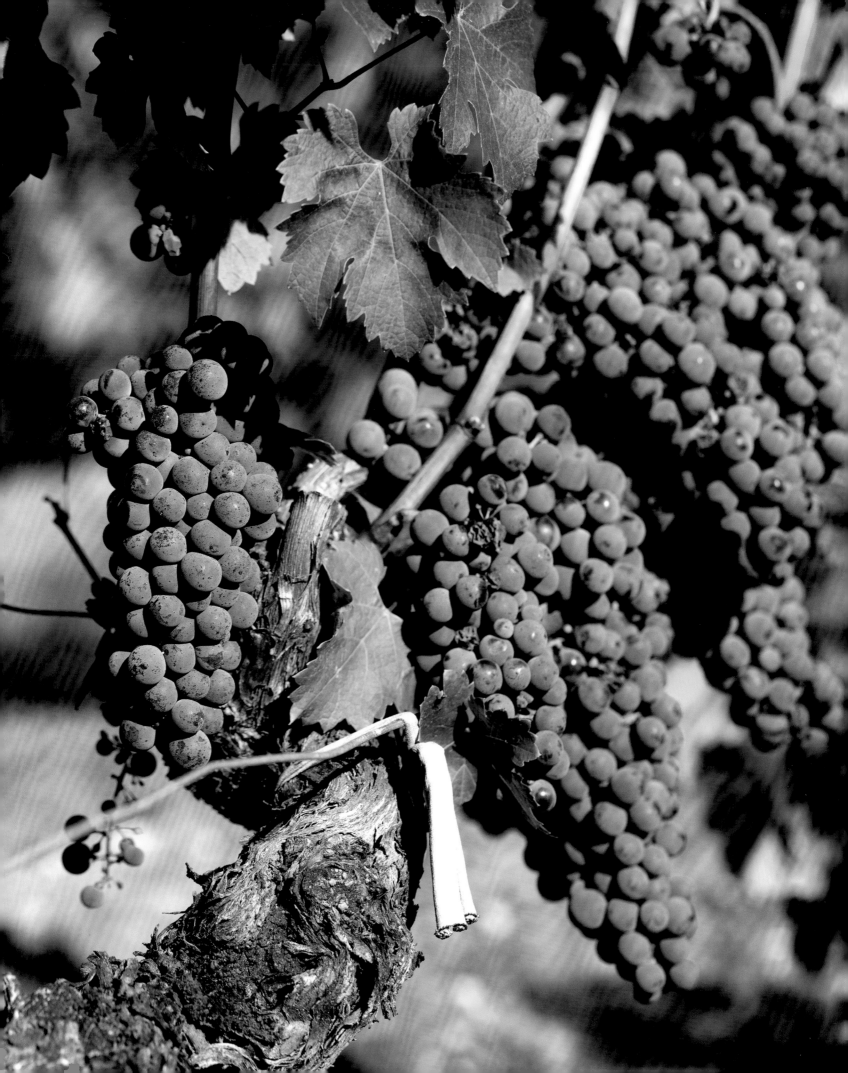

Though man cannot
take the place
of Nature, the
vineyard can be given
a direction; it can be
guided, encouraged
and above all…
revered

The "stewards" of the estate understand this well. It's a question of balance and harmony, of knowing how to wait. At times to wait without doing anything, to watch without intervening, and then all at once to act! For though man cannot take the place of Nature, the vineyard can be given a direction; it can be guided, encouraged and above all… revered. The vines of Cantemerle have Philippe Glumineau to count on. Clearly this jovial-looking young man is a conscientious manager, with determination to spare. He joined the estate of on 1 January 2000 as assistant vineyard manager. The place must have exercised quite a pull on him, since six short months after receiving his diploma he leapt at the opportunity offered to him by château director Philippe Dambrine. Like everyone who visits the extensive grounds and pathways of Cantemerle, he must have been spellbound by the magic of the estate. At the tender age of twenty-one, he took on the responsibility of managing the vineyard of a Grand Cru Classé, working hand in hand with Pascal Berteau, cellar director at the time and today the technical director. From the pruning of the vine in winter to the final harvesting of grapes in the fall, our young man with an early vocation zealously tends the former lands of Baroness Caroline.

Faithful to its terroir and its appellation, Château Cantemerle combines traditions with modernity. "Médoc double Guyot" vine training is practiced at Cantemerle, as it is at all vineyards in the region. This method of pruning, done entirely by hand and leaving an *aste* (a fruit-bearing branch) on both sides of the vine, is considered one of the most effective since it respects both the vine and the flow of sap while extending the vine's longevity. Though ever mindful of traditional practices, the estate has never dismissed more modern methods. Sustainability and respect for the environment are the foundation of Cantemerle's viticultural methods today. Progress through caution and enthusiasm could be its motto! Much as it is for mid-latitude regions in

Previous pages: Cabernet Sauvignon, Merlot, Cabernet Franc and Petit Verdot, are the grape varieties typical of this region, and they flourish on the Cantemerle estate.
Opposite and following pages: Harvest time draws nigh. The same plot of vines may be harvested twice – a selective picking to ensure the premium quality expected of this Grand Cru Classé. Winegrowers mark the vines to show which grapes are ready for picking so must be harvested first.

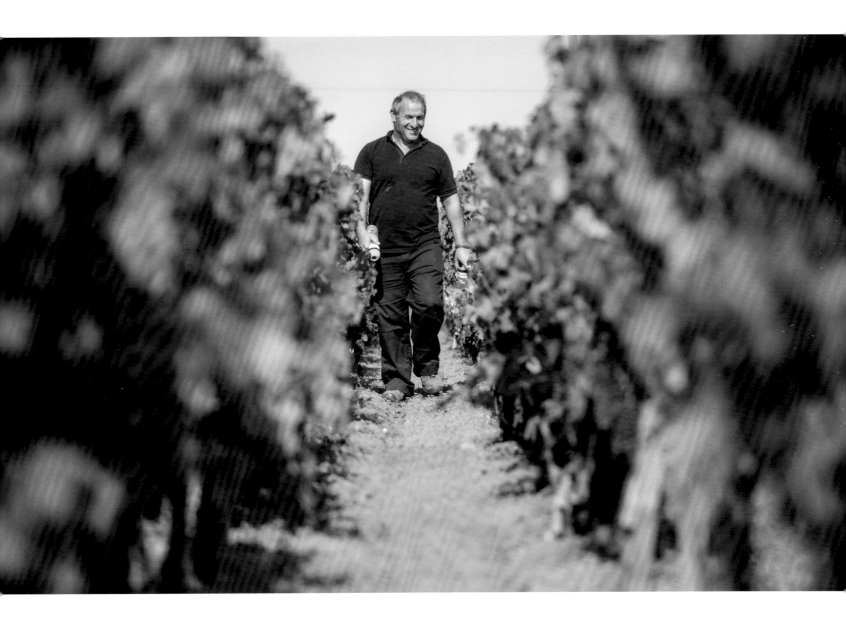

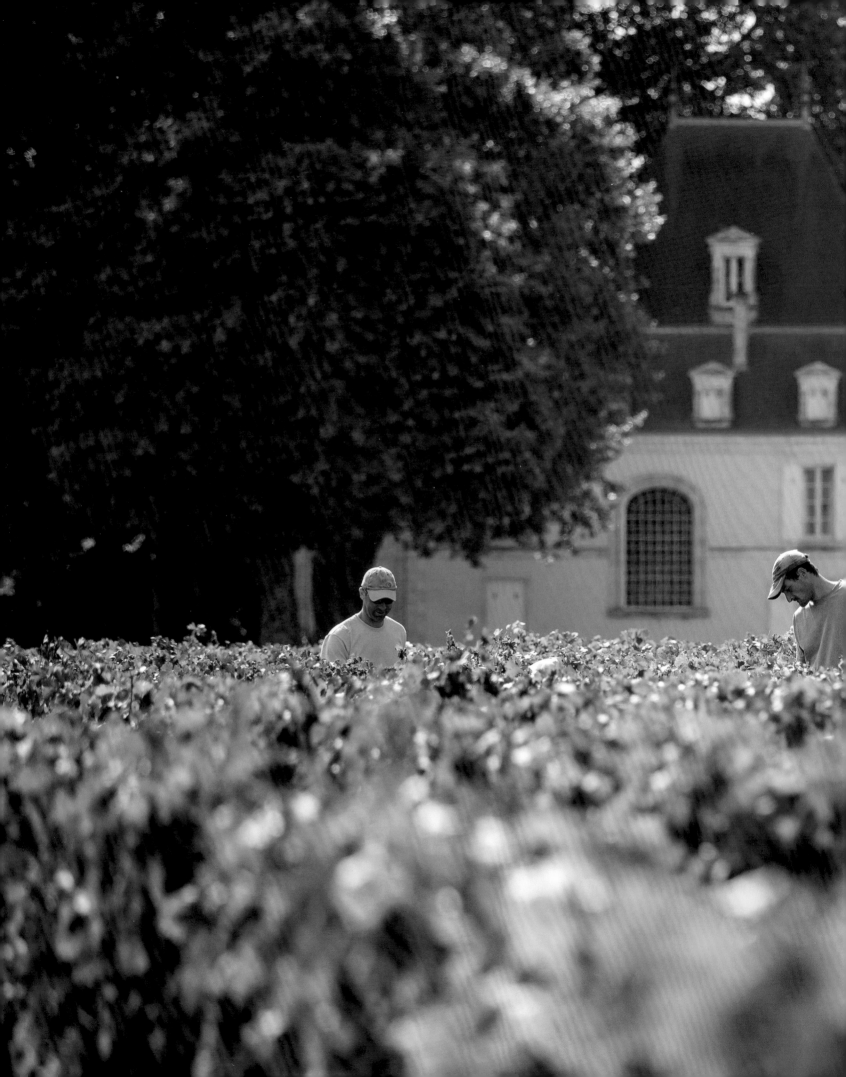

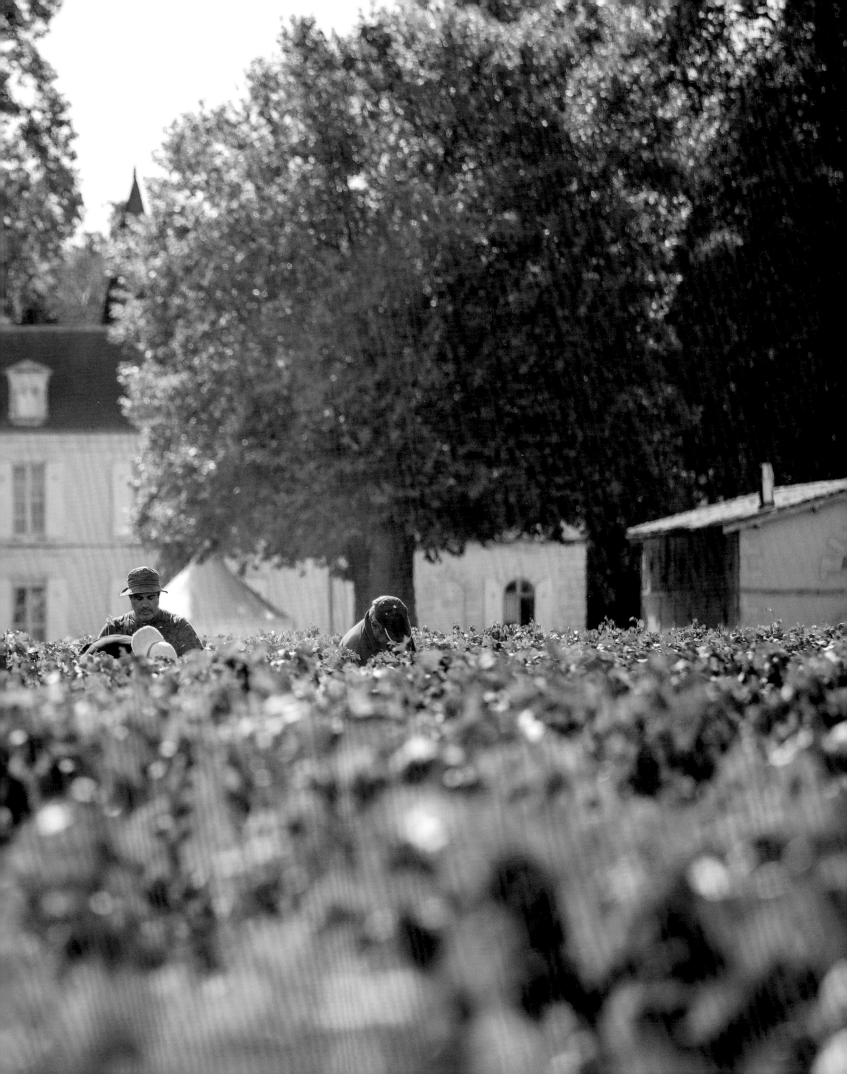

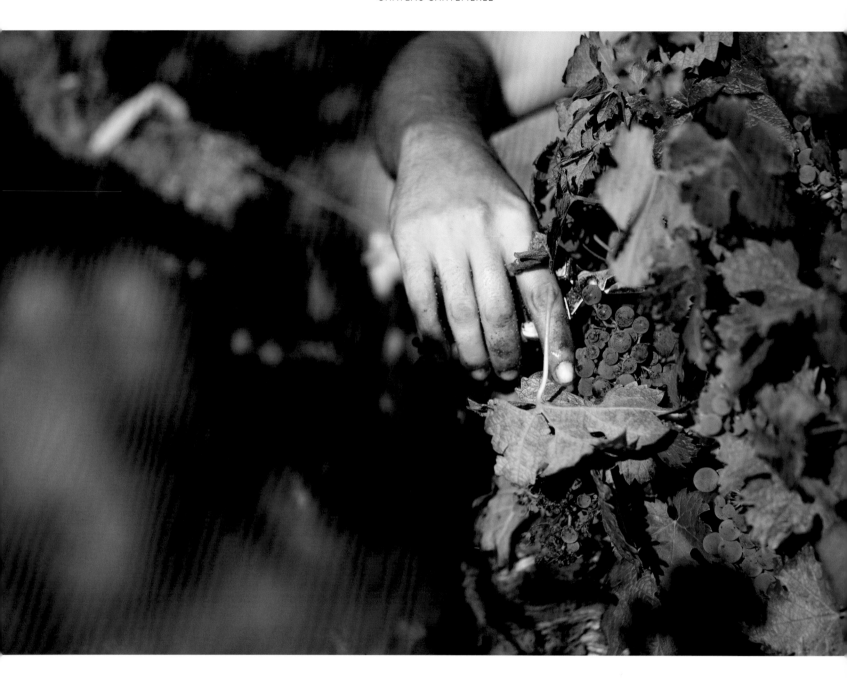

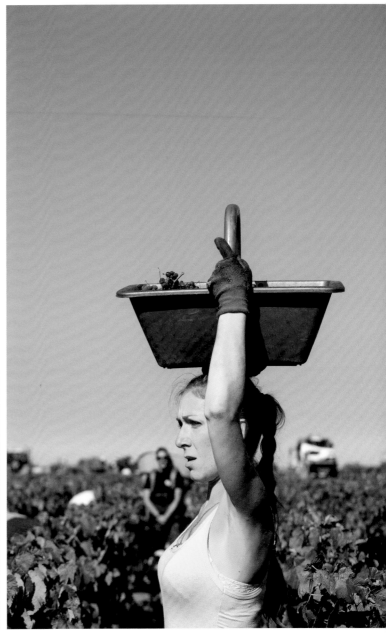

THE VINEYARD
ROWS ARE SUDDENLY
FILLED WITH DOZENS
OF MEN AND WOMEN:
HARVEST TIME
HAS ARRIVED.

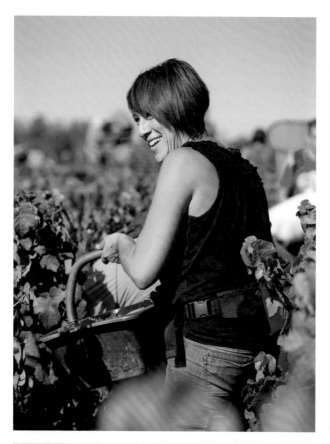

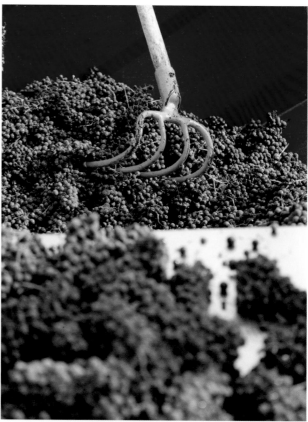

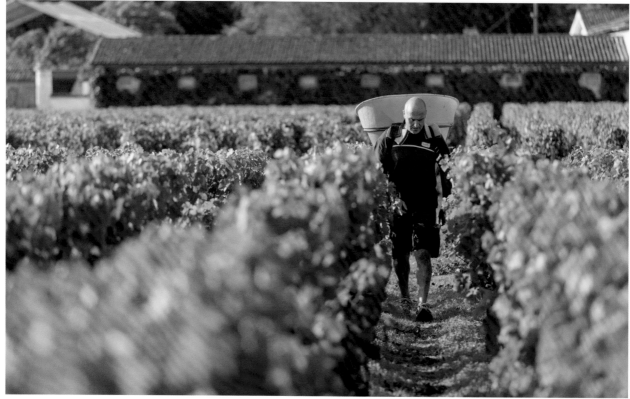

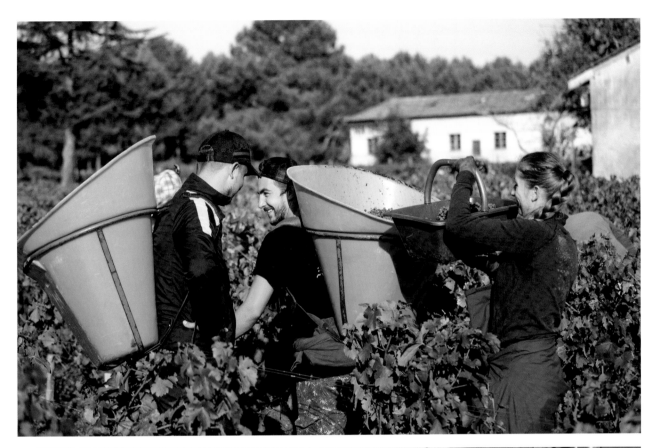

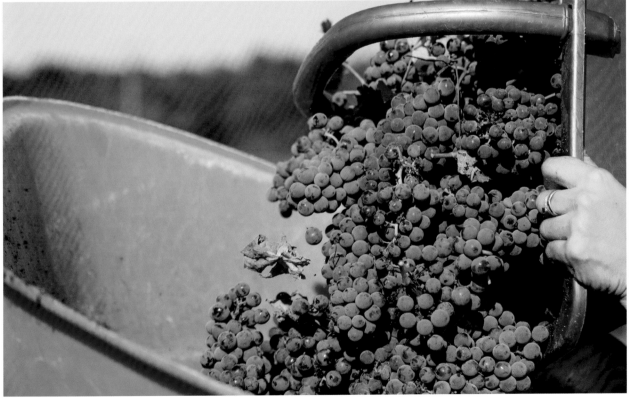

general: excellence through temperance! And since staying abreast of things is important too, no efforts are spared. At Cantemerle, two hectares of land are renewed each year. The number of Cabernet Sauvignon vines has increased and Petit Verdot, which does extremely well in the Cantemerle *terroir*, is gradually replacing the Merlot. This robust grape variety may be a little tricky to cultivate, but it will do wonderfully in future *assemblages…*

Agronomy, ampelography and oenology are the fields of botany concerned with wine and the grapevine, and they have led to greater understanding of a process that was once based on instinct and empirical knowledge alone. Research in the Bordeaux region has played an important part here. At Château Cantemerle, innovation is taken into account. For all that, nothing can replace close observation. A poet at heart, Philippe Glumineau can often be seen walking in the vineyard to get a sense of the vines. Year after year, ever alike yet always different – no two years are ever the same – the sky, the earth and the grapes must be taken into account. And when harvest time approaches, the estate hands are ready, more focused than ever, to intervene or… just wait.

Previous pages, below and opposite: Manual harvesting is the tradition at Château Cantemerle. The work itself is demanding but, today as yesterday, harvest time is always a time of celebration and sharing.

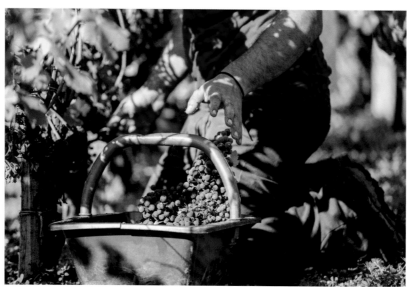

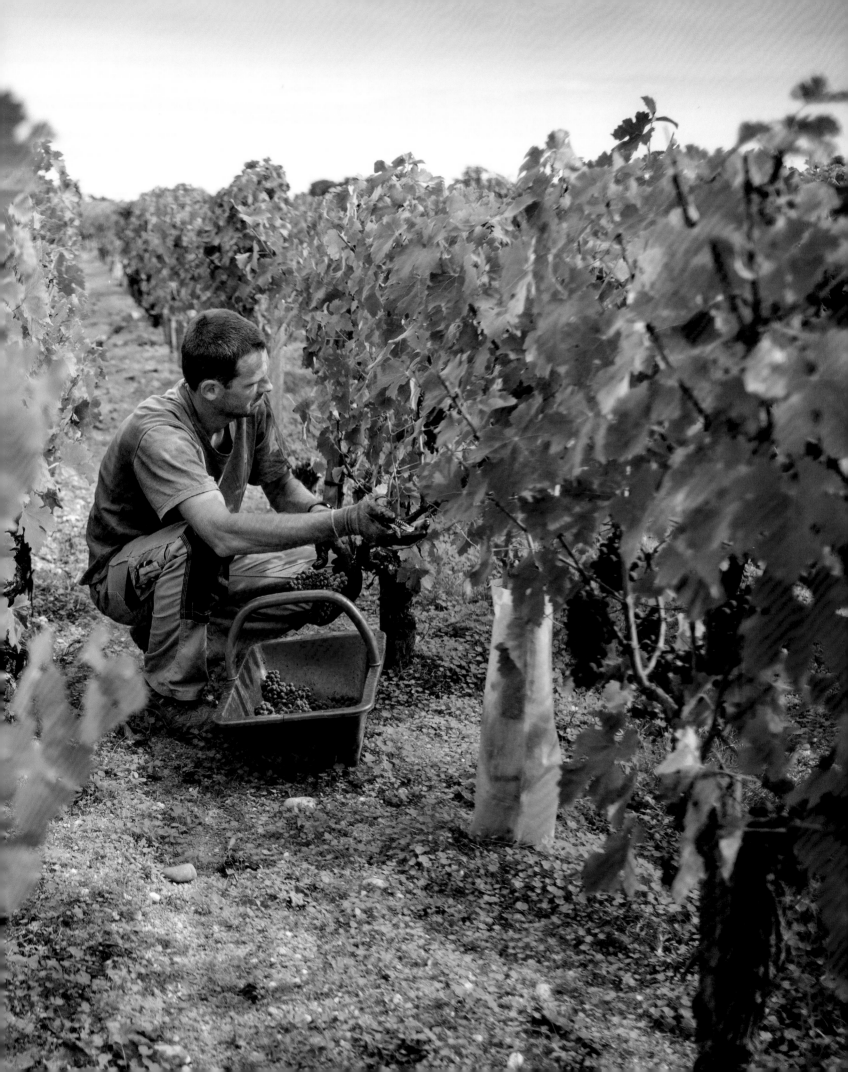

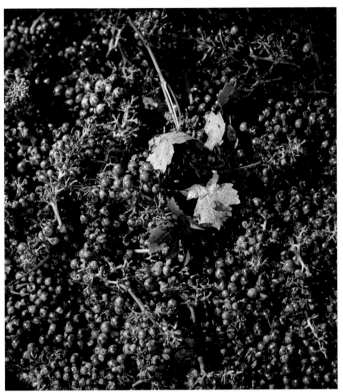

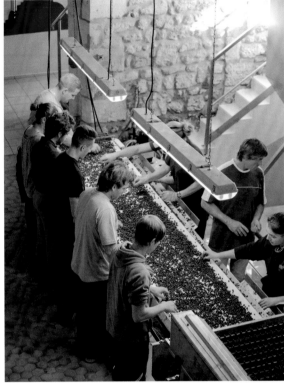

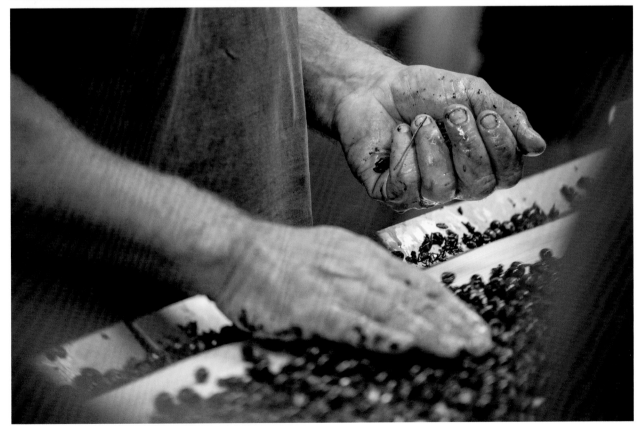

Previous pages, left and opposite: The grapes are meticulously sorted upon arrival at the winery – a decisive stage for the quality of the future vintage. Following a first mechanical sorting, they are sorted by hand to remove any remaining stalks, stems and leaves.

The harvest is the long-awaited reward for the year's labors, but it is also an exhausting process for all concerned. The same tasks must be repeated every day: grape delivery, sorting, pressing and vatting; then at night, cleaning and preparing the winery for the following day.

When the time comes to give thanks to the vines for the grapes that have been so patiently nurtured, when the moment is ripe to tap into the fruit of an entire year's work, the sense of tension and joy is palpable. The right time to start the grape harvest is a serious issue. Should you wait a little longer, or is it already too late? Weather becomes an obsession, maximal grape maturity a priority. The team at Cantemerle gets together to talk things over and share ideas: employees consult one another. Only one thing matters now: to harvest the grapes at the top of their form. If the raw material is excellent, the wine will be divine, and isn't that the ultimate goal of all the hard work?

THE FINAL ASSAULT

The decision made, dozens of men and women descend all at once into the quiet rows of the vineyard, crouching, snipping and filling baskets. The image is reminiscent of former times, though traditional songs are no longer sung. Grape harvesting is still done by hand at Château Cantemerle, however, and selective sorting has lately been put in place. Grapes from a certain plot are picked in two stages to separate the fruit of the old vines from that of the younger. Quality is a sum of small details and excellence a priority for our Grand Cru Classé. When the last bunches of grapes are deposited in the wine cellar, Philippe the crop manager can breathe a sigh of relief. But things in the wine cellar are only just beginning, and out in the vineyard it is back to Square One… spring, summer, fall, winter… the attention paid to this great wine never ceases!

Opposite: Oak vats stand ready to receive the year's crop, provided with ideal humidity levels thanks to the vapor that fills the cellar environment. Soon maceration and fermentation will do their work – a gentle process that respects the character of the future wine.

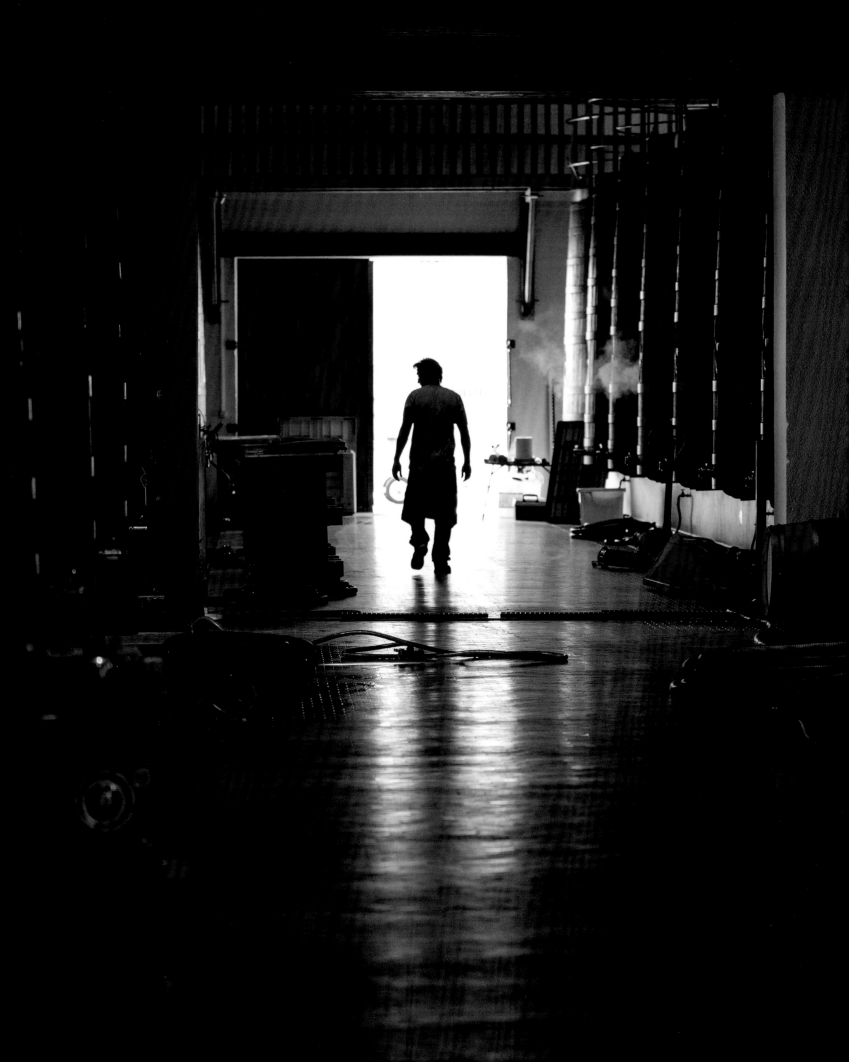

One year quickly follows the next, and nothing can ever be taken for granted. Before long everyone is back on the job with one thing in mind: to maintain beautiful vineyards and superior wines for generations to come.

MAGIC IN THE WINE CELLAR

Now the grapes pass into other hands. These are still early days in the preparation of the divine brew that will eventually fill 560,000 bottles… Cellar master Grégory Thibault is going to "watch the wine the way you would a child," always seeking to combine the best possible conditions.

The fruit of the vine is given a simple welcome. Step One: the grapes are carefully sorted. After an initial sorting at the time of the harvest, the selection must now be optimized. A second sorting by machine separates stems, green berries and leaves from the freshly cut grapes. Next there's a further removal of unwanted elements at a sorting table, this time by hand. These little things are not niceties. Careful sorting is decisive for the quality of future vintages, to eliminate any undesirable vegetal character in the eventual wine.

Tucked into the corner of a majestic sun-filled courtyard, the cellars have an elegant neo-classical air. They have all the same been at the forefront of technical progress since the 1980s. The first thing one notices in the three thermo-regulated vat rooms is the predominance of wood. Twenty-four wooden conical frustum vats, larger at the base than the top, provide for optimal *marc* immersion during the maceration process. Then the wine is transferred to 2,000 French oak barrels for aging. Wood is a porous material that like the cork can contain liquids but allows the wine to "breathe" – an interior-exterior gas exchange that plays an important role in combining the wine's essential elements.

Opposite: After all the excitement of the harvest, a relative peace returns to the winery before the long process of making wine commences.
Following pages: The *test de la bougie* (candle test) precedes *décuvage* (racking), when cellar workers must climb into the now-vented vat. If the candle goes out, there is still some carbon dioxide remaining.

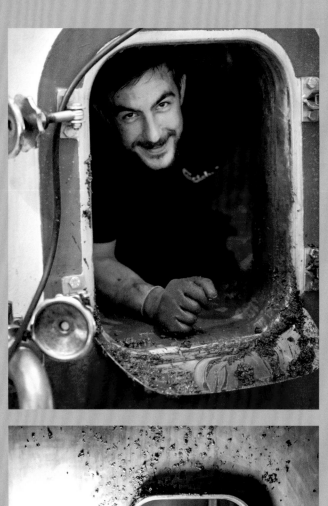
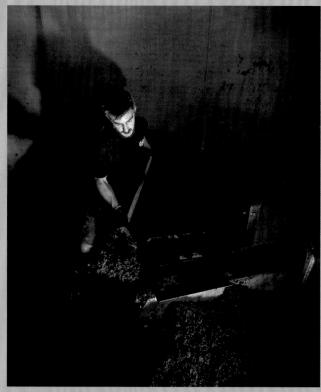
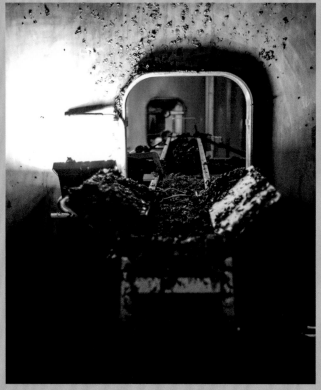

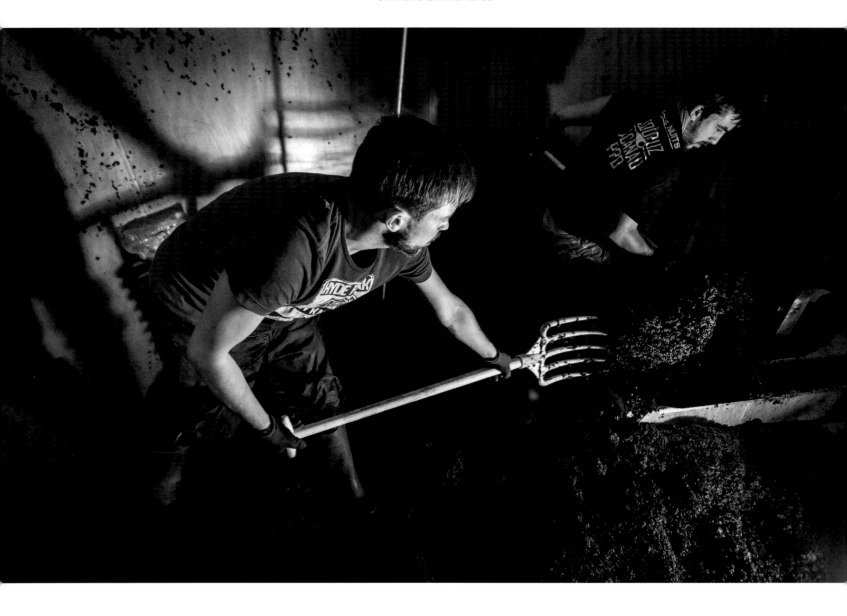

After alcoholic fermentation, the wine is racked (*décuvage*) and the solids transferred to a press – a messy job to recover the solid residue (cap of seeds, skins, etc) from the vat.

AFTER THE FREE-RUN
JUICE (*VIN DE GOUTTE*)
HAS BEEN DRAWN OFF,
DECUVAGE RECOVERS
THE POMACE FOR SECOND
PRESSING (*VIN DE PRESSE*).

The ghostly figures of men at work in the vats.

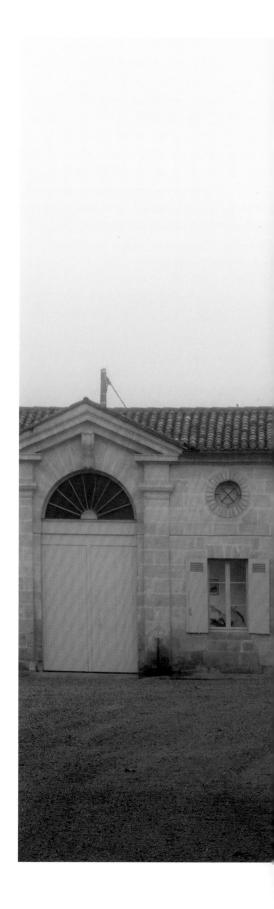

THE ENCHANTMENT OF THE VINE

So it is that in September and sometimes in October, thousands of lovingly harvested grapes arrive to be triumphantly pressed and then placed in vats where they will infuse until the month of December. For it is indeed a question of infusion: the fruit must macerate the way a good tea infuses – without brutality – so fermentation may freely pursue its course. ("Divine fermentation", as Louis Pasteur discovered, is actually the result of the metabolic activity of micro-organisms. In the absence of oxygen, the yeast reacts to transform sugar into alcohol. It is an exchange of energy, and therefore a highly dynamic reaction.) Malolactic fermentation is the secondary stage of fermentation and this remains a real mystery. Once the alcoholic fermentation is complete, lactic bacteria that are naturally present in wine start to break down the malic acids, transforming them into acids with a more mellow taste. This secondary stage is critical because it makes the wine stable for the market. However, as soon as the process is finished, the bacteria must be prevented from pursuing their destructive course! Though the process can be controlled, fermentation is nonetheless a capricious phenomenon, starting in one vat before it starts in another, despite very similar conditions, and terminating when it sees fit… So you must remain vigilant. Once a week, samples from each vat must be sent to the lab to measure bacterial activity. Making wine is a profession, and improving wine is a genuine commitment!

One thing at Château Cantemerle that never changes is constant experimentation. Year after year the estate's staff experiment with new methods. If the experiments prove conclusive, they go into general use. For the past several years, the estate has practiced selective devatting during the running off, a technical innovation that has proved to be very successful. After the running off, all of the solids – the pips, skins and solid matter called the "cap" – are left in the vat. The top and bottom of the cap, which are either overly oxygenated or washed out, are removed to leave just the unspoiled, denser and more mellow heart to be pressed. That is to say, only the best!

Another improvement introduced by the team at Cantemerle concerns the production process itself. Wines comprise free-run wine (the wine that is run off during devatting) and *vin de presse* (the wine produced from pressing the *marc*); and wines with higher percentages of *vin de presse* have qualities that are more dependent on origin. Previously the *vins de presse* were roughly divided into three grades corresponding to the number of pressings;

Opposite and following pages: The Cantemerle *chais*, tucked into a majestic and light-filled courtyard, display a neoclassical style that belies their state-of-the-art technology.

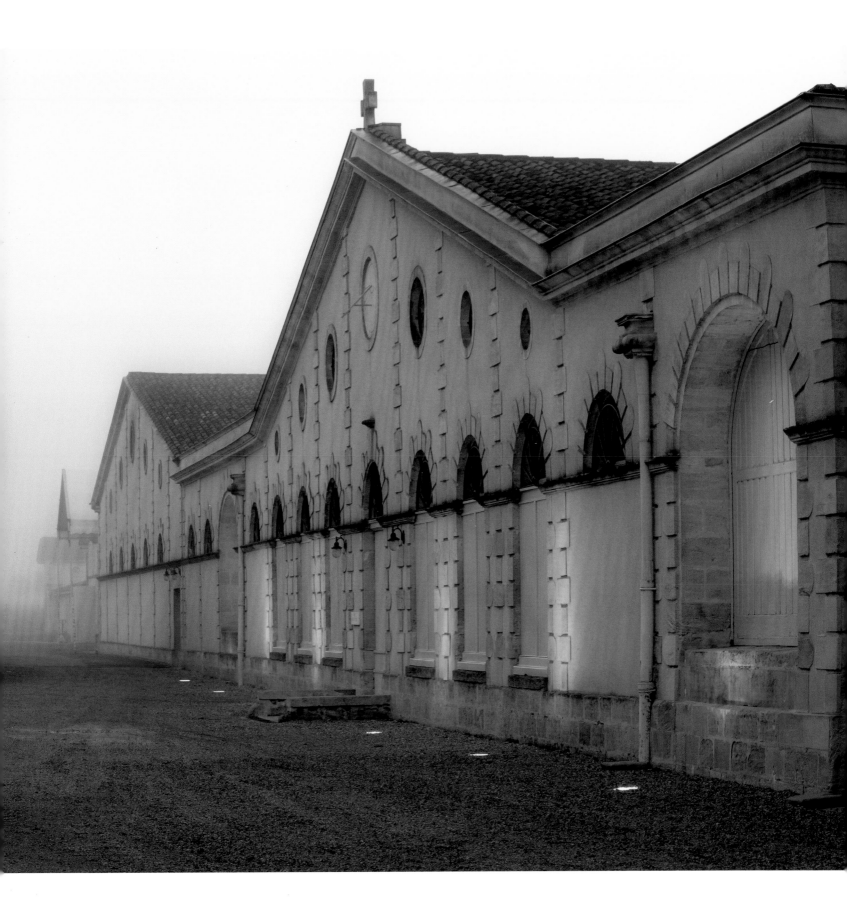

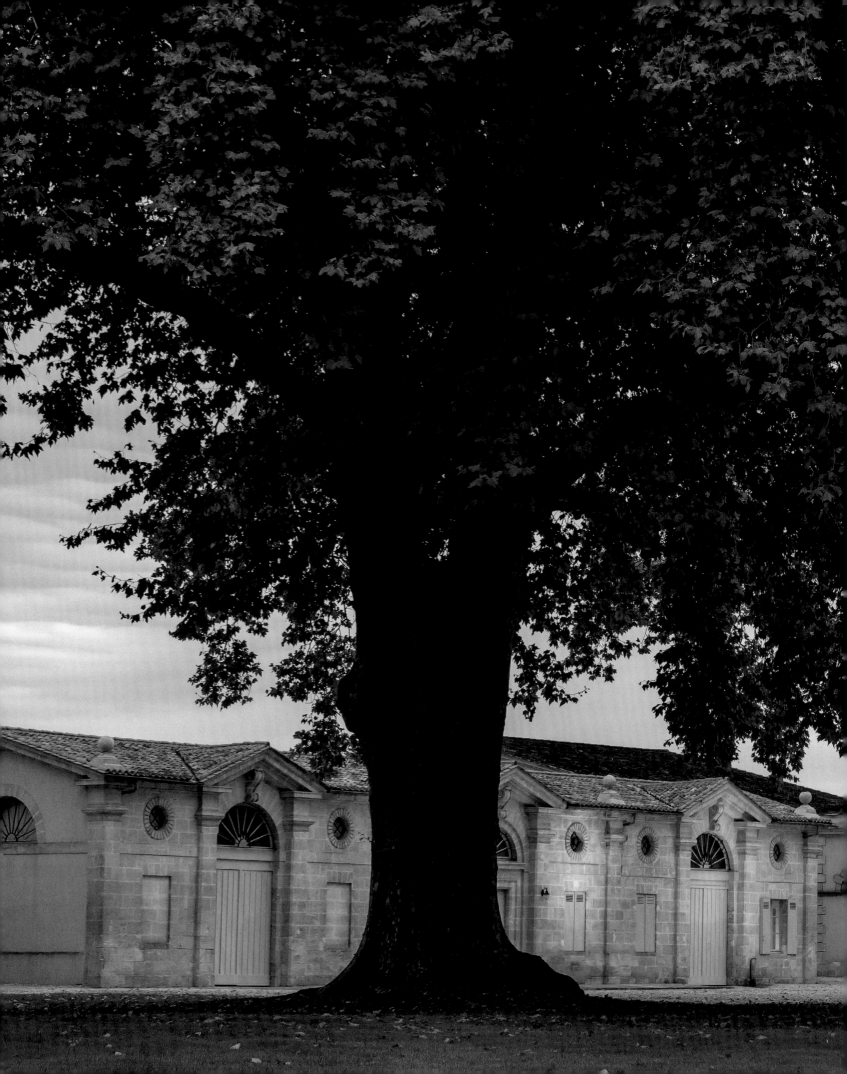

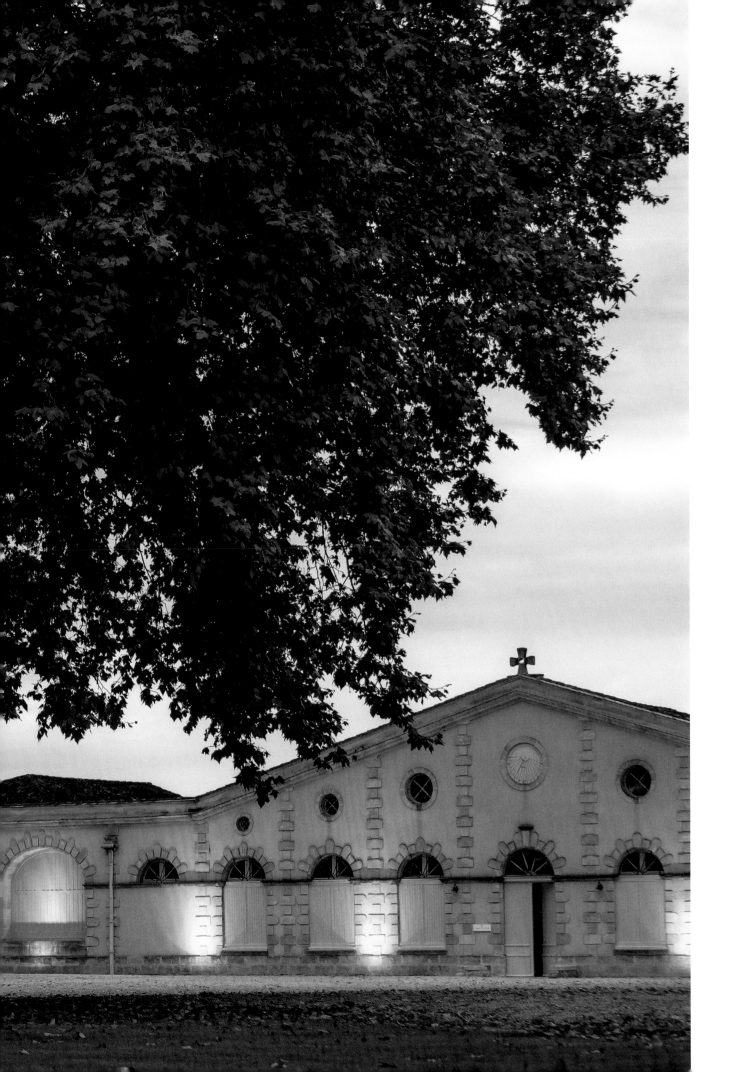

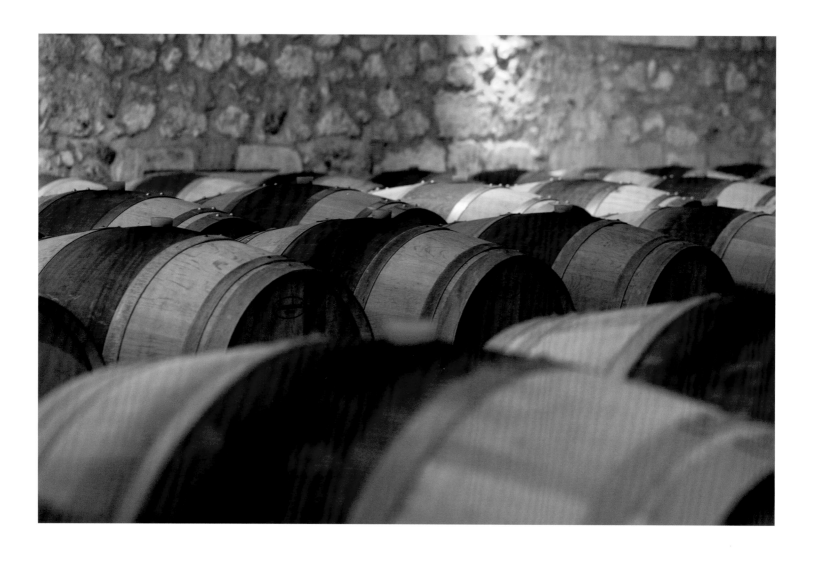

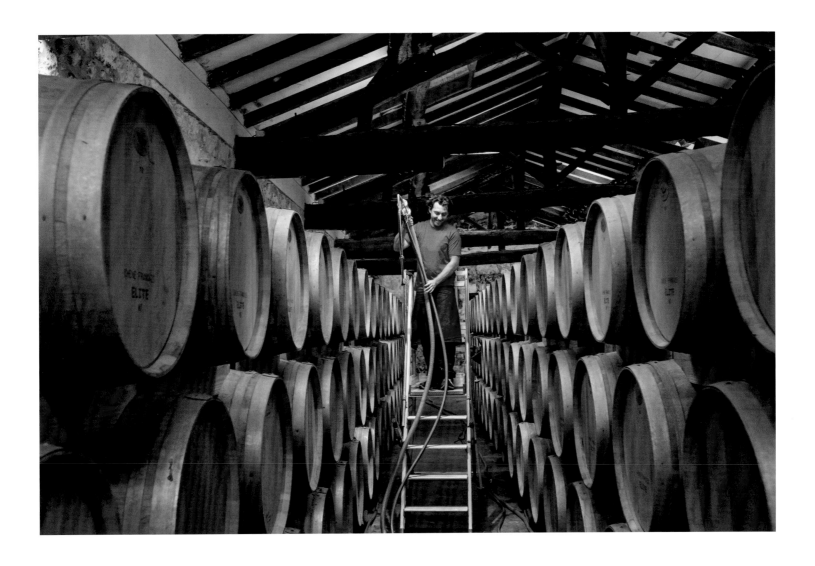

Opposite: Two thousand French oak casks housed in Cantemerle's temperature-controlled cellars ensure ideal maturation conditions.

Above: The bottles of wine slowly maturing in the *chai* require attention on a daily basis.

Maturation continues for 18 months, including 12 months in oak casks – ideal conditions to bring out the aromas of the future Grand Cru

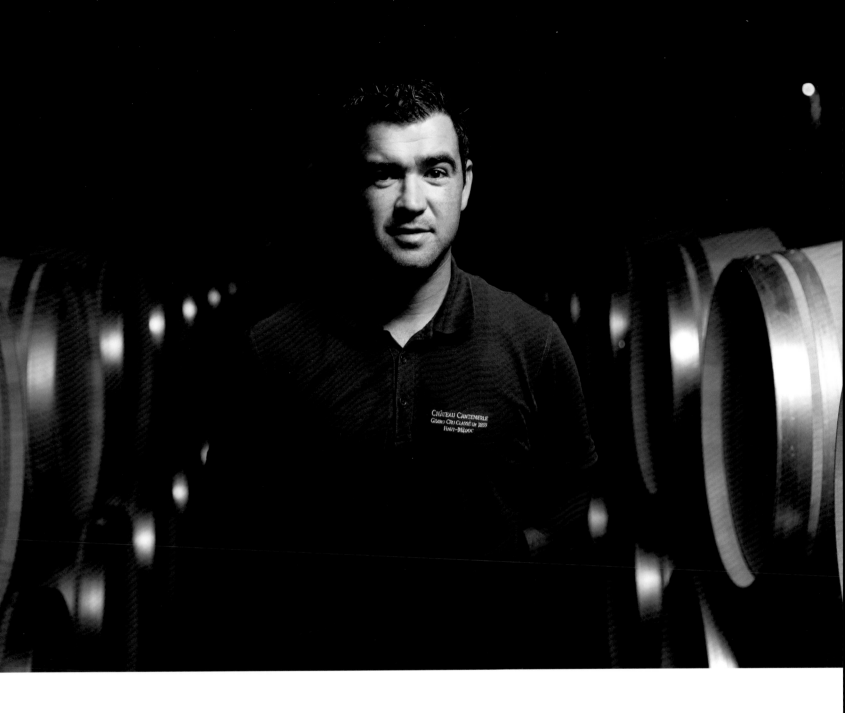

Above: Cellar-master Grégory Thibault safeguards the consistent elegance of Cantemerle wine.

today they fill six to seven hundred barrels, each of which must be individually tasted and classified on a scale of four grades. A tough job...

Making wine is a profession, and improving wine is a genuine commitment.

SHARING KNOWLEDGE

Like the entire team assembled since Philippe Dambrine has directed the estate, cellar master Grégory Thibault came on board and never looked back. It has been ten years now, and his enthusiasm has never waned. He is captivated by the château's exceptional atmosphere, and delighted to be working with a prestigious Grand Cru Classé in a close-ly-knit team. With a broad smile and a twinkle in his eye, he welcomes the unexpected events that give his work its particular appeal. Vinification works according to an extremely precise cycle, but no two vinifications are ever the same; it is necessary to adapt to each new harvest and the exacting chemistry of the fermentation process. The effort is largely outweighed by the rewards of the tasting sessions – and the success of a fantastic vintage! But one year quickly follows the last, and nothing can ever be taken for granted. Before long everyone is back on the job with one thing in mind: to maintain beautiful vineyards and superior wines for generations to come.

WHAT HAVE THE COMBINED ACTION OF VINE, SKY AND HUMAN EFFORT PRODUCED THIS YEAR?

It's the moment everyone has been waiting for. The bottles are arranged on the table, and they represent the work of an entire team. Besides the hundred or so seasonal grape pickers, forty-two people are permanently employed at Château Cantemerle, from vineyard to office. Philippe Dambrine, Pascal Berteau, Grégory Thibault, Philippe Glumineau and the estate's oenology consultant Éric Boissenot are gathered in the tasting room. The bottles are marked with grape variety, parcel number and vat number, no more than that. One by one, the wines will be studied, sniffed, tasted, discussed and ultimately judged. What has the combined action of vine, sky and human effort produced this year? Experience and skill already give a sense of what the palate can expect – and some samples will far exceed those expectations.

Opposite: The wines of the vintage are tasted and assessed at an early stage. In the tasting room, Château Cantemerle Director Philippe Dambrine takes note of the comments of his team.

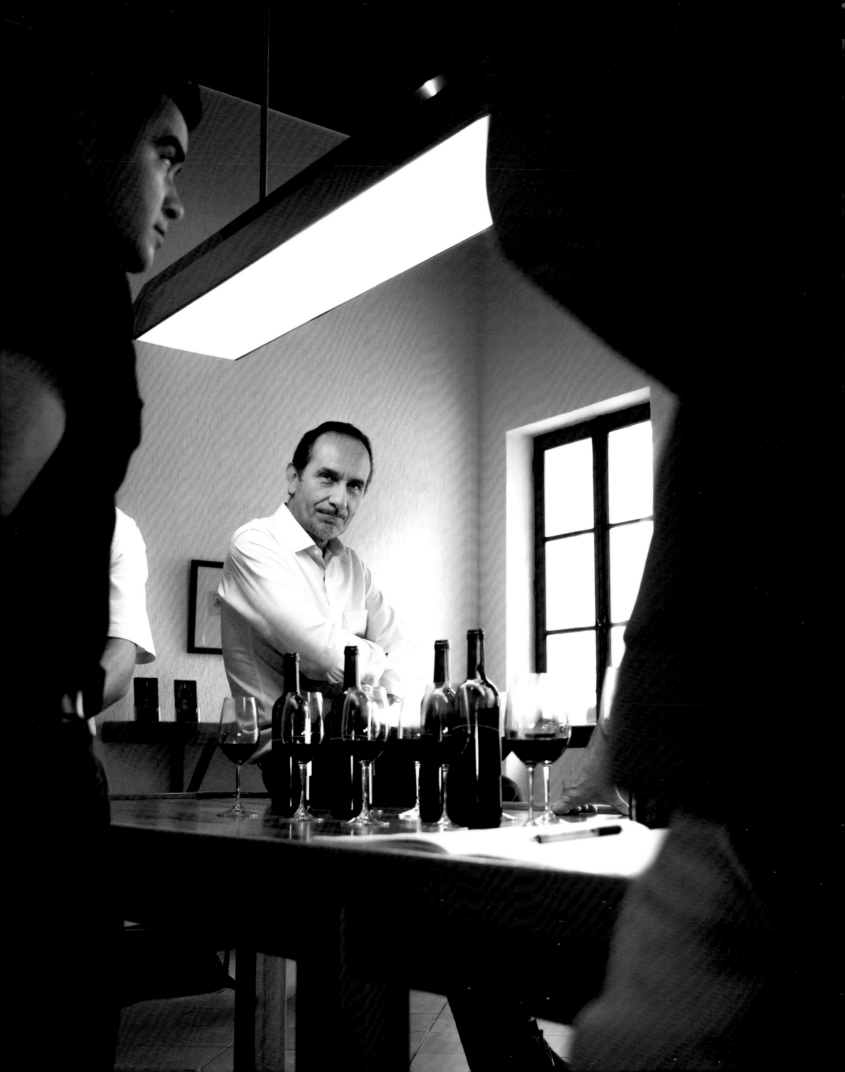

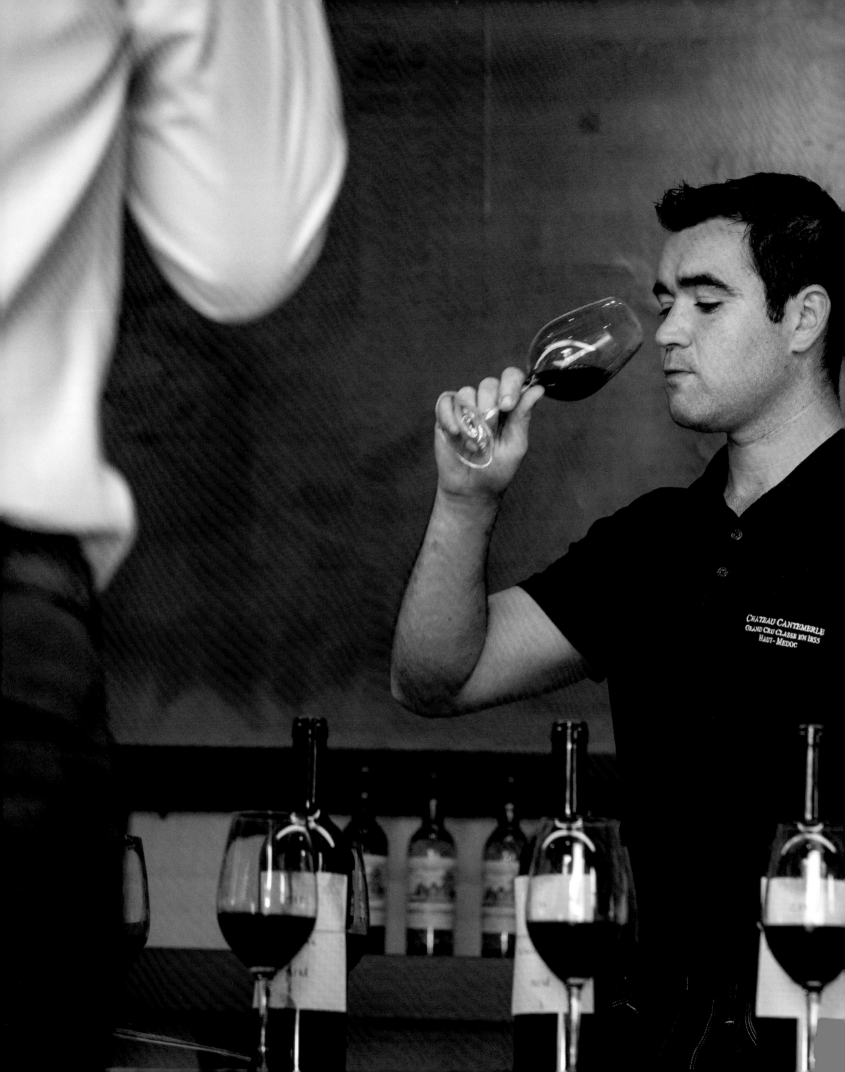

A large table is laid with samples from different vats and vineyard plots, eagerly awaiting the moment when cellar-master Grégory Thibault will assess the characteristics of the year's wines.

117

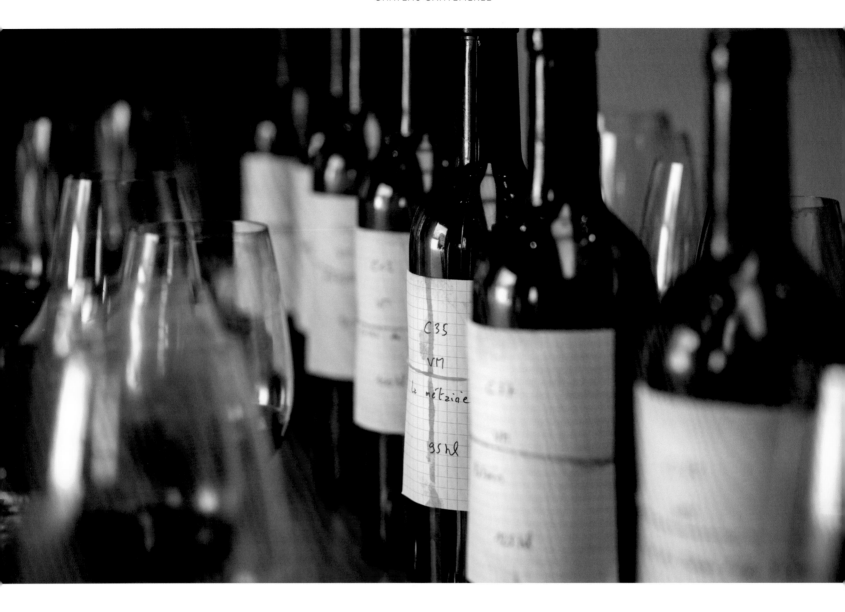

Opposite: Technical director Pascal Berteau has been with Château Cantemerle since 1987 and is one of the longest-serving members of the team.

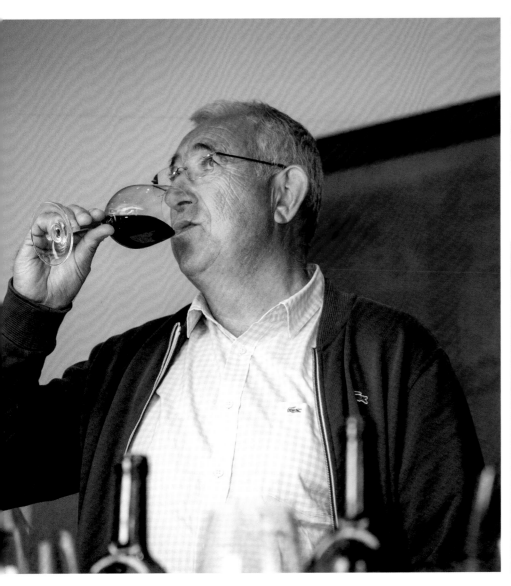

FIRST TASTINGS:
WHICH PLOTS AND
WHICH GRAPE VARIETIES
WILL BE SELECTED
TO BLEND THE NEW
CANTEMERLE VINTAGE?

The excellent management of the vineyard has paid off. Each new harvest seems to surpass the quality of the previous year. This solemn and happy occasion will serve to identify the best plots and establish varietal percentages for this year's vintage…

THE SPIRIT OF THE *TERROIR*…

It is unreasonable to expect that the vines will produce identical grapes every year, because the tannins, power and density of a grape are variable. But the essence of a vintage, its temperament and intrinsic qualities, will remain the same for so long as the *terroir* is respected. The spirit of the *terroir* must be free to express itself, its voice must ring out and be heard. Château Cantemerle is a perfect example of this principle, never submitting to passing fads. From time immemorial the wine has remained true to its style, even in the vineyard's most recent period of expansion. Great care was taken to preserve the typical expression of the *terroir*.

… AND THE VOICE OF MAN!!

The practice of *assemblage* became common in the nineteenth century, encouraged by the Bordeaux wine *negociants*. In the Médoc, four typical grape varieties – Cabernet Sauvignon, Merlot, Petit Verdot and Cabernet Franc – are blended to produce great wines. The quality of the grape varieties aside, the origin and age of the plots are also decisive factors. The older the vine, the better the grape. *Assemblage* is an essential stage that guarantees the consistency of a Grand Cru – an art that requires both experience and talent, and an intangible science of incredible complexity where smell, taste and memory are combined in a sensuous and mysterious dance.

For the past ten years, a legendary figure renowned for the refinement of his palate and nose has been collaborating with the estate. Éric Boissenot, a reticent man of few words, is working to conserve the noble heritage of Cantemerle. Impressed by the expression of its Cabernet Sauvignon and the qualitative consistency of the Cantemerle vine, Boissenot immediately recognized the great *terroir's* potential – and a person with his winemaking experience is hard to fool! Today, he collaborates with Philippe Dambrine's team and is responsible for developing and perpetuating the identity of the vintage with its high percentage of elegant Cabernet Sauvignon. Powerful, balanced and complex, this is a grape variety that thrives in the sand-gravel *terroir* of Cantemerle, which is one of the southernmost in the Médoc and ideally positioned for the growing of perfectly ripe grapes. In the years ahead, more Petit Verdot is likely to be grown, its intense color and concentration contributing remarkable structure and aromatic complexity to Cabernet Sauvignon *assemblages*. But don't forget Merlot, for its color and smoothness, or the Cabernet Franc that adds complexity and aroma. Assembled in different proportions from one

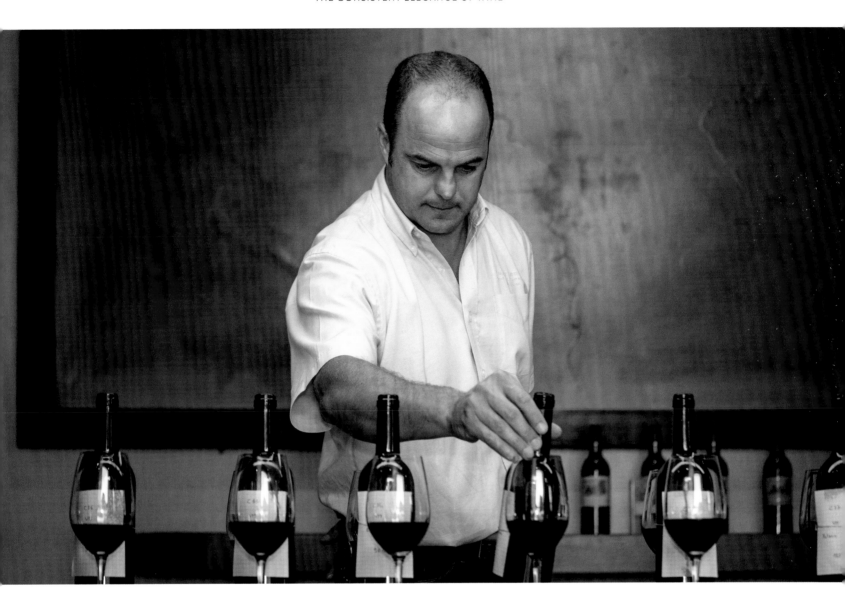

EXPERIENCE AND
TALENT MAKE BLENDING
AN ART ESSENTIAL TO
THE CONTINUITY OF
A GRAND CRU.

The Grand Vin is blended from the Médoc's four traditional grape varieties. The Petit Verdot, the Cabernet Sauvignon and the Merlot bring good depth of color. The Cabernet Franc adds complexity and rich aromas.

125

year to the next, each of these four grape varieties is a part of what gives the great wines of Château Cantemerle their distinctive personality.

ELEGANCE, CALM AND SENSUALITY

When it comes to describing the qualities that make Cantemerle's vintages so unique, an abundance of adjectives comes to mind: authentic, refined, delicate; generous, round, expressive; full but not heavy; fat, chewy and dense; complex but precise. To name just a few!

Cantemerle vintages are ready to be enjoyed young, when the wine's charm, finesse and suppleness are already fully expressed. But they also age extremely well, revealing over the years a wealth of hidden qualities. Leading French wine critic Michel Bettane says that the estate's wines quite simply get better over time, displaying balance and harmony "with neither disproportionate pride nor sloppiness." Éric Boissenot speaks of the wonderful complexity of the Grand Cru: "It is not a monolithic wine. It has a wide range of expression. It is rich, subtle, complex and multifaceted, with a persistent mouthfeel." Praised like an Old Master whose value is beyond question, the key quality is what Boissenot calls "a subtle balance." Didier Ters, a journalist and author who knows the estate well, speaks of its typicity and personality: "It may not be the most powerful, but it is certainly the most endearing." This bon vivant is equally enthusiastic about the Grand Cru Classé's afford-ability – "everyone can afford a bottle of Cantemerle!" – and its versatility. It is a wine that can be enjoyed young but also has the potential for a fabulous maturity over the decades, and that's well worth the wait. You cannot taste a Cantemerle vintage without liking it immediately. Admirers of the Grand Cru are many, including Philippe de Rothschild himself who liked to say he drank Cantemerle when he wasn't drinking Mouton…

Château Cantemerle may well be the perfect expression of its *terroir*, but it is also much more – thanks to the vintners' love and care, perhaps, or the exceptional tranquility of those lands on the outskirts of Bordeaux? A single sip conjures up a world of trees, sun and water, of woods, flowers and fauna. One taste whisks us away to a world where expertise and careful observation are brought to perfect pitch, to a place where pleasure and peace-fulness are intimately entwined…

Opposite: Delicate and supple in its youth, Château Cantemerle becomes increasingly elegant with age, evolving into a wine of extreme refinement.

ASPIRING TO GREATNESS

The wine of Château Cantemerle has always been true to its unique personality, and has today recovered its signature style of 1855 – the Baroness Caroline would be delighted! Through the restitution of historic lands, the intelligent planting of grape varieties and the careful tending of vines, not to mention the improvements made to both vineyard and wine cellar, the wines of recent years have reached unsurpassed heights. Many of today's professionals agree that the identity of Cantemerle wines grows stronger every year in the refinement of its aromatic purity and the expression of its *terroir*. This is not the result of chance but the shared determination of a succession of fiercely loyal families. Cantemerle was owned for more than three centuries by the Villeneuve family, then purchased in 1892 by Théophile-Jean Dubos whose descendants would manage it for nearly a century. Its irresistible ascent is owed to the tenacity of generations of winegrowers and passionate owners who navigated both calm waters and storms. The estate was sold in 1981 to the Mutual Insurance Division of the SMA Group, the first corporate entity to acquire a Bordeaux vineyard. Today it pursues its destiny under the direction of Philippe Dambrine, a capable man worthy of the estate's historic past.

The pursuit of excellence with no loss of identity... The vines may perform differently each year but the backbone of the wine is ever the same thanks to blending, savoir-faire and respect for *terroir*. Château Cantemerle is a true expression of its vineyard, always faithful to its own distinctive style.

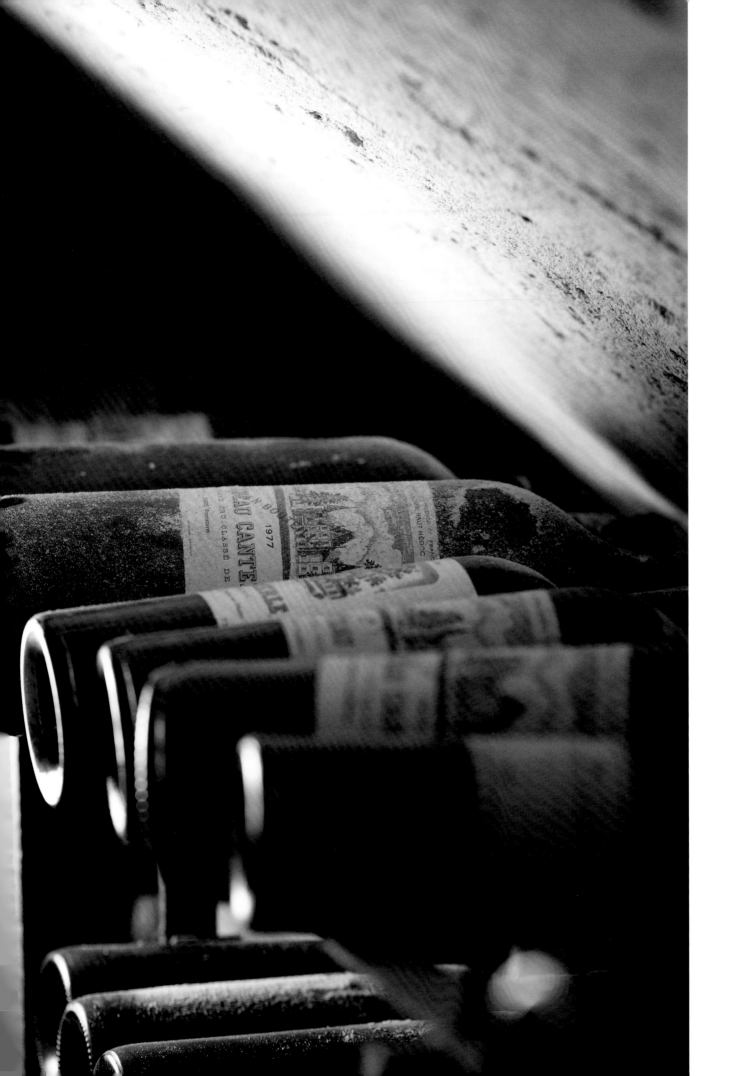

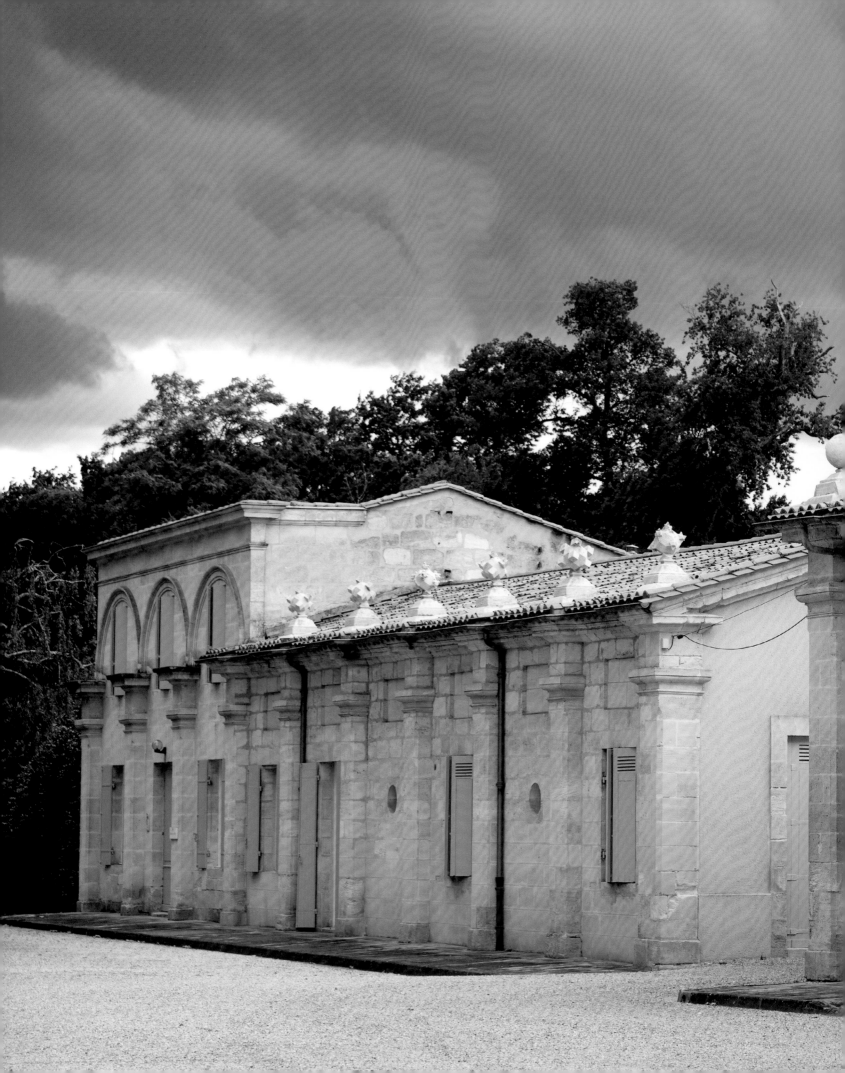

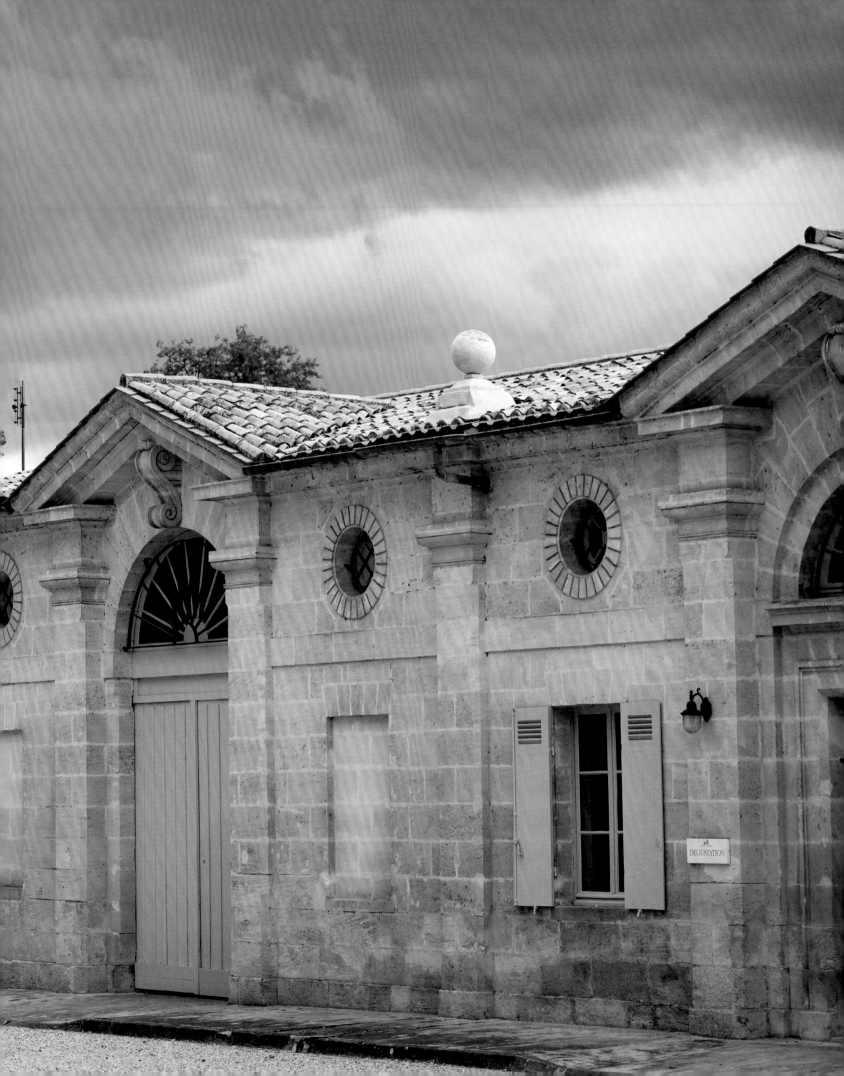

HUMANITY
AT
THE HEART

❝ For all of its attractiveness to investors, my estate has meanwhile become an element of heritage inseparable from the affection that is has always aroused. It is that human dimension that has been handed down by the great families who formerly owned this estate to the company that owns the estate today. Therein lies the magic of Cantemerle: this alchemy of an extraordinary *terroir* that draws out the very best a human being can achieve. **❞**

Since the early 1980s, the estate has pursued a destiny that had admittedly unusual beginnings, when it departed the family fold and was acquired by Groupe SMA, a mutual insurance company in the building and civil engineering sector. SMA was the first insurance company ever to invest in a Bordeaux estate. As it turns out, the move has been about much more than investment, helping to revive SMA's corporate values as a *société civile de personnes* (a non-trading, membership-based company) and a non-profit mutual benefit organization. The constitution of Groupe SMA means it can arrange insurance to meet the needs of its members – businesses, directors and salaried staff, all working together in a spirit of solidarity. In this respect, Cantemerle benefits from the strength and unity of a solid structure composed of attentive and caring family members.

THE PASSION OF A MAN CALLED ALBERT PARMENT

It was also in the early 1980s that Albert Parment took over as Chief Executive Officer of SMABTP (Mutuelles d'Assurance du Bâtiment et des Travaux Publics). Though the company traditionally invested in real estate, Groupe SMA was thinking of acquiring a vineyard in the Bordeaux region. The choice quickly turned towards Château Cantemerle, an estate that looked promising for a number of reasons. It had enjoyed Classed Growth status since 1855; its potential was under-exploited; the quality of the wine was open to improvement; the scale of the investment was reasonable; and, it almost goes without saying, the estate's grounds were among the finest in the Bordelais.

The priority from the outset was the business of winegrowing, and Bordeaux trading house Cordier was entrusted with the management and redevelopment of the estate. Under the leadership of technical director Georges Pauli, vineyard replanting commenced alongside work on the *chai* (vat house) focusing on cleanliness and hygiene. The renovations were completed in record

Opposite: Château Cantemerle Director Philippe Dambrine – at the helm for nearly 30 years.

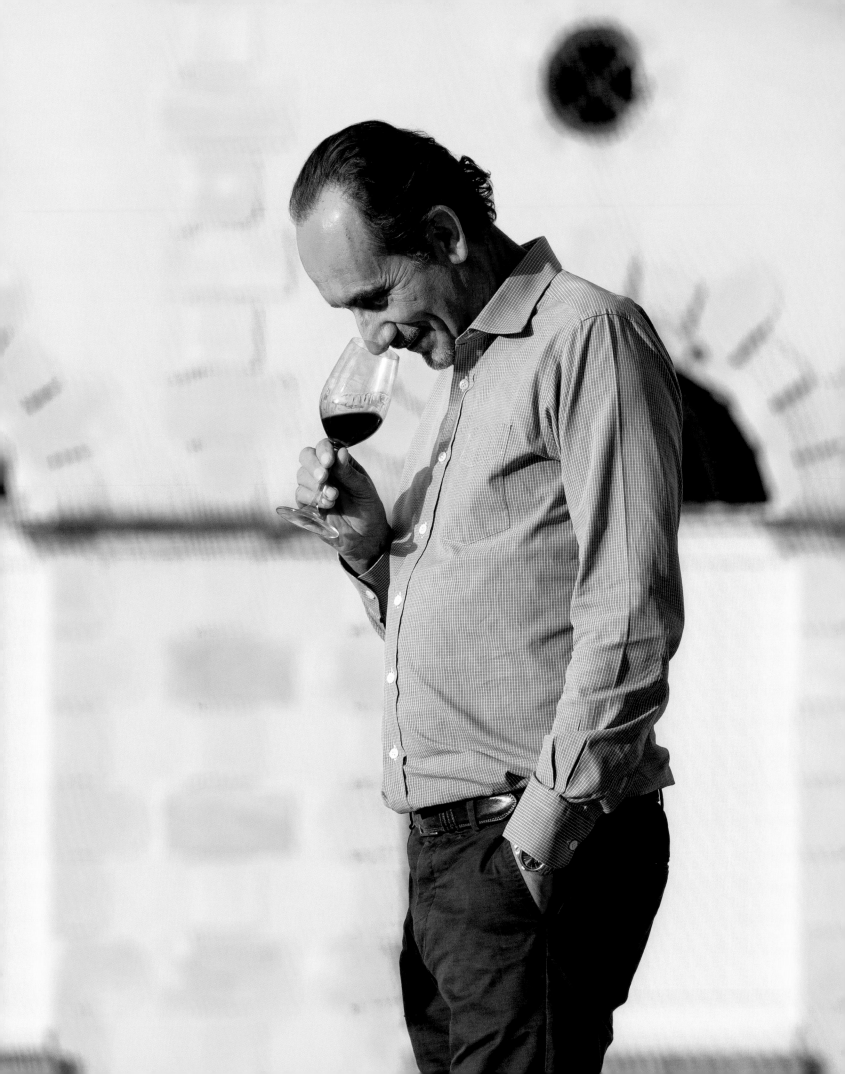

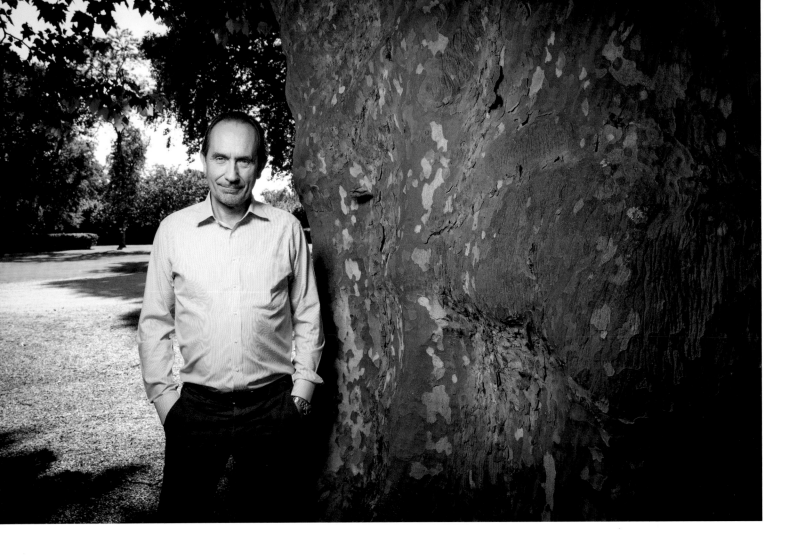

time. Between 1981 and 1985, 40 hectares of vines were replanted, rising to 60 hectares by 1987. The winery was entirely refurbished, complete with a new 3200-hectoliter wooden vat that came on stream in 1990. Other buildings were meanwhile fitted out for packaging and shipping functions, and work began on renovation of the château itself, spearheaded by Albert Parment who aimed to transform the building into a venue suitable for receiving guests and clients. Being profoundly attached to the estate, he gladly volunteered to assist in the acquisition of furnishings, scouring auction rooms for bedroom and living-room furniture with an inherent good taste that is reflected in the simple elegance that defines this property.

Above: "When we show visitors around the estate, we always start by saying hello to the trees!" says Philippe Dambrine with a smile. "The presence of the 'twins' tends to fill people with feelings of peace and serenity." The "twins" are the hundred year–old plane trees pictured here – one of the treasures of this estate.

Yet for all their expertise in renovating the property and expanding the vineyard, the Cordier executives were not image-builders. Château Cantemerle had yet to emerge from its convalescence and establish an identity for itself. The turning point came when Cordier was bought out and the business model changed. At this point Albert Parment enlisted the help of his nephew Philippe Dambrine, a trustworthy and experienced man whose personality and genuine fondness for Château Cantemerle augured well for the future of the estate.

A MYSTERIOUS VIBRATION

Philippe Dambrine joined the winegrowing world as a humble grape-picker at the Cordier-managed Gruaud Larose estate, and it was then that he discovered Château Cantemerle. The charms of the property were irresistible – the grounds, the majestic trees and the baroque elegance of the property itself, all of which seemed to resonate with positive vibrations that he attributed to the ancient history of the site. The Romans after all were famous for building their homes in carefully selected locations, being guided by their animals' instinctive selection of resting places that harnessed the Earth's telluric forces.

For all of its charms, the property was in a sadly dilapidated state. In the early 1980s, Château Cantemerle had yet to recover from the crises of the 20th Century. The vat house still had its original dirt floor. The vineyard had shrunk to 20 hectares and the château interior was hopelessly outdated.

As renovation work started on Château Cantemerle, Philippe Dambrine set out to carve his own destiny. He took courses in wine business at the Bordeaux Chamber of Commerce and Bordeaux University, and worked as a trainee at several wine estates – in the vat house, in the vineyard, any job he could get. His career took off at lightning speed after that. Bordeaux became his adoptive city and brought him into contact with the owners of Château Greysac, a vast Cru Bourgeois in northern Médoc owned by Baron François de Gunzburg and the Italian industrialist family, the Agnellis. Too busy to manage the estate themselves, the Agnellis and Baron François saw Philippe as a young man well able to help them run things and appointed him assistant director of the château in late 1982. It was a huge responsibility and he had to learn fast. He quickly became interested in wine marketing, working alongside Baron François, with whom he got along famously.

Shortly before he died, a year and a half after hiring Philippe, the Baron wrote a glowing letter of recommendation to the Agnellis. He said he had every confidence in Philippe's ability to take over the running of the estate single-handed and urged them to appoint him as head of operations. In July 1984 Philippe Dambrine attended a meeting with the Agnellis expecting to meet his future "boss", Baron François' successor. Instead, as he stepped into their Fiat showroom on the Champs-Elysées, they immediately asked him to take the job himself. Greatly surprised, Philippe said he needed time to

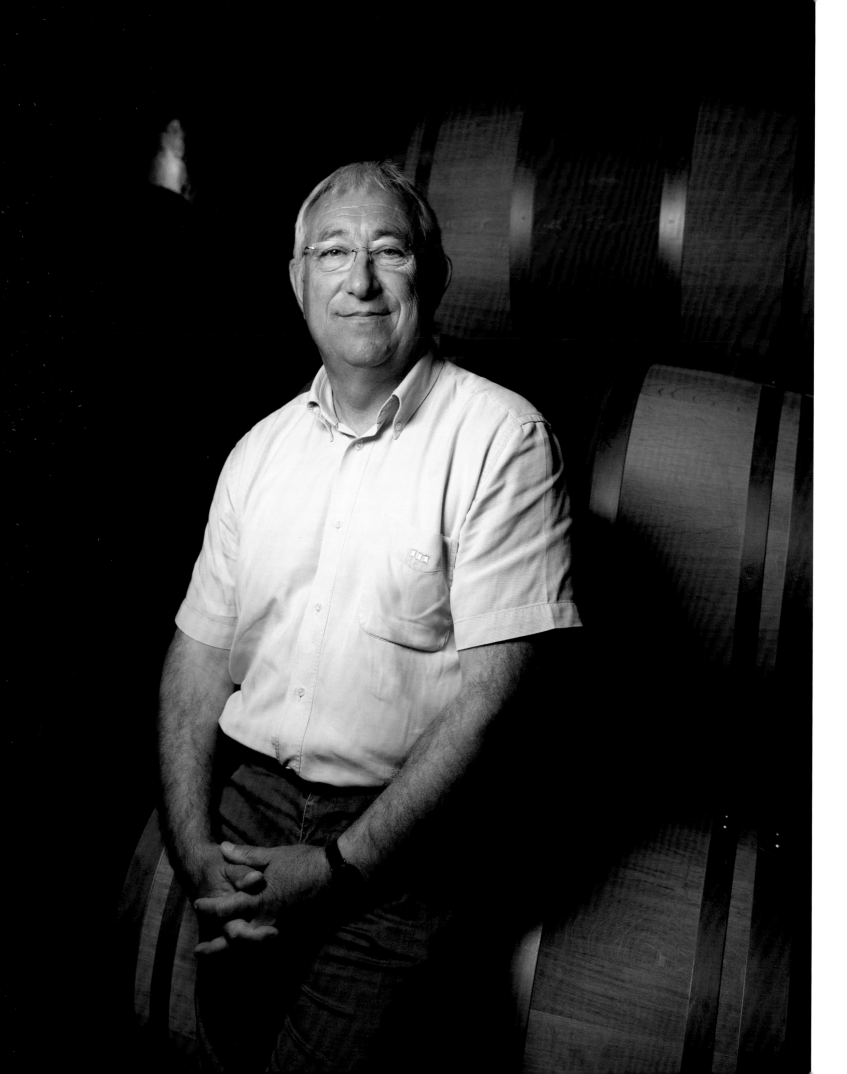

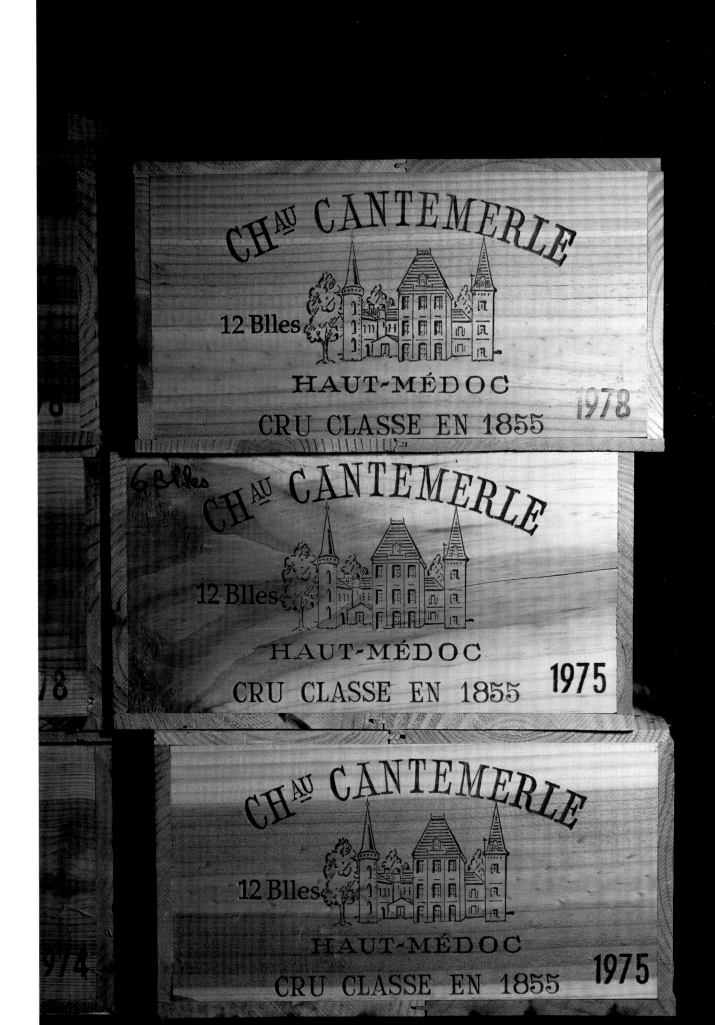

think it over. "You can have five minutes in the waiting-room," came the reply. Philippe decided to accept the offer there and then. "If it doesn't work out, you'll let me know," he added modestly. Looking back, Philippe sees his many years as chief executive of Château Greysac as a hugely formative experience. "It was an ongoing relationship, hand in hand with a family whose impeccable credentials inspired me. As members of Europe's industrial elite, the Agnellis could be extremely generous at one moment and extremely firm the next; but they were essentially human – imbued with a human dimension and simplicity that are the hallmarks of greatness."

THE RE-DISCOVERY OF A SOUL

" Today my estate is embodied in a man who, dare I say, suits me perfectly. Philippe Dambrine runs Château Cantemerle with delicacy – elegant and discreet but with a delightful sense of mischief that shows through in unguarded moments. We have things in common. Like me, he stood up for his beliefs. Like me, he put the wine back on the Bordeaux map. I could not remain insensitive ... "

When he arrived at Cantemerle in 1993, Philippe Dambrine had to build a team and get to know the existing team members. Pascal Berteau was the first to introduce himself, a six-year veteran of the estate with an expressive face set off by big pale blue eyes that could look happy one minute and sad the next. He was instantly likable. Pascal is a self-taught man who at the age of 17 applied to be a cellar worker with the House of Mouton Rothschild. "Give us one good reason why we should take you on," they said. Pascal simply replied that his father would kick him out if he didn't find a job. There could be no better incentive. He went on to work at different properties, eventually becoming cellar master at La Tour Carnet. Ten years later the technical director of Maison Cordier offered him the job of cellar master at Château Cantemerle. He had two admirable cellar hands to work for him, but at heart he always remained "a simple peasant winemaker". The estate workers confined their activities to wine production while Maison Cordier took charge of everything else.

Opposite: Laurence Beuton is responsible for communications and events management. She also assists Philippe Dambrine with European missions.

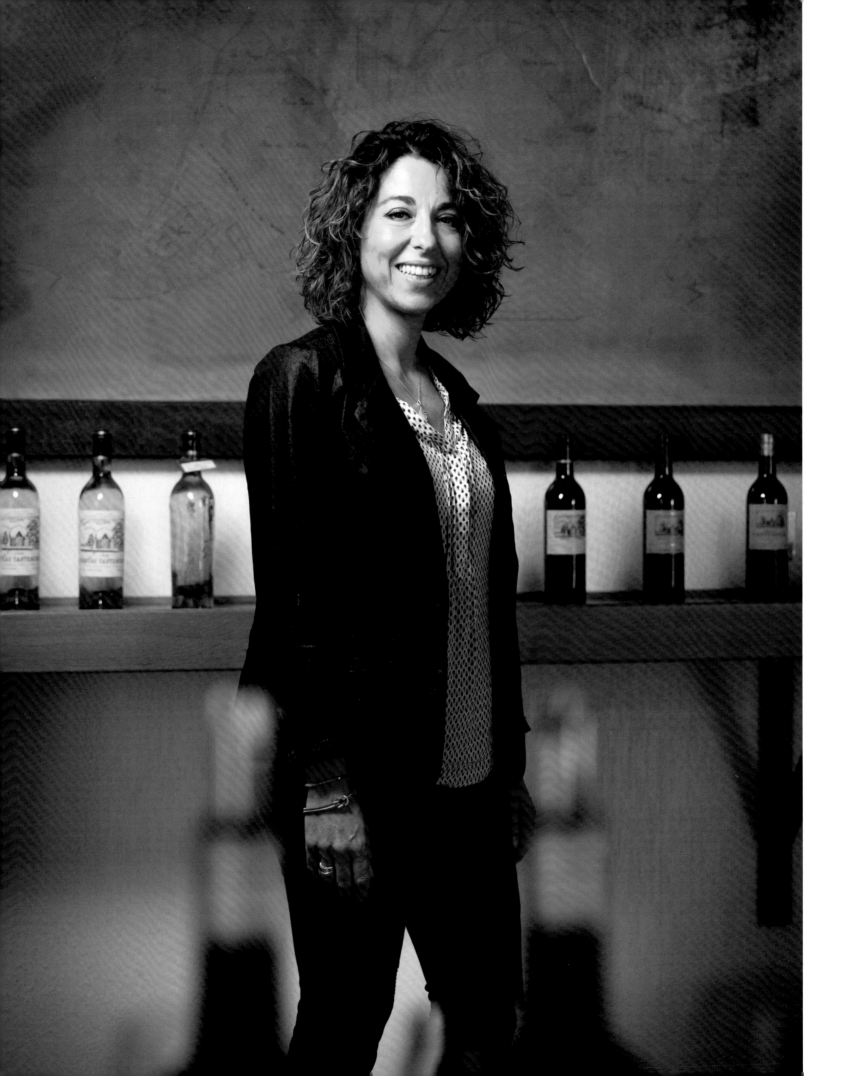

Philippe Dambrine's arrival marked the recruitment of the extra operational skills required to pursue the development of Cantemerle. His first mission was to restore the vineyard's original autonomy. From marketing management to everyday management (accounting, finance, bottling, labeling and packaging) he had to establish the estate as a self-sufficient entity. It was quite a challenge. Cantemerle regained its liberty by breaking all commercial ties with Maison Cordier. The varietal composition was rebalanced, reducing plantings of Cabernet Franc in favor of a greater percentage of Cabernet Sauvignon and Petit Verdot. The *terroir* was then further expanded through the acquisition in 1999 of a new plot in the commune of Ludon.

But the early 1990s were also a time of crisis for the wine industry, with wine production continuing unabated despite a downturn in sales. Philippe Dambrine saw an opportunity for global distribution (drawing on his experience and little black book of connections). But he decided otherwise, firmly convinced that a Grand Cru Classé like Cantemerle belonged with its fellow First Growths. So like Baroness Caroline before him, he opted to sell the wine on the Place de Bordeaux: an open, non-exclusive market where anyone buying wine is then free to sell and resell it throughout the world.

Over the years Dambrine reorganized his teams, driven by the need to bridge the gap between vine and wine and build collaboration in the workplace . He also appointed a technical director – an innovative step since taken by many other estates – giving the responsibility to Pascal Berteau who was promoted to the role of technical assistant to the CEO.

Then there was the protection of the Cantemerle name itself. Philippe Dambrine, like Baroness Caroline in her time, would play an active role in its defense, building on the renovations, improvements and changes spearheaded by Groupe SMA. In 2013, he took action against Société Vignobles Mabille for misusing the "Cru Cantemerle" brand name to promote its own wines. The Bordeaux Tribunal de Grande Instance accepted the complaint and Vignobles Mabille, like Sieur Chadeuil in his day, were found guilty. Dambrine would also do battle against the lunatic project to run an orbital motorway around the city of Bordeaux and through Château Cantemerle … As he made abundantly clear in his communiqué, the idea filled him with horror:

"Has everyone forgotten that Château Cantemerle was included in the 1855 classification and ranks as such among the symbols of the Gironde's historic winemaking heritage? Its vineyard extends over 90 hectares, planted in an almost continuous, single block on land in the commune of Macau, at the gateway to Bordeaux. It surrounds the magnificent château and its famous grounds, which are considered among the finest testaments to the landscape plantings

Opposite and following pages: En *primeur* tastings are now a tradition, hosted by the Union des Grands Crus de Bordeaux. No fewer than 300 chateaus gather to offer buyers and members of the press a sneak preview of their future vintage.

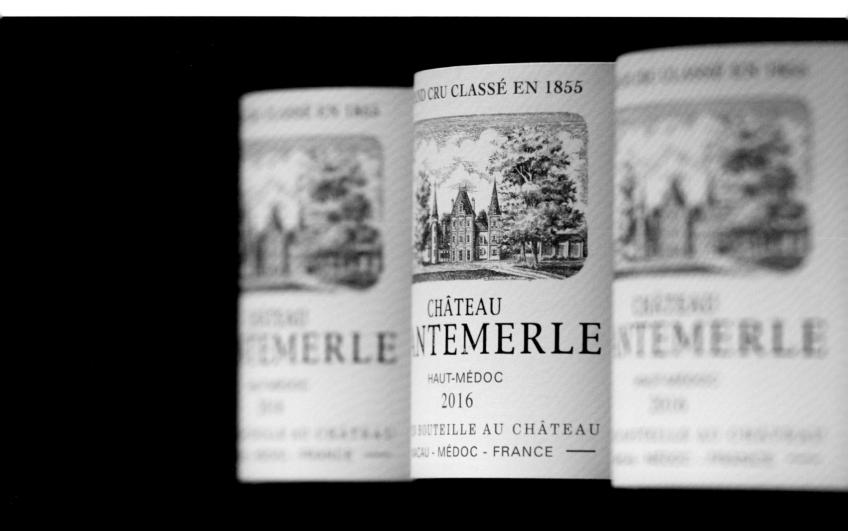

undertaken in the Bordeaux region in the 19th Century, by the most famous botanists of their time. This grand orbital motorway project, as currently proposed, would leave a permanent scar on a terroir that is by definition unique. Quite apart from the visual, aural and atmospheric pollution that would blanket our canton due to a never-ending procession of trucks, there would be irreparable consequences for the extremely complex dynamics of soil hydrology. Like an ugly gash, gouged out for the benefit of international haulage, it would drain the lifeblood out of an entire region, one whose economic and social life depends on the vine."

THE IMPORTANCE OF BLOOD VESSELS

The team that was built by Philippe Dambrine at that time is still in place, proof if proof were needed of the harmony that has prevailed since his arrival, not to mention the attachment that everyone feels towards the estate. Patrick Jirot, Cantemerle's discreet and efficient accountant, and Christine Kaufling, the conscientious marketing assistant in charge of sales administration, have both worked alongside Philippe Dambrine for 25 years now. Pascal Berteau like Françoise Dupouy, the château steward now assisted by Emilie Teepen, were there when Philippe arrived. They remain full of praise for their CEO and tremble at the idea of his eventual departure. Philippe the vineyard manager and Grégory the cellar-master are other long-serving members of staff. Why look elsewhere when everything they need for their professional development is right here, as members of a highly motivated team? Laurence Beuton too, head of communications and event management, has seen her role expand with every passing year. She originally joined the château on a temporary basis, a sparkling brunette fresh from the world of Bordeaux wine trading and eager to work for a great estate. She was soon hired and after taking a course in oenology to improve her knowledge of wine became Philippe Dambrine's assistant on European missions, a position she has held ever since.

Château Cantemerle is a member of the Union de Grands Crus de Bordeaux. Established in 1973, the UGCB brings together some 140 top châteaus with the aim of building their visibility throughout the world. It organizes tastings of their wines in Europe, America and Asia, which must be attended by the château owners themselves. En *Primeur* week – when the new vintage is tasted by trade and press – gives them the opportunity to sell their wines *en primeur*, and is also an ideal time for corporate promotion, raising awareness of the reputation and image of their châteaus – what's known in French as "savoir-faire and "faire-savoir" (knowing and being known). From vine to finished wine, passing through the upkeep of château and grounds, wine promotion and marketing… everyone functions as part of a whole, like the blood vessels that irrigate our cells from head to toe. Without them, there is no circulation, no cell communication, no life.

HERITAGE, HEART AND TALENT

Château Cantemerle today enjoys the benefits of joint representation. At the helm are a CEO with proven expertise in wine-estate management, and an owner with a realistic grip on the business, its long-term investment prospects and its vulnerability to extreme weather. The dynamism of Groupe SMA is matched by its CEO Bernard Milléquant, a man equally committed to his relationship with the Cantemerle team. Shared experiences, feelings and skills count as key factors in the success of Cantemerle. The connection with head office, from the day-to-day running of the estate to questions of strategy, is maintained by chief operating officer Hubert Rodarie, a man of wit and unfailing good humor, assisted by Pierre-Louis Carron, director of real estate investment and custodian of estate records since Cantemerle's acquisition.

The organization is solid, and the estate is equally dear to the teams who work there and the enterprising men and women within Groupe SMA. Remembering the great families of the past, SMA's devoted members recognize the legacy that resides in these lands – a legacy that allows human talent to express itself and inspires each individual to serve this great estate. We saw this demonstrated in the appointments that followed Albert Parment's retirement in 1992. Groupe SMA administrator Jean Migault succeeded him for a few years, lending notable support to the proposal to expand the Cantemerle vineyard in 1999. And another mode of management was born in that interim period: the running of the estate is henceforth assured by a *conseil d'administration* (board of directors) headed by the acting president of Groupe SMA. Like Albert Parment in his time, Bernard Milléquant is sensitive to the charms of Cantemerle and has played a part in its life by introducing a series of paintings. They say that the portrait of Baroness Caroline now takes pride of place in the living-room…

THE FOUNDERS

"You will recall that Jean de Villeneuve, my husband's grandfather, bought the domain of Cantemerle in 1579. It was his aim to make it a great winegrowing *terroir*. Given good management, vines were a good investment, the more so for a bourgeois from Bordeaux who was Second President of the Bordeaux parliament, enjoying privileges granted by the town that favored the commercialization of his wine. To establish a cru was also a mark of social position, a flamboyant symbol of success. Who would have thought that this acquisition motivated by personal status and profit would be the start of three centuries of family passion?

So in the 16th Century, the Villeneuves became big vineyard owners, with a great number of noble houses such as Gironville, Maucamp and Sauves under their authority. In the time before they exported to Holland, they sold their production to the English, those long-standing rivals who were faithful customers of Graves and Médoc wines. A thousand years of trading with the British and the countries

of the north, a *terroir* like no other in the world and a geographical position ideally suited to trade... the vineyards of Macau enjoyed a number of advantages from which I would benefit.

There were many who came before me. Jean's successor was Louis de Villeneuve Durfort (Jean having added his wife's prestigious family name to his). At this time, the ancient fortified château was still the family's main residence. Sauves, where the winemaking facilities were installed and where the harvested grapes were delivered, was home to Louis' brother, Hector.

In 1698, Pierre de Villeneuve became Lord of Cantemerle. His successor was Joseph-Emmanuel de Villeneuve Durfort who participated in the *assemblée de la noblesse* in 1789, and would be the property's last baron. My destiny was now taking shape: Joseph-Emmanuel's son was Jean de Villeneuve Durfort, my future husband. He fled to Holland during the Revolution and when he returned our wines were sold directly to the Low Countries, without passing through the hands of the Bordeaux wine traders... These would be the connections on which our success was built."

THE DUTCH CENTURY

In the 17th Century, the Low Countries became a substantial commercial power. Being accomplished sailors, they would dominate the French Atlantic coast and fundamentally transform the wine business. In the course of several decades, they replaced the English with an unprecedented demand for wine. The Dutch were looking for quantity – they exported a large proportion of the wines to their colonies – and their tastes were different. Exotic imports had created a new preference for sweetness, sugar and spices. But there remained the problem of delivering the wine to its destination: French clarets didn't travel well. With this in mind, the Dutch developed new techniques, which were sometimes slow to catch on due to their revolutionary nature. It was the Dutch who established the use of sulfur, the famous "Dutch match" (whose anti-bacterial properties would be confirmed once again by Louis Pasteur two centuries later …). Other wines with less alcohol would be distilled, destined to become one of South West France's first export products.

Against this background of vigorous commerce, the Dutch became increasingly established in Bordeaux society. The Médoc, like the coastal area as a whole, remained an area of inhospitable and marshy land, and it was to Flemish engineers that Henry IV turned for the necessary works – they being the masters in this field. The presence of the Dutch and their gift for commerce encouraged them to invest in wine trading. Big names were established, such as the House of Beyerman in 1620. Beyerman is today the oldest brokerage firm still operating in Bordeaux; and by a quirk of history, the Binaud and Dubos families, future proprietors of the Cantemerle and Tour de Mons estates, were descended from the House's founder, the ship-owner Jean-Simon Beyerman…

Being accomplished sailors, the Dutch would dominate the French Atlantic coast and fundamentally transform the wine business.

Opposite and following pages 152–155: The promise of things to come. At this stage, the wine is unfinished, a work in progress. Only wine professionals can tell how good it will eventually be. Tasting *en primeur* provides them with an informed basis for the marketing of the future wine.

"The Cantemerle estate became mine, and I naturally continued trading with the Dutch. As we know, I also had battles to fight. In 1845, Pierre Chadeuil, then mayor of Macau and owner of Château Pibran, claimed that the name "Cantemerle" belonged to the surrounding region. So he started to label his wines "Chadeuil Cantemerle Château Pibran". To my great joy, I could prove that there was no basis for his claim and the court's decision was final: "The Tribunal forbids Sr Chadeuil to sell or distribute wines from the Priban estate or any other cru or source under the Cantemerle name, whether used alone or linked to the name Chadeuil or any other name, and likewise forbids him to use the name Cantemerle on any stamp or label applied to bottles, or any stamp applied to barrels, whether used alone or linked to the name Chadeuil or any other name. Considering that there are no grounds to conclude otherwise with regard to the payment of damages, Sr Chadeuil is hereby ordered to pay 256 francs and 48 centimes in cash, this not including the cost of expediting and notifying the present judgment, which costs shall also be borne by him.""

I said I would say something of Jean-Baptiste Fleuret, Comte de La Vergne, manager of the estate, mayor of Macau and an active member of Gironde's agricultural association. Oïdium was the first fungal disease to reach France, and in 1854 it contaminated the entire Médoc vineyard. Sulfur was the miracle cure introduced from 1850 onwards, greatly aided by the Comte de La Vergne's invention of the bellows in 1857, which spread the sulfur more easily and more evenly. In 1852, he conducted his first sulfur-spreading trials on my land and the following year published a document setting out the rules for treatment. What luck to have him by my side!"

The arrival of these diseases was a real disaster for wine estates. Nearly two thirds of harvests were wiped out and vineyards everywhere had to be ripped up. It is likely that those early trials in the Cantemerle vineyard were the factor that allowed the property to preserve its vineyard and maintain a reasonable level of production. In 1858, the vineyard matched the area today, at more than 90 hectares, producing 160 barrels of our first wine and 30 barrels of our second. In 1865 when the House of Beyerman's barrel price was 1600 francs, our production was assessed at 160 barrels of the first wine and 50 barrels of the second. This distinction between first and second wines is evidence of the importance attached to its quality.

THE ELITE ENGLISH MARKET, AND THE PURSUIT OF QUALITY

Prior to 1854, Château Cantemerle exported all of its production to Holland. Meanwhile from the beginning of the 18th Century, the English influence had returned in force with an impact on the character of wines throughout the Médoc. Rich English aristocrats with refined gourmet tastes were determined to set themselves apart from ordinary wine drinkers. They rapidly became enthusiastic for these New French Clarets that were better

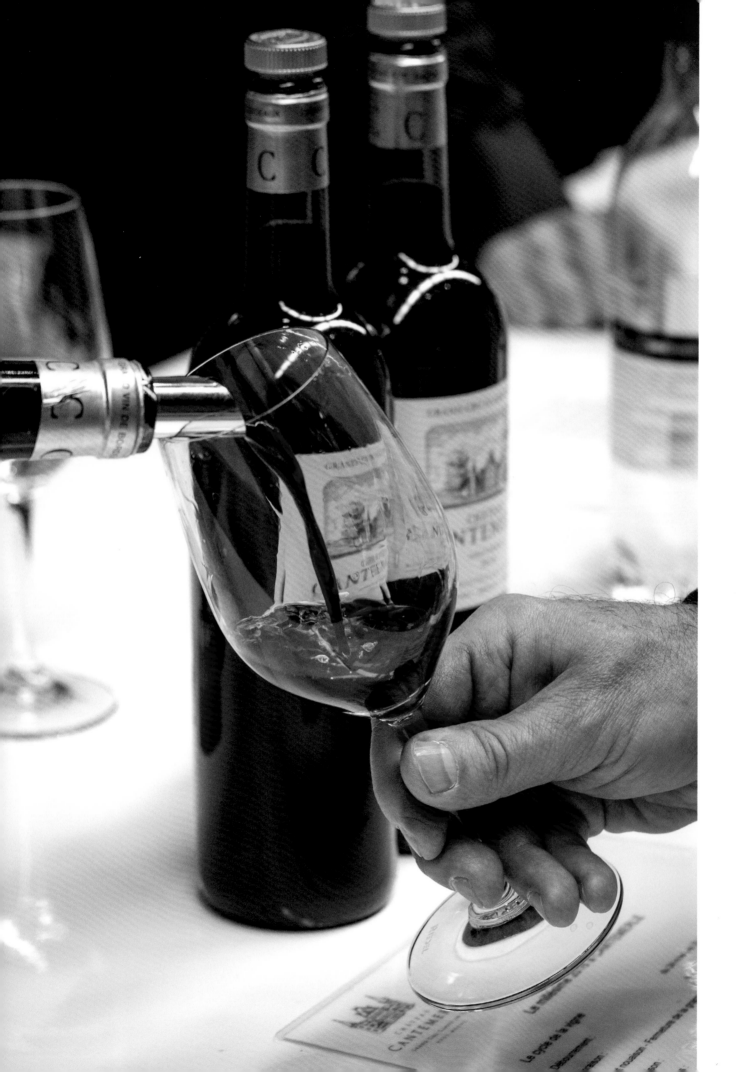

produced, more stylish, more expensive and fit to serve with the most refined dishes. The pioneer was Arnaud de Pontac, president of the Bordeaux parliament and owner of Château Haut-Brion – a man devoted to his vineyard and the quality of his wine, which he worked hard to improve. He opened a restaurant in London where the English elite flocked to taste *du Haut-Brion*. He created a demand and it was he who introduced the concept of "cru", identifying a wine by its place of origin and not by the name of the owner. The winegrowers on the banks of the Gironde were quick to play the quality card. It was a real revolution in the world of winemaking.

The Médoc commenced a "frenzy of planting", vines replacing staple food production on the alluvial and gravel soils. Grape varieties were selected and sorted, giving preference to old vines with proven value; pruning became more precise; and grapes were harvested later for the sake of ripeness. The wine was matured in new oak casks, sulfur-spreading became a widespread practice, ullage and racking were adopted, and egg white was used to eliminate fine particles that remained suspended in the wine at maturity. From these exceptional improvements were born the future Grands Crus Classés of 1855...

A STORM OF FUNGAL DISEASE

When Baroness Caroline died in 1866 in Bordeaux, her estate totalled 110 hectares. The sole inheritor was her daughter Jeanne-Armande de Villeneuve Durfort, Baroness d'Abbadie. The Comte de La Vergne's administration and a combination of the best grape varieties had considerably enhanced the quality of the wines. The estate ranked as one of the best-cultivated in the Médoc and one of the most prosperous. But this golden age of the Second Empire was followed by one of the darkest periods for vineyard owners. Between 1879 and 1887, phylloxera and mildew devastated the Macau vineyard. Chateau Cantemerle was in the front line of the epidemic and had to clear half of its vines.

On the death of the Baroness d'Abbadie in 1891, the estate was hurriedly sold by its inheritors. At the dawn of the 20th Century, the Villeneuve Durfort family handed over to the Dubos family, marking the end of a dynasty that had spanned three centuries.

PIERRE'S CENTURY

The Calvet trading house bought the Cantemerle estate for 660,000 francs and resold it fifteen days later to Théophile-Jean Dubos, vice-president of the Union des Crus Classés de Bordeaux and a wine merchant with the House of Dubos Frères. It is said that behind every great man and every transaction, there is a woman. The woman in this case was skilled horsewoman Charlotte Delbos, wife of Théophile. An old friend of the Baroness d'Abbadie, she was eager to acquire her own property like her brother who was the owner of sev-

eral Médoc châteaus. What better acquisition than Cantemerle, with its fine reputation and large vineyard, plus huge grounds in which she could gallop at leisure. Thus commenced the Dubos century.

Théophile-Jean Dubos managed the estate supported by his sons Pierre and Bernard. After his death in 1905, his sons remained co-owners until 1923 when Pierre bought his brother's share and steered the destiny of Cantemerle alone, while his younger brother took over the trading house.

With his goatee beard and black beret, Pierre Dubos was a well-known figure – a countryman with an air of nobility, grown wealthy through wine trading and devoted to wine. He brought a terrific energy to the property, nurturing his cru with a rare discipline and thoroughness. But he was not spared the storms of the 20th Century. The period marked the start of a crisis, with wine production outstripping demand. This imbalance between supply and demand was temporarily corrected by the two world wars: on the one hand vineyards shrank for lack of labor and vine-treatment products; on the other hand, the army needed all the wine it could get to supply the daily ration to its soldiers.

In the aftermath of the stock-market crash of 1929, the Médoc *terroirs* were already in a sorry state. Preyed on by fungal diseases, the vineyards lay in tatters, either ripped up or overgrown. Pierre Dubos, the owner until his death in 1962, saw his vineyard holding shrink to 25 hectares in 1945, compared with some sixty in 1907 ...

Winegrowing apart, the Cantemerle estate remained full of life. Pierre Dubos settled there with his wife Henriette Marie Dieudonnée Suzanne de Morin de Senneville, the heiress to Tour de Mons, a Margaux that Pierre also managed. Their marriage produced two daughters, Pia and Bernadette, who both lived in Bordeaux. Patriarch Pierre's real ambition meanwhile was to make his 360-hectare estate a place of life and gaiety. He surrounded himself with entire families. It was a time when herds of cows and sheep still grazed the land, a time of endless walks through forests and vineyards dotted with the silhouettes of cattle and horses. It was a time when everything was still done by hand, calling for an army of men and women (shepherds, butchers, cooks, vine workers, cellar workers, chambermaids, ladies' companions ...) to service the property. The estate provided work all year round. Taking care of the grounds, the dovecote, the kitchen garden (a whole hectare!) Madame's roses, harvesting the pine resin, the wheat and the oats, maintaining the farmyard (chickens, pigs, ducks!) and not forgetting to forage for porcini in the grounds... The Cantemerle estate was a village community in its own right. Devoted to his *terroir* and ever concerned for the wellbeing of his "people", Pierre Dubos was a regular visitor to the cellars. He smoked his little cigars, handed them around, and invited his employees' children to the house at Christmas to give each one a coin and some sweets...

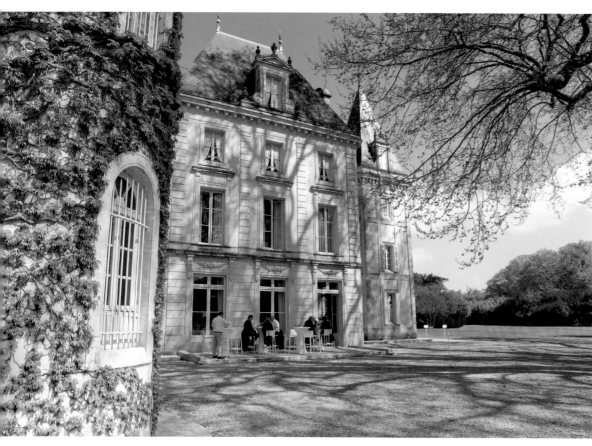

A few years before his death, Pierre Dubos suffered another blow with the famous Black Ice of 1956. Even though the Médoc was one of the regions least affected, the temperature dropped to -20 degrees for three whole weeks, putting paid to many vine plants.

Pia and Bernadette Dubos inherited the estate at the beginning of the 1960s and, being both married, passed the management of the property to their husbands and sons. Henri Binaud, manager of the famous Beyermann trading house, and his nephew Bertrand Clauzel would jointly manage Cantemerle until 1977, at which time Bertrand, Bernadette's son, became the sole manager.

The 1970s were by no means a prosperous time for the wine trade. The crisis continued unabated and the estate, subject to inheritance *en indivision*, struggled to make progress. The vineyard was no more than 22 hectares and the owners could not contemplate the investment required to replant, renovate and modernize the château and out-buildings. Chickens were running round the vat house, the grapes were still foot-trod, and a tractor had only just replaced what few draft horses remained.

Château Cantemerle was all the same blessed by the care that it had received over the years. The estate had managed to conserve its old vines and the quality at its heart. But in the face of history and recessions, the Dubos family had only managed to ride out each crisis, without ever producing growth.

Today this great *terroir* has recovered all of its splendor and prestige, thanks to the investments and modernizations that Groupe SMA has put in place since buying the property in 1981, The human spirit of the estate is moreover faithfully preserved. With its familial roots intact, a fine public profile and a sound economic foundation, Château Cantemerle can now look to the future with confidence.

Opposite: En *primeur* season finds guests gathered for lunch amid the spectacular surroundings of Cantemerle in the fall.
Above: Emilie Teepen joined the Cantemerle team alongside Françoise Dupouy, jointly responsible for overseeing the stewardship of the chateau.

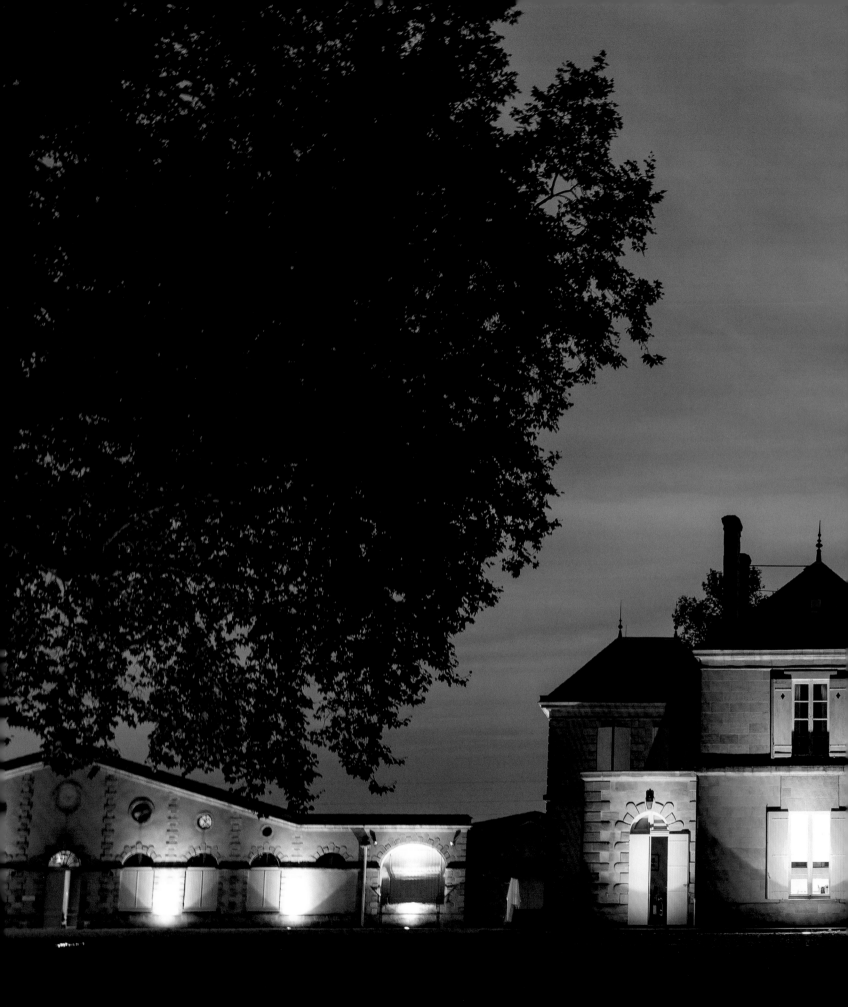

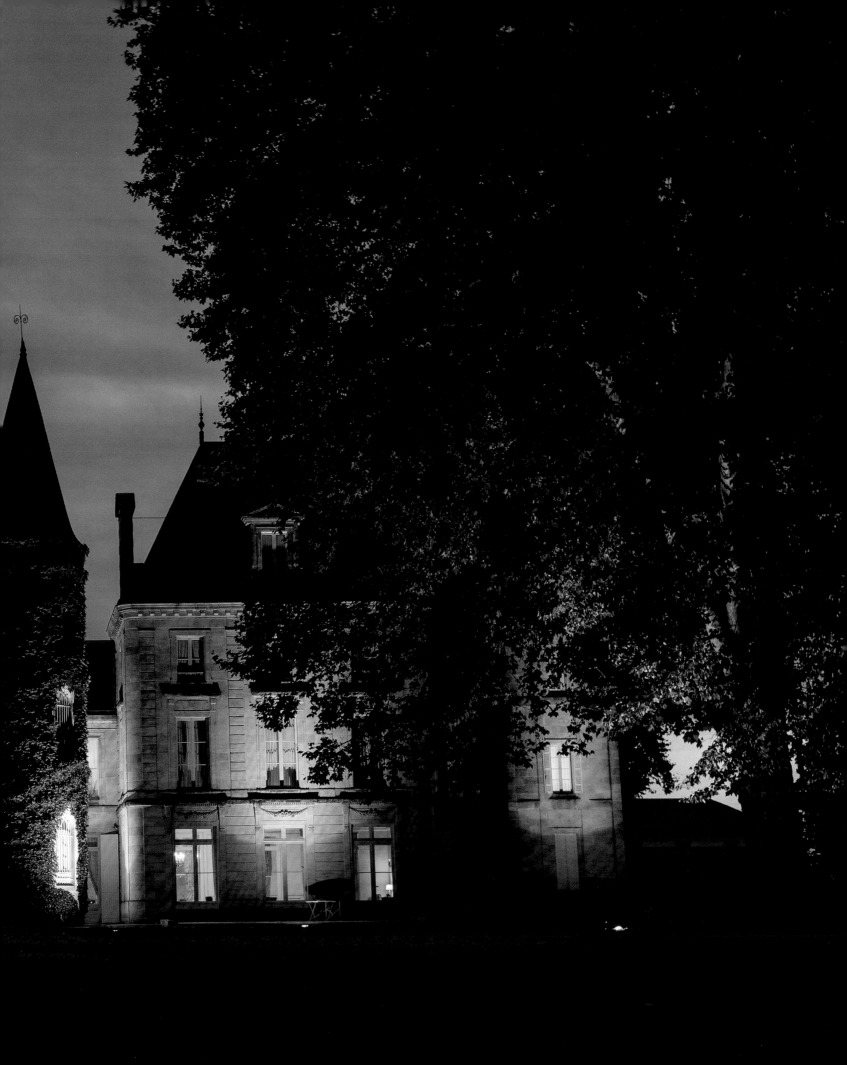

BEYOND
THE
VINES...

" The land shapes destinies, and destinies shape the land…
Long before its stories were told, before a domain was shaped by the
efforts of men and women in the vineyard and the cellar, the lands of
Cantemerle were a vibrant presence, a unique expression of Nature.
The domain is one of those magical places that radiate peace and
happiness, that refresh the weary and stir the lover's dormant heart.
Could it be that unseen forces are at work behind this palpable aura
that is felt by all who encounter it? I would like to believe it…
but of course that depends on harmony, the harmony that prevailed
when man was still one with Nature. "

What lies beyond the extensive parkland on the road from Bordeaux to Pauillac? What will we find at the end of the long drive – Sleeping Beauty's castle! Michel Bettane, Laurence Beuton, Eric Boissenot and many a visitor might surely exclaim at the sight of the château, appearing without warning from behind a wall of greenery in a resplendent sunlit courtyard. A strange stillness hangs over the grounds, despite the bustle of activity in the large airy wine cellars. A silhouette stirs behind a pair of tall French windows revealing another pair through which the vineyard is visible. With dazzling yet solemn luminosity and translucency, the unique architecture attests to the passage of time. This former manor house of Sauves, at one time the estate's wine cellars, became the primary residence of the Villeneuve family at the end of the French Revolution. The original fortified castle dating from "the era of the Ponsets and Gaillards" was located on the boundary between the communes of Ludon and Macau. It was demolished in 1789 and only the watchtower was conserved and moved to Sauves. During the first half of the 19th Century, the Villeneuve's new residence would undergo continued improvements and extensions. Two towers, one round and one square, were added at each end of the château's intersecting gabled rooflines. In 1875, a few hundred acres of vineyard were sold to the Compagnie du Médoc to finance further renovations to the domain, now under the stewardship of Baroness Caroline. The roof was restored, flat roof tiles replacing slate, and the building was again enlarged.

Opposite: The estate's long avenues suddenly open on the property itself – a glittering fairytale castle straight out of the pages of Sleeping Beauty.

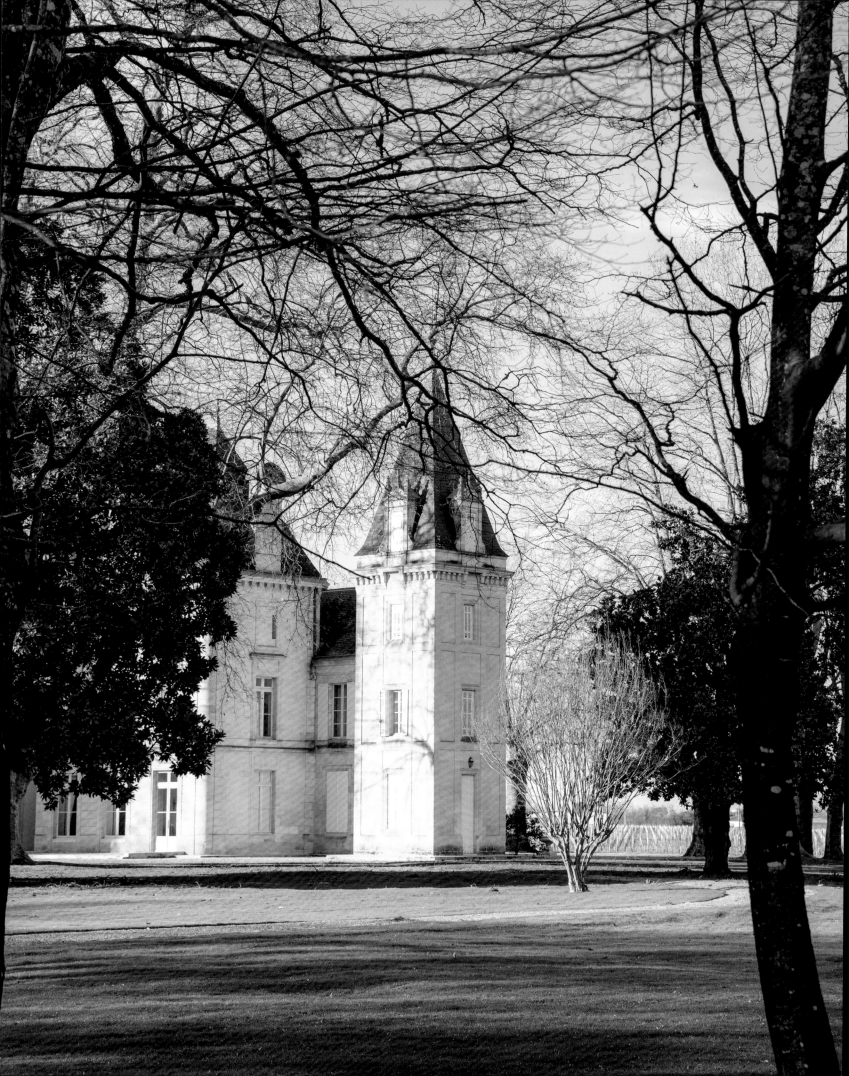

A bartizan (watchtower) is all that remains of the fortified castle originally built by the Lords of Cantemerle. It was relocated to Sauve, present location of Château Cantemerle.

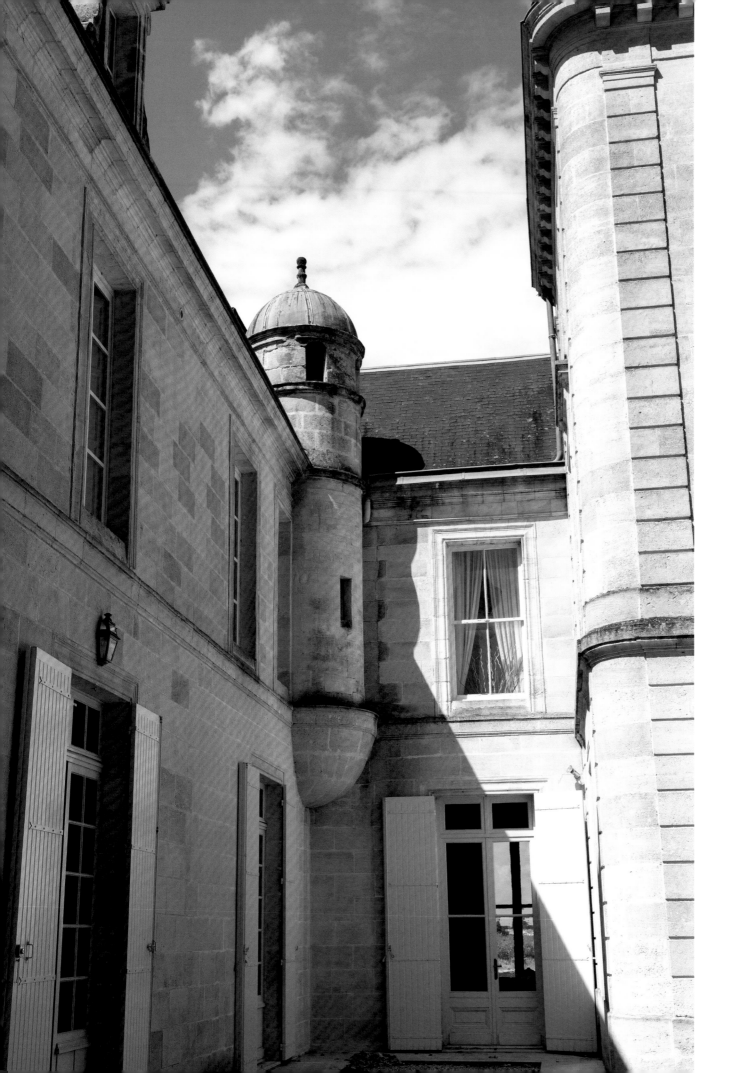

Above: Elegant and refined, the château interior bears all the credentials of a Grand Cru Classé.

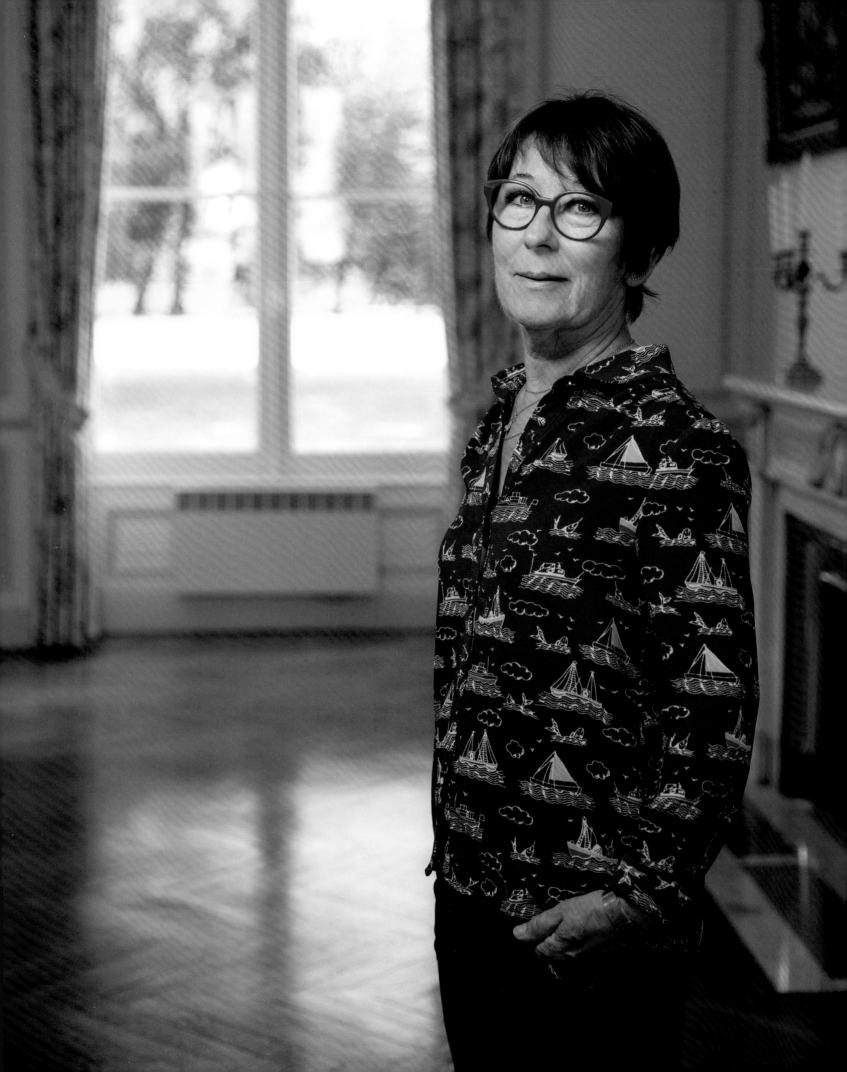

Graceful deer are
sometimes seen at
the far end of a walk,
foxes play in the
mossy woodlands and
wild rabbits scurry
over fields.

The arrival of the railroad marked a revolution in the region, and estate owners naturally welcomed this new communication route. The first section of track was inaugurated with great pomp in 1868, and the same day a lavish reception was organized at Cantemerle.

THE CHÂTEAU, INSIDE AND OUT

There are men and women whose presence alone serves as a benign influence. Françoise Dupouy joined the estate in the early eighties. Not cut out for work in the vineyard, she gladly accepted the task of managing the château. Today this gourmet cook and invaluable housekeeper supervises the château with a generosity and apparent ease that proves her unfailing professionalism. No guest can resist her kind attentions and warm welcome, "not even the most cantankerous", as Pascal Berteau likes to say with a grin. As Philippe Dambrine embodies the lands of the estate, so Françoise Dupouy personifies the heart of the château. Like a cat on a windowsill surveying its domain, no sound or silence escapes her notice. The château is her territory, and she knows it inside out, every inch of the building and every walk in the gardens.

"Cante merle," which roughly translates as "the song of blackbirds," is also where hoopoes, thrushes and ringdoves sing. Every year at the approach of Valentine's Day, kestrels build their nests in the castle's tower. A pheasant couple, nicknamed Kiki and Coquette by Françoise, can be seen strutting on its lawns. The arrival of "Ple-Ple" announces bad weather. The mischievous woodpecker makes its way between tree trunks, convinced no one is watching, its ritualistic dance interrupted only by the squirrels who scurry, stop short and scurry again, also persuaded that no one is watching... Graceful deer are sometimes seen at the far end of a walk, foxes play in the mossy woodlands and wild rabbits scurry over fields. This botanical fairyland, this parkland of a thousand and one wonders, is also home to wild mushrooms, strawberries and plums, chestnuts and hazelnuts. But the terrible fury of Nature can be unleashed here too…

Opposite: Françoise Dupouy is another long-serving member of the Cantemerle team and knows the property and grounds inside out.

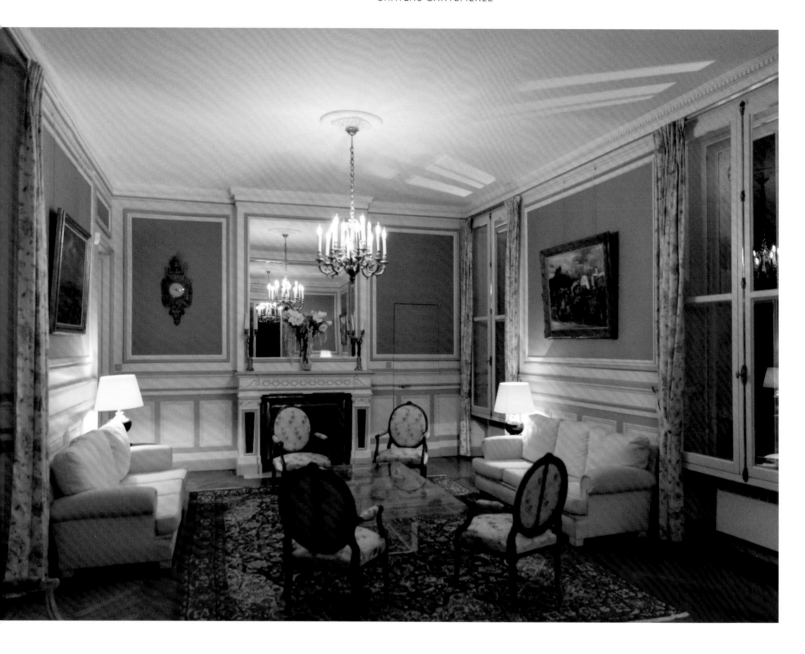

Below: The living room reflected at night...

WHEN NATURAL DISASTER STRIKES

Nature would release its fury on the night of 27 December 1999. At daybreak, a vision of hell: fifteen hundred trees downed by the onslaught of the wind. Maritime pines and oak trees litter the grounds of the great park. One of the great bald cypresses has been toppled, lying near another that is still standing, while yet another has fallen onto the gates of the château, blocking the route to Pauillac. The disaster is sobering, but it is also an opportunity for re-evaluation. At the time, the avenues and walks of the grounds were only basically maintained. Now newfound attention would be paid to the parkland, this exceptional natural sanctuary, which though inherently wild and abundant had always been carefully tended by the Cantemerle groundskeepers.

The twenty-eight hectares of parkland represent what is doubtless one of the region's most beautiful parks, laid out in the 19th Century by Louis-Bernard Fischer, a renowned botanist who designed the Jardin Public in Bordeaux. There was a profound understanding of the plant world at the time. Chambrelan curbed the advance of the dunes in that era with an ingenious system of replanting. Landscape gardeners were meanwhile eager to introduce new plant species and adapt Nature to their whims. For Cantemerle, Fischer envisaged a landscape based on a series of wide avenues converging at the château with secondary paths for more leisurely strolls. He left the extensive woodlands unaltered while domesticating the lands surrounding the buildings. The grounds were laid out to a precise plan, like a stage set suggesting backstage secrets. Arranging each tree so another might be concealed behind it, Fischer generated an atmosphere of curiosity and carefully calculated suspense. The two great plane trees, today proudly measuring six meters in circumference and forty-five meters in height, were most likely planted in those days. France was dotted with royal nurseries at the time seeking to show off French plant varieties and enrich the countryside. The choice of plant species spoke volumes about an owner – and the delivery of new trees more than fifteen meters high towed on carts was clearly a symbol of power and success. The age and diversity of the plantings at Cantemerle are proof of work on this scale. There are still plane trees and magnolias from that time, black walnut trees, bald cypresses and black locust trees. The forest is rich with stalked and sessile oaks, hornbeam, pine, mountain ash, arbutus and chestnut trees.

Opposite and following pages: The grounds were laid out by famous 19th Century landscape gardener Louis–Bernard Fischer and count among the finest and most extensive anywhere in the Médoc. They include many specimens more than 100 years old – such as these venerably weathered plane trees, now with conjoined roots that make them appear as one.

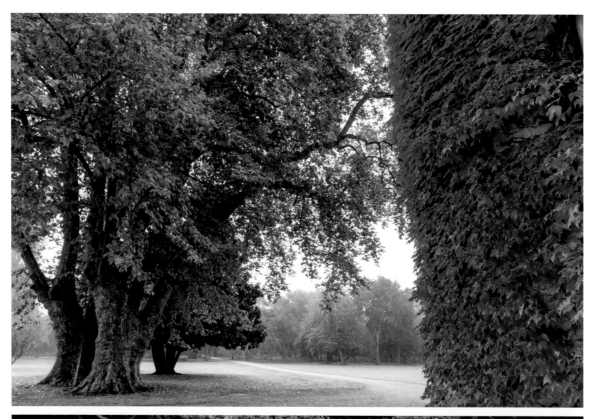

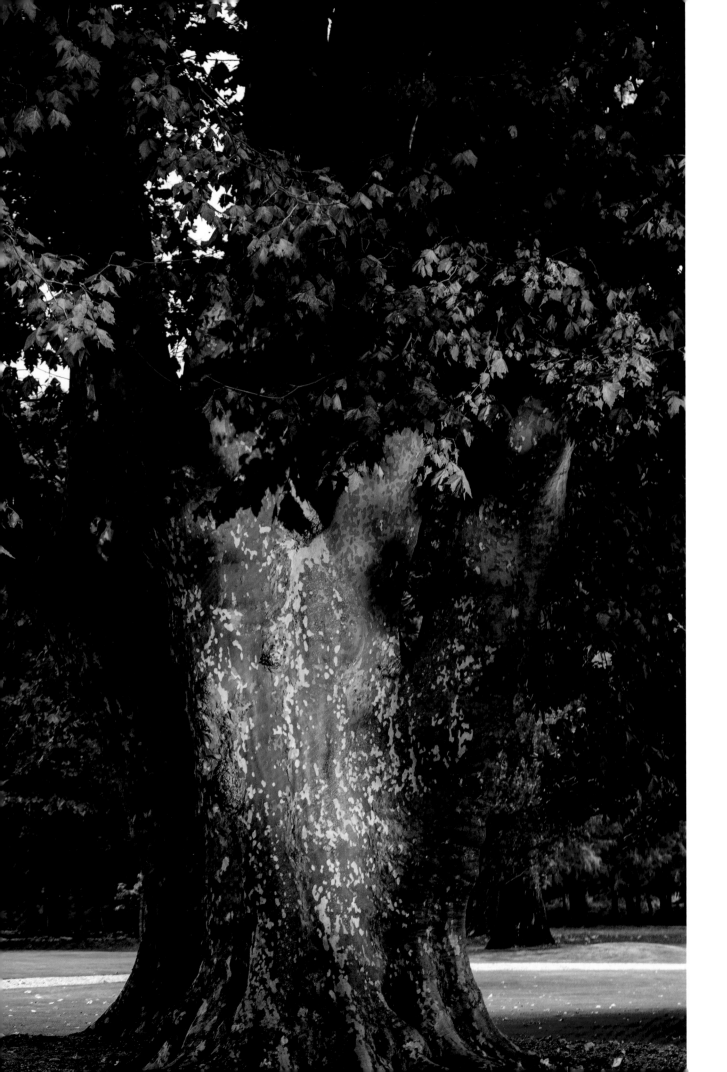

Above: Where beauty and delicacy abide in every detail. A flower that looks like a snake; the entwined leaves of ferns; the patient labors of a spider – Cantemerle's lovingly tended grounds create a protected habitat full of surprises. **Page 180:** Two royal ferns prepare to unfurl in spring. **Page 181:** An owl (or is it?) appears hidden in a tree trunk.

The untamed charm of the park is still intact, its mysteries, delights, and rustlings encircling the château like a magical shield.

The forest floor is dominated by flamboyant eagle ferns. Around ponds, fleeting pairs of royal fern intertwine.

In the aftermath of Hurricane Martin in 1999, local species of birch, holm oak and service trees were planted, along with more exotic sweet gum and redwood. The astonishing yew tree is still standing! This age-old ancestor, which is neither coniferous nor leafy and able to slow growth or accelerate it as the situation requires, continues its centuries-old life today on the verdant lawns of the château. Man has always bordered his lands with trees or stones, and this tree that descends from ancient Christian traditions was most likely planted in the days when Château Cantemerle was still called Sauves. Today, "the first thing you do when you get to Cantemerle is go and say hello to the trees," says Philippe Dambrine.

The untamed charm of the park is still intact, its mysteries, delights, and rustlings encircling the château like a magical shield. Avenues with poetic names lead to and from the house. There is the Avenue of the Foxes, the Avenues of Bordeaux and Macau; the Avenue of the Calvary, named on account of its steep incline; the Avenue of Sands and the Avenue of the Wolves; and of course, the Avenue of the Vegetable Garden, so important in former times.

" At the end of the day, as the last glimmer of daylight gives way to the first stirrings of night, go out to those noble trees, a glass of Château Cantemerle in hand, and there where the blackbirds sing let the magic of the domain envelop you. "

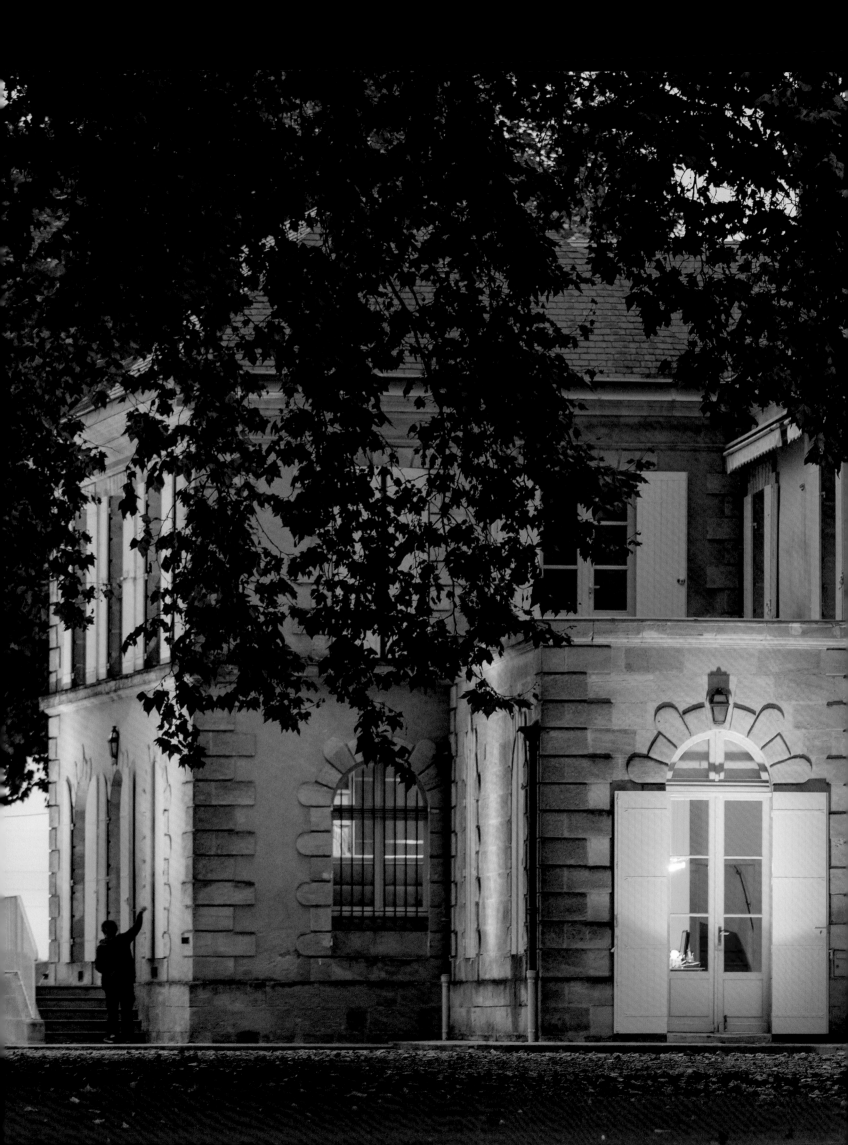

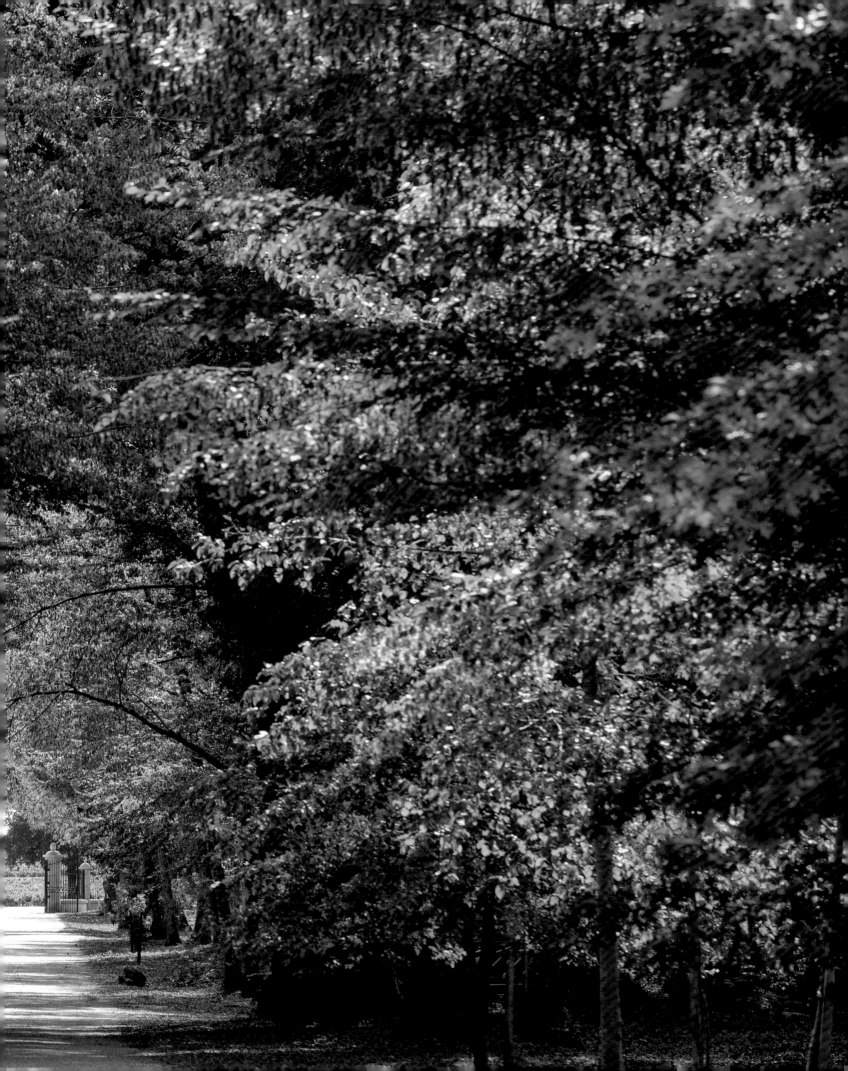

BIBLIOGRAPHY

Birlouez, Éric. *Histoire du vin en France, de l'Antiquité à la Révolution*. Rennes, Éditions Ouest-France, 2015.

Chapuis, Claude. *L'esprit du vin. Les 50 plus belles histoires*. Boulogne-Billancourt, Timée-Éditions, 2005.

Coutier, Martine. *Dictionnaire de la langue du vin*. Paris, CNRS Éditions, « Biblis », 2013.

Daney, Charles. *Petite Histoire du Médoc*. Pau, Éditions Cairn, 2016.

Dion, Roger. *Histoire de la vigne et du vin en France, des origines au XIXᵉ siècle*. Paris, CNRS Éditions, 2010.

Gautier, Jean-François. *Histoire du vin*. Paris, Presses universitaires de France, « Que sais-je ? », 1996.

Lefèvre, Ségolène. *Les femmes & l'amour du vin*. Bordeaux, Éditions Féret, 2017.

Markham, Dewey Jr. *1855: A History of the Bordeaux Classification*. Boston, Houghton Miffin Harcourt, 1997.

Pivot, Bernard. *Petit dictionnaire amoureux du vin*. Paris, Pocket, 2015.

Tahon, Thierry. *Dictionnaire philosophique et subtil du vin*. Toulouse, Éditions Milan, 2011.

Thiney, Marie-José. *Fascinant Médoc*. Bordeaux, Éditions Sud-Ouest, 2013.

ACKNOWLEDGEMENTS

The author extends her thanks to the Groupe SMA and societaries.

Bernard Milléquant, Hubert Rodarie, Annabelle Grandjean
and Philippe Dambrine.

Thanks also to Pascal Berteau, Laurence Beuton, Grégory Thibault,
Philippe Glumineau.
Françoise Dupouy and Émilie Teepen for their attention and unfailingly
warm reception; to Didier Ters, Michel Patarin, Marie-Stéphane Malbec and
Michel Bettane for their memories and invaluable documentation; and to
Jean-Michel Larché for his ethnobotanical tour of the Cantemerle grounds.

Special thanks to all the team-members of Château Cantemerle
for their comments and hospitality, and to the entire workforce
for so graciously tolerating my photographic indiscretions.
To the *vigneronnes*: Lydia Bargas, Annie Corbineau,
Marie-Françoise Cressini, Isabelle Joly, Audrey Legrand, Agnès Rouchon
and Mariza Sahun.
To the *vignerons*: Claude Arnaud, Laurent Autier, Bruno Bouchet,
Philippe Caussan, Carlos Da Silva Mendes, Christophe Dassens, Amandio
Ferreira, Sylvain Londey, José Rolo and Benoît Thibault.
To the vat house workers: Franck Duboé, Mostapha El Kharif,
Adrien Nicolle, Inès Pacheco and Rémi Vales.
To office workers: Jennifer Baquière and Aurélie Bernède;
head of shipping: Benoît Berteau; accountant: Patrick Jirot; head of sales
administration: Christine Kaufling; gardener: Jérôme Texier; mechanic:
Patrick Payeur; drivers: Philippe Corbineau, Thibault Lombart and Jean-
Michel Loubaney; trainees: Benjamin Nadalié and Lilian Chevalier.

To Romain Grandjean for his wings!

My thanks to the team at Éditions de La Martinière: Corinne Schmidt,
Virginie Mahieux and Laurence Maillet.

Thanks also to Aurore Labadie, Simon Psaltopoulos, MC Labadie and
Gaëlle Lochner for their careful re-reading, help and useful comments.

A final word of thanks to the eternally good-natured JLF.

Graphic design and art work: Laurence Maillet
Translation from French: Heather Allen ; Florence Brutton for "Humanity at the heart"

Copyright ©2018, Éditions de La Martinière, an imprint of EDLM for the original and English translation
ISBN: 978-1-4197-3089-4

Printed and bound in Faenza Group Italy
10 9 8 7 6 5 4 3 2 1

Abrams books are available at special discounts when purchased in quantity for premiums and promotions as well as fundraising or educational use. Special editions can also be created to specification. For details, contact specialsales@abramsbooks.com or the address below.

The abuse of alcohol is dangerous to health, consume in moderation.

ABRAMS The Art of Books
115 West 18th Street, New York, NY 10011
abramsbooks.com

195 Broadway
New York, NY 10007
abramsbooks.com

SMA

Ensemble, allons plus loin !